The Beginner's Guide to
Drawing People

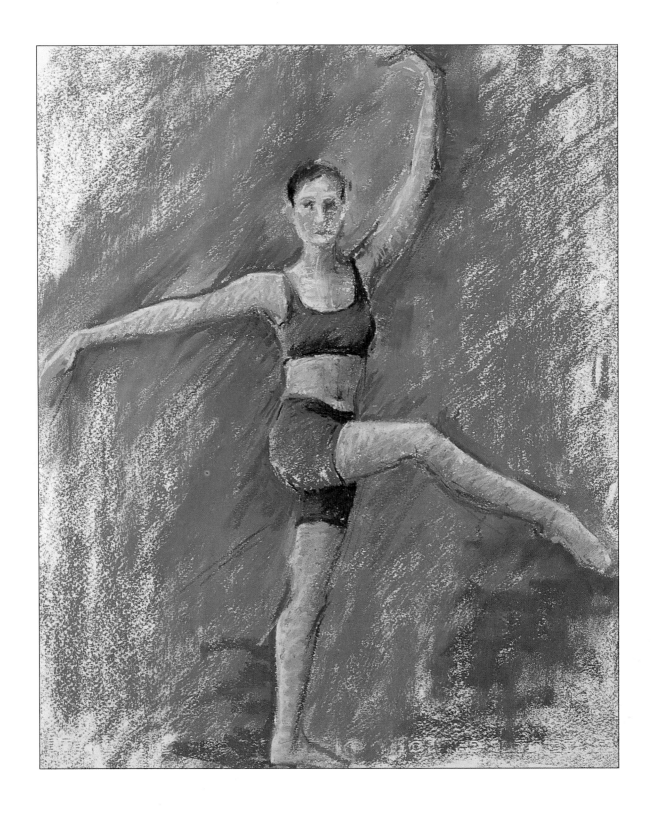

The Beginner's Guide to
Drawing
People

Step-by-step techniques for beginners,
covering figure drawing, human
anatomy and the female nude

PATRICIA MONAHAN
with **ALBANY WISEMAN**
JAMES HORTON
IAN SIDAWAY

NEW
HOLLAND

First published in 2003 by
New Holland Publishers (UK) Ltd
London • Cape Town • Sydney • Auckland

Garfield House, 86–88 Edgware Road
London W2 2EA
United Kingdom
www.newhollandpublishers.com

80 McKenzie Street
Cape Town 8001
South Africa

Level 1, Unit 4, 14 Aquatic Drive
Frenchs Forest, NSW 2086
Australia

218 Lake Road
Northcote, Auckland
New Zealand

1 3 5 7 9 10 8 6 4 2

ISBN 1 84330 563 1

Photography: George Taylor, David Jordan and Nicola Jordan
Production: Hazel Kirkman

Reproduced in Singapore by Pica Digital PTE Ltd
Printed and Bound in Singapore by Craft Print International Ltd

ACKNOWLEDGEMENTS
Special thanks are due to Daler-Rowney,
P.O. Box 10, Bracknell, Berkshire, RG12 4ST
for providing the materials and equipment featured in this book.
Step-by-step demonstrations and artworks for Figure Drawing are by
Albany Wiseman unless otherwise credited.
Special thanks are due to the models who posed for drawings in this book:
Nadia Dean, Stephen Fall, Felicitas Grabe and Sarah Hickey.

CONTENTS

MATERIALS AND EQUIPMENT

The choice of drawing and painting materials is infinite. Only by experimenting with different media and surfaces can you decide on, and begin to develop, a style that you feel expresses your personal creativity.

The range of materials available is bewildering to say the least. Despite technological advances in many areas of life, artists' materials have remained, in essence, unchanged in their construction for centuries. There is a wider range of pigments available now and materials have been made easier to use. The way that we use these modern versions of traditional materials remains unchanged.

CHALKS

Red, black and white chalks are probably the oldest drawing materials in the world. They are found as natural rocks throughout the world. For the most part, however, today we tend to use the modern stick form. This is more or less the same material, ground to a pigment, mixed

with a setting agent and set into a mould to form a stick. A whole range of colours are available. Modern chalk can be sharpened to a point.

CHARCOAL

Made from various trees, charcoal is essentially charred wood. Some woods perform better than others – willow is the best and the most popular with artists. It comes in almost any thickness from wafer thin to very thick, depending on the size of the branches used. It is a beautiful material to draw with and has a delicate touch, capable of producing the gentlest of lines to the darkest, blackest tones. It can also be smudged or blended easily with tissue or a finger and has been a favourite drawing medium with artists for many centuries. Artists often use a fixative to prevent the final charcoal image from fading or being smudged. Sticks can be sharpened with a craft knife or

rubbed on sandpaper.

Charcoal sticks and pencils made from compressed charcoal are also available. These are harder and encased in wood or found as short dumpy sticks. They are often graded in hardness like pencils. They are cleaner to use than stick charcoal but the line tends not to have quite the same fluid quality.

Charcoal can be blended in many ways but a useful tool for doing this, and one which you can also use when working with pastel, is the paper torchon. This is a tight roll of paper drawn to a point which is used to push charcoal dust around the paper, altering the tone and blending or softening lines.

PASTELS

Pastels are available, depending on the manufacturer, in three qualities: hard, medium and soft but the term is generally taken to mean soft pastels. As a medium, pastel is relatively modern,

not being used much before the 18th century. Pastels are made from pigment bound together with a gum. When applied, the effect can be a dense area of pigment that resembles a painting in its opacity. Alternatively, it can be used in thin strokes, built up in layers known as crosshatching. Pastel comes in an astonishing range of colours, gradated from the lightest tint through to the darkest. There are visually six to ten grades of each colour, depending on the manufacturer. Softness varies according to the manufacturer. Although the choice and range of pastels is huge, it is not necessary to buy an enormous selection. First-class work can be done with as few as a dozen colours. It is also possible to buy selection boxes that will preselect a range of pastels according to subject – for instance, landscape or portrait. All pastels can be purchased individually so a range of colours can be acquired to suit the subject matter. To keep loose pastels clean, place them in a jar or box half full of rice. When you shake the jar or box, rice rubs on the dirty pastels and cleans them.

PENCILS, GRAPHITE PENCIL/STICKS AND COLOURED PENCILS

The "lead" pencil is made from a thin graphite strip encased in wood to protect it and to make it easier to hold. The wood case can be round or six-sided.

Pencils are graded according to hardness. The scale runs from 8H, the hardest, down to H, F,

HB and B, then up to 8B, the softest. Avoid dropping pencils, especially in the softer range, as the graphite strip can shatter making it next to impossible to sharpen them.

Studio pencils have a rectangular graphite strip. These are useful for quickly laying in areas of tone.

Conté pencils are a type of hard pastel or chalk encased in wood to make them cleaner and more convenient to use. They make dark marks that can be smudged and blended.

Better still are graphite pencils and sticks. Graphite pencils are simply solid thick strips of graphite and are graded in hardness like pencils. They have the added advantage of making not only fine lines but also, when the pencil is used at an angle so that more of the pencil comes into contact with the paper, broad areas of tone. Graphite sticks are used in much the same way but are dumpy and thicker. Whilst pencils are best sharpened with a sharp knife, graphite pencils are more easily kept sharp with a pencil sharpener. As with pencils, try to

avoid dropping them on the floor. It is important to take great care when using very soft graphite pencils as, if held too far up the shaft whilst applying pressure, they can break. Graphite is also available as a fine powder which can be spread over and worked into the paper with the finger or using a torchon.

As with ordinary pencils the strip in coloured pencils is encased in wood in order to protect it. Made from pigment, binder and lubricant to make the crayons move smoothly across the support, they have a slightly waxy feel to them. The range of colours to be found is quite wide.

PEN AND INK

Once again, this is an ancient medium still in use today, with some modifications. Today we use mostly steel nibs, which come in all shapes and sizes and are fitted on to a penholder. These are known as dip pens. In addition, there are a huge number of commercial pens available that contain their own supply of ink. Traditional inks, such as sepia (made from cuttlefish) and iron gall ink (made from oak galls), were permanent and light fast. Many of the inks available today – either in bottle form or cartridge or as an integral part of a commercial pen – are impermanent. Ink is available in a wide range of colours at a modest cost, in either water-soluble or water-resistant form. Water-soluble inks can be thinned with water. They will

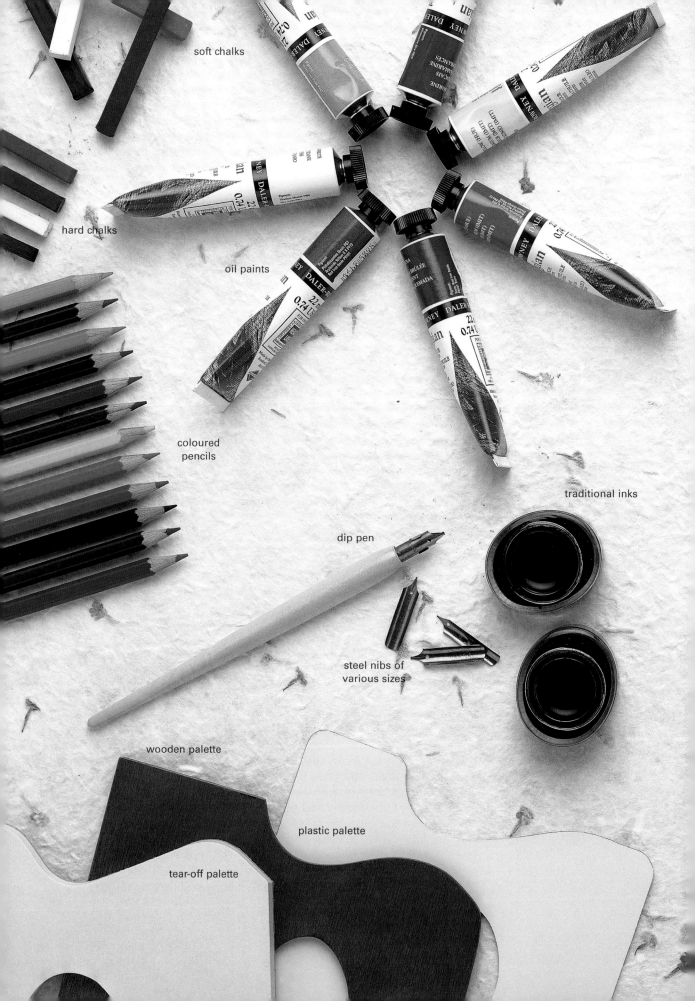

soft chalks

hard chalks

oil paints

coloured
pencils

traditional inks

dip pen

steel nibs of
various sizes

wooden palette

plastic palette

tear-off palette

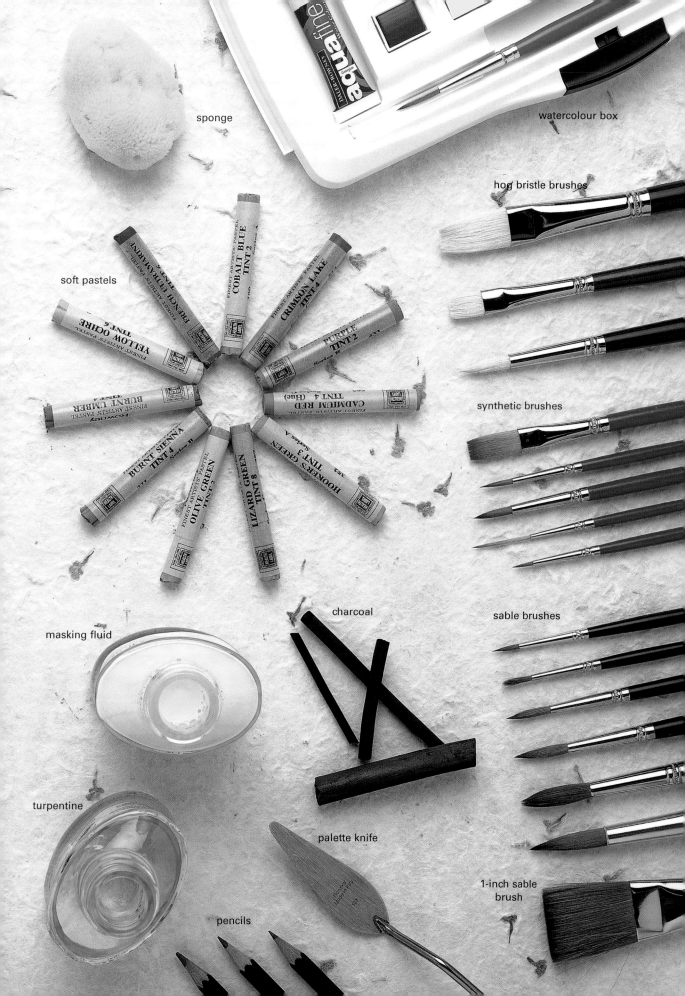

sponge

watercolour box

hog bristle brushes

soft pastels

FRENCH ULTRAMARINE

COBALT BLUE TINT 2

CRIMSON LAKE TINT 4

YELLOW OCHRE TINT 6

PURPLE TINT 2

BURNT UMBER

CADMIUM RED TINT 4 (Hue)

BURNT SIENNA TINT 4

OLIVE GREEN TINT 2

LIZARD GREEN TINT 8

HOOKER'S GREEN TINT 3

synthetic brushes

charcoal

sable brushes

masking fluid

turpentine

palette knife

1-inch sable brush

pencils

also soften if rewet, which allows for lines to be lightened or corrections to be made. Combining both types of ink opens the way for a variety of techniques.

Watercolour brushes can also be used with ink. Clean the brushes thoroughly or the dry ink will ruin them.

WATERCOLOUR

When buying watercolour paints, buy the very best that you can afford. If you have ever used cheaper paint, you will have noticed the difference. Watercolour paints are available as pans, half pans, tubes and as liquid colour, which is most often used by illustrators. It is not necessary to have lots of different colours and by working with a limited palette you will learn more about colour mixing.

A good range of colour to start with would be cadmium red, alizarin crimson, cadmium yellow, lemon yellow, yellow ochre, cerulean blue, ultramarine blue and Payne's grey. If you wish, you could add viridian and sap green, burnt umber and burnt sienna. Whether to buy pans or tubes is a personal choice. Pans are more economical as less paint is wasted. Various additives can be bought to mix with the paint. Some will extend drying time, add texture, intensify colour or cause the colour to granulate. White gouache is sometimes used to give watercolour body and make it opaque. It's also worth buying a bottle of art masking fluid to protect parts of the

paper you don't want to paint.

A range of different metal or wooden boxes can be bought to hold your paints but remember that you will almost certainly need more colours at some point, so make sure your box is large enough for them. You can also buy watercolour boxes with a range of pans already selected. A pre-selected box is quite adequate until you gain some experience.

WATERCOLOUR BRUSHES

The best brushes for watercolour painting are sable. There are different grades, the top grade being very expensive. It is possible to get away with only one medium-sized brush, say a No. 9 or 10. The capacity to hold water and come to a point is essential. Ideally, a selection of round brushes comprising a No. 2, 5, 7 and 12 should cope with most demands. For much larger washes, a flat 1-inch brush might also be needed. Watercolour brushes can be made from synthetic hair but they will not produce as good results and do not last as long as sable brushes.

OIL PAINT

Oil paint, like watercolour, can be bought in a range of colours, and, as with watercolour, using a limited palette will not only teach much about colour mixing but will also be economical. Cadmium red, alizarin crimson, cadmium yellow, lemon yellow, yellow ochre, ultramarine blue, cerulean blue, viridian green, ivory, black and titanium white

would be a good starter palette. You could add to this sap green, raw umber and burnt umber together with Payne's grey at a later date.

Oil paint should never be used straight on to paper, wood or canvas because the surface will be far too absorbent and also oil and turpentine will attack the unprepared surface. Traditionally, artists primed their own canvases or boards and even paper, which can work well – many of Constable's *plein air* oil sketches were made on paper and cardboard. These days it is much easier to go to the art supply shop and buy ready-prepared boards and canvases. If you become more involved with oil painting, then priming your own surfaces is great fun and, best of all, made to measure.

Oil paint is very flexible and can be used thinly to create a translucent effect or thickly for an opaque look. It is applied with bristle, sable or synthetic brushes or a palette knife.

Colours are mixed on a palette made of wood or plastic and large enough to allow them to combine freely. Tear-off paper palettes can also be used, but a good mahogany or hardwood palette becomes an old friend in a way that others do not.

The range of oil brushes is vast. Good quality bristle brushes are best. The main shapes are round, flat, fan and filbert, a flat brush which tapers to a slight point. They give a good repertoire of strokes. The size of brush you choose will depend

to a degree on the size which you intend to work. Brushes should be cleaned in white spirit and then soap and water if you want them to last. Painting knives come in various shapes to give a range of marks, while a palette knife is handy for cleaning palettes and mixing paint.

Oil paint is thinned with thinners such as turpentine or white spirit. A bewildering range of paint mediums and oils, including linseed oil, are also used. Some are used for glazing, some for impasto work (applying the paint very thickly) and others to speed up the drying time. Palettes for mixing paint are flat, made from plastic or wood, and vary in shape and size. A double dipper, which clips onto the palette and holds thinner and oil, is a useful purchase.

Cheap and easy surfaces to paint on can always be made by priming hardboard or MDF with acrylic primer.

PAPER

For pencils, chalks and charcoal any standard, lightweight paper will work well enough. Paper with a tooth or grain is a good surface for chalk or charcoal. For pen and ink, a lightweight drawing paper without too much grain is most suitable. Commercially made pens will move on a surface texture much better than a dip pen, whose steel nib may get snagged and scratch the surface. If a wash is to be used, a heavier paper will be needed to avoid buckling.

There is a whole range of papers specially developed for pastel, and in a wide variety of colours. Because pastel is fully opaque, it works particularly well on a toned surface where both light and dark colours can be seen. Also, because it is dry there are no buckling problems, so lightweight papers can be used. However, surface texture is very important and will influence not just how the image looks but how much pastel can actually be applied before fixing becomes necessary.

The importance of paper to watercolour painting cannot be overstressed. The quality of any paper will have a profound effect on your painting. There are two basic types of paper: Hot Pressed, which has a smooth surface and is more suited to drawing than to watercolour; and Not – which simply means the paper is not hot pressed and so has a surface texture. The latter is the type of paper best used for watercolour, and ranges from light to heavy. There are also handmade papers that are beautiful to work on but also very expensive.

ADDITIONAL EQUIPMENT

Erasers can be found in a multitude of forms. The best are the softer so-called putty erasers. These are kinder to the paper surface and have the advantage that they can be moulded to a point. They can get dirty very quickly so when erasing a particularly dark area, cut a piece of the eraser off and use it. This will keep your eraser cleaner for longer. Whichever eraser you choose, it is important not to think of it just as a means to make corrections. Use it to add texture or lighten tone and, by working through an area of tone to expose the white paper, as a drawing implement itself.

A good craft knife is invaluable; even better, have two, a smaller fine one and one such as a retractable knife found in DIY stores for heavier work. Pencils, crayons, charcoal and pastels can all be sharpened better with a sharp knife.

Fixative is needed to prevent any drawings that use soft pencil, graphite, charcoal or pastel from smudging. Remember when fixing a drawing before it is finished, that the fixed part cannot then be erased. This can be an advantage, as it enables complex areas of texture to be built up. Fixative can be bought in bottles and used with a diffuser, or you can buy an aerosol spray, which is easier to use.

A drawing board provides a firm surface to which you can attach loose sheets of paper. Use it on an easel, on a work top or on your knee. A piece of 6 mm (¼ in) plywood will make a good, light board. If you are going to use it for stretching watercolour paper, you should seal both sides.

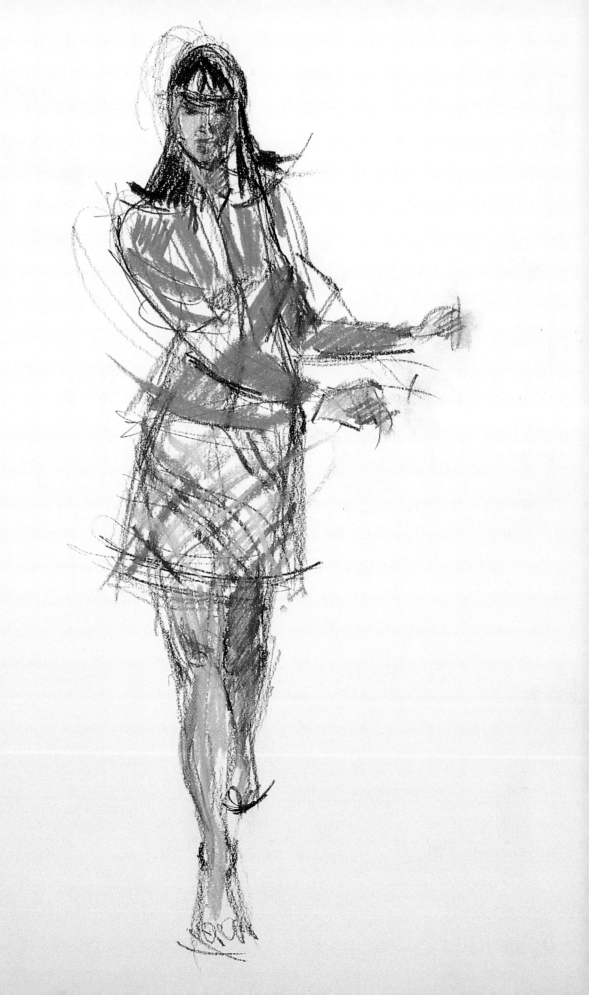

FIGURE DRAWING

INTRODUCTION

For the artist, the human figure is infinitely absorbing and inspiring. Attitudes to the human body and the way it is depicted in art have varied throughout the centuries and seem to reflect a society's social structures and religious beliefs, as well as its views on the individual.

The art of ancient Egypt was a funerary art, designed to glorify a dead pharaoh or other powerful person. The figures in surviving tomb paintings have a flat, stylized quality, with clear, crisp outlines infilled with flat colour. Each part of the figure was depicted from its most recognizable angle. Feet were shown from the side, one in front of the other, while the head was in profile with the eye shown from the front. The shoulders were straight on, hips and legs were in three-quarter view and the torso was slightly turned. Identity was established by inscriptions rather than physical likeness. Artists were craftsmen who worked to a rigid set of rules and Egyptian art changed little over 3,000 years.

The Ancient Greeks were concerned with the ideal beauty of gods, heroes and humans. From ancient writers we know that they attributed great importance to drawing, but the best record of Greek figurative art is their pottery which was elaborately decorated. Prior to

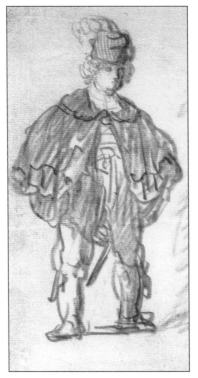

the fifth century BC, the figuration was geometric, stylized and worked black on red. Later, in the classical period, figures were picked out in red against a black ground and were elaborated with line to give the forms more detail and solidity. Artists also attempted to suggest space and recession by overlapping elements. These drawings, made 2,500 years ago, look remarkably modern and realistic.

The Romans borrowed heavily from Etruscan and Hellenistic art. They were concerned with the actual rather than the ideal view of the figure and produced some very realistic 'warts and all' portraits.

The Renaissance was crucial to the development of Western European art and culture. It can be dated from the early fifteenth century in Florence, reaching its high point in the early sixteenth century, by which time it had spread to the

An Actor Standing
Rembrandt van Rijn (1606–1669)
Chalk on tinted paper

Dutch artist Rembrandt was a gifted student of the human form. In this drawing, he has used a variety of techniques to capture the volumes of the figure, using fine lines in the lighter areas and applying the chalk with more vigour for the heavy creases of the actor's cloak.

rest of Europe. It was a time of intellectual and artistic upheaval and revival. Portraiture and mythological themes became popular and artists sought to represent the human figure naturalistically. They studied proportion and explored ways of depicting solid form, space and depth. This interest in anatomy can be seen in the sketchbooks of Leonardo da Vinci (1452–1519). The Renaissance was also a time of technical innovation. Artists used a range of drawing media including chalks, charcoal, pen and ink, brush and wash and silverpoint – a technique which used metal wires to create a line on a prepared support. Drawings were used as preparations for paintings, but they were also made as artworks in their own right.

By the seventeenth century, artists were drawing with greater freedom, using a flowing, expressive line. Rembrandt van Rijn (1606–1669) was a master draughtsman with a succinct but lively line. Among his many portraits, he captured the continuing concern with scientific research into the human body in his paintings *The Anatomy Lesson of Dr Tulp* (1632) and *The Anatomical Lesson of Dr Joan Deyman* (1656) in which he depicts the dissection of a human brain.

During the Rococo period in the eighteenth century, France produced François Boucher (1703–1770), Jean-Honoré Fragonard (1732–1806) and Jean Antoine Watteau (1684–1721), whose drawings were lively, colourful and charming. With the classical revival at the end of the century, free drawing and the spirit of frivolity were abandoned in favour of a more severe style epitomised by Jacques-Louis David (1748–1825) and Jean-Auguste-Dominique Ingres (1780–1867).

Later artists valued an even more personal and expressive style. Vincent van Gogh (1853–1890) used reed pen to create vigorous, often decorative images. Georges Seurat (1859–1891) is famous for developing pointillism in which the primary colours are applied to the canvas in dots. Edgar Degas (1834–1917) drew from the model throughout his life, and sometimes recycled a composition by tracing it several times and reworking it in different colours and tones to create a series of variations on the original theme. He was a master draughtsman in many media, including pastel, often using strong, almost expressionist colour.

In the twentieth century, figure drawing produced many exponents, from Henri Matisse (1869–1954), with his decorative use of flat colour, to Pablo Picasso (1881–1973).

You can learn a huge amount from the artists of the past and the present. By looking at the human figure through their eyes, you will see it in a new way, finding solutions to problems and discovering innovative ways of using materials.

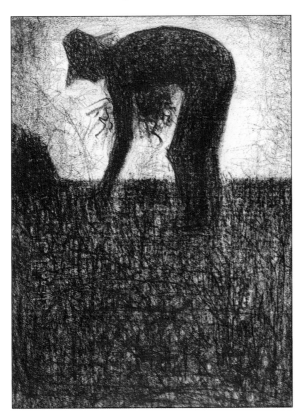

The Gleaner *Georges Seurat (1859–1891)*
Conté crayon

In this simple, evocative drawing, Seurat has built up the dark, stooping figure from layers of wispy, agitated strokes.

Approaches to Drawing the Figure

The figure is probably the most important subject in the artist's repertoire. As human beings, we have a natural interest in investigating and recording our own kind, but our close involvement with the subject can make drawing the figure seem more daunting than it really is. One of the aims of this section is to help you rid yourself of preconceptions and see the figure as an abstract assemblage of shapes, volumes, surfaces and textures. Only then will you be able to look rigorously, stripping away the significance and associations of the subject so that you can see objectively. When you've learnt to see, you will be able to draw.

Why Draw the Figure?

Until the 1960s, the ability to draw the figure competently was a primary test of artistic skill. Every art school held life classes and all students were required to attend. The thinking behind the curriculum was that if you could draw the figure you could draw anything.

The processes involved in drawing the figure are actually no different from drawing a still life group or a landscape, but our 'knowledge' of the subject and our preconceptions about the way that we look can interfere with our ability to see the figure clearly. All the skills acquired in learning to draw the figure can be applied to other subjects, so if you absorb

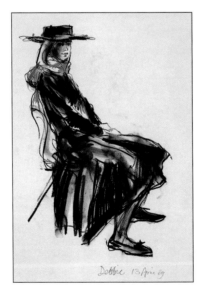

In this striking study of a young woman, Albany Wiseman has used black coloured pencil to establish the figure and then applied bold, black crayon for the dress. The touches of scarlet provide an eye-catching contrast.

the lessons in this section and work through the projects, you will find that not only can you tackle the figure competently and confidently, but your general draughtsmanship will also have improved.

Learning to Draw the Figure

Drawing the figure is not about specific techniques such as hatching, shading, using a pen or handling a pastel. There are many amateur artists who have a wonderful technique in an array of media, but can't draw. Being able to get the best from your chosen medium is an advantage, and a beautifully handled line or a well-laid wash will add to the viewer's enjoyment of an image, but it won't make a poor drawing better, nor will it make a badly proportioned figure look convincing.

The ability to draw the figure accurately and confidently is gained from an understanding of the proportions of the figure, its structures and volumes and the extent and limitation of its movements. The exercises in this book are designed to give you that understanding.

WARM-UP EXERCISES

Before you start a drawing session, try some or all of the following warm-up exercises. They will help to dispel the fear of the blank white page and the hesitation that is inevitable when you begin.

You will need a good supply of cheap paper and some charcoal, chalk or a soft (6B or 4B) pencil – whichever medium you feel most comfortable with. Try to persuade a friend or a member of your family to pose for you. If you are really stuck for a model, you can always draw yourself in a mirror. Secure the paper to a drawing board with bulldog clips or masking tape, and position yourself comfortably.

Exercise 1: Use a single line to draw around the silhouette of the figure. Avoid the temptation to put in any details. You should end up with a continuous outline containing an empty space. If the figure is crouched, seated or kneeling, the shape may look a little strange. Now try the same exercise but don't look at the paper – keep your gaze fixed on the subject. See if the end of your line links up with the beginning of the line.

Exercise 2: Make a quick line drawing using your left hand, or your right hand if you are left-handed. Because you are engaging a different part of your brain, you will find that you bypass your normal assumptions about the figure and produce a surprisingly lively drawing.

Exercise 3: For this exercise, cut a rectangle in a sheet of paper or card and hold this up in front of you so that it frames the subject. Make sure that some parts of the figure – for example, the head and the feet in a standing pose – are cropped by the edge of the frame. Now draw the spaces which are trapped between the figure and the edge of the frame. You'll find that by drawing 'nothing', you have actually drawn the figure.

ABOUT FIGURE DRAWING

Each project in this section deals with a basic principle, such as reducing the figure to simple geometric shapes, considering the way the bony skeleton and the soft tissues affect the appearance of the figure or drawing with line or tone. You are then invited to apply these concepts in a series of associated projects. Read through the project and then set up a similar pose. Draw the figure, applying the concepts outlined in the theory boxes and the project.

Remember that it is the process that is important, not the finished image. You often learn more by making mistakes, recognising them and righting them than by producing a

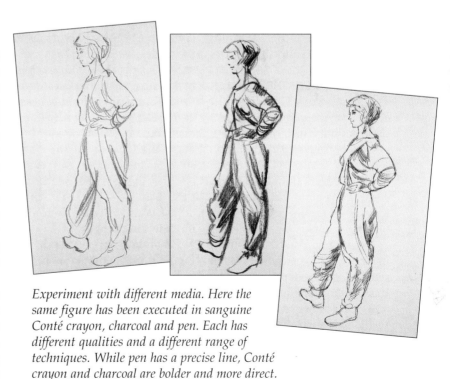

Experiment with different media. Here the same figure has been executed in sanguine Conté crayon, charcoal and pen. Each has different qualities and a different range of techniques. While pen has a precise line, Conté crayon and charcoal are bolder and more direct.

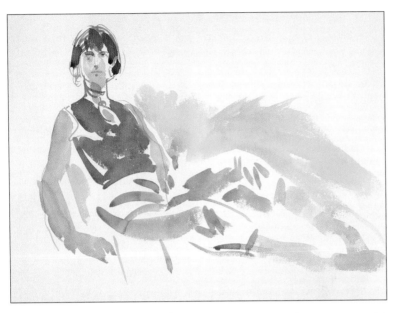

This study was made directly using brush and watercolour. It has a force and simplicity which could not be achieved in any other way.

perfect 'finished' drawing. Practice will improve your ability to see and to draw accurately, and inevitably your manual dexterity and the skill with which you handle different media will also improve.

WORKING WITH THE MODEL

The best way of finding out about the figure is by direct observation, which means using a model. You need cooperation for subjects such as the figure in arrested motion (see pages 40–47), but often you can draw friends or family as they relax watching television or reading. Alternatively, drawing yourself in a mirror is an excellent way of making studies of particular features such as the head or hands and feet. However, if you are really to get to grips with the volumes of the figure in a variety of poses, you need to work from a model. If you can get a group

of artists together, you could hire a model or take turns to pose for the group. You can also attend a life drawing class at a local college – they offer excellent opportunities to work from the nude at very little cost.

Be considerate to your models, make sure that they are comfortable and allow them a break at regular intervals. Chalk or masking tape can be used to mark the location of the body, so that the model can easily resume the pose. And, if the pose isn't exactly the same, adjust your drawing to accommodate the changes.

When you are setting up the model's pose, think about the background and the lighting. The background can become an important element in the finished image and it can also enable you to draw more accurately (see pages 36–37). Clothes can be used to add

character, create a mood or add a splash of colour and texture. Fabrics are interesting to draw and can reveal the underlying forms or completely mask them. A large hat often creates an interesting shape on the page and can also be used to reflect a personality or tell a story.

Light is a vital component of any drawing and, by adjusting it, you can affect the amount of detail that it is possible to see and also create a specific mood (see page 66). Strong side light produces dramatic contrasts of

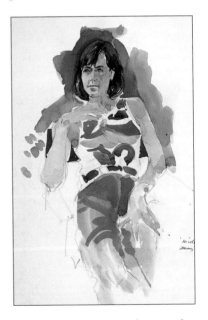

Pencil line and watercolour wash combine control with spontaneity. The figure is beautifully resolved, but the washes of colour give it a fresh and lively quality.

tone and dark shadows, while a more diffuse overall light allows you to see the entire figure in detail.

TYPES OF DRAWING

The human figure is uniquely flexible and expressive, and lends itself to many interpretations. A figure drawing may be made as an exercise, a record, an investigation, a preparation for another work, or it may be a 'finished' work in its own right. Some drawings are developed slowly over a period of time and have a cool, restrained quality while others are dashed down at great speed and retain the immediacy of the moment. The subject will affect the approach and the mood of the drawing so, for example, an informal drawing of a young child will have a different feel from a formal portrait of a distinguished adult.

As you become more accomplished and confident of your abilities, you will inevitably develop a personal drawing style. You will find that certain media suit your personality, method of working and subject matter. Nevertheless, it is a good idea to force yourself to experiment with different media and approaches from time to time – it will keep you alert and your drawings fresh. And, no matter how skilled you become, you should never abandon drawing directly from life. Even the greatest draughtsmen never stopped looking and learning about the figure.

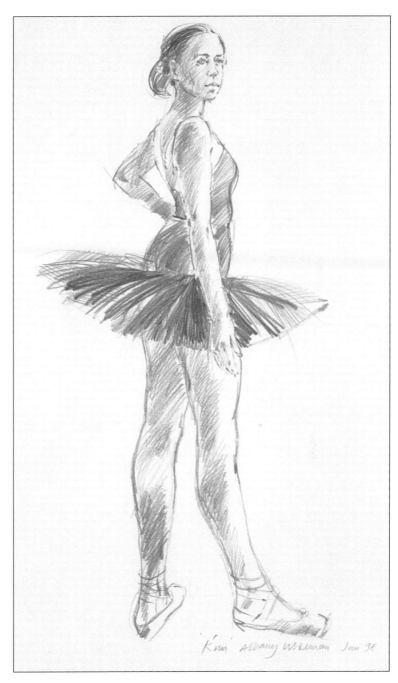

Conté crayon in a sanguine shade was used for this acutely observed and carefully rendered study of a dancer. The artist has combined a precisely drawn line with meticulous hatching, to create an image which has a classical rigour and beauty.

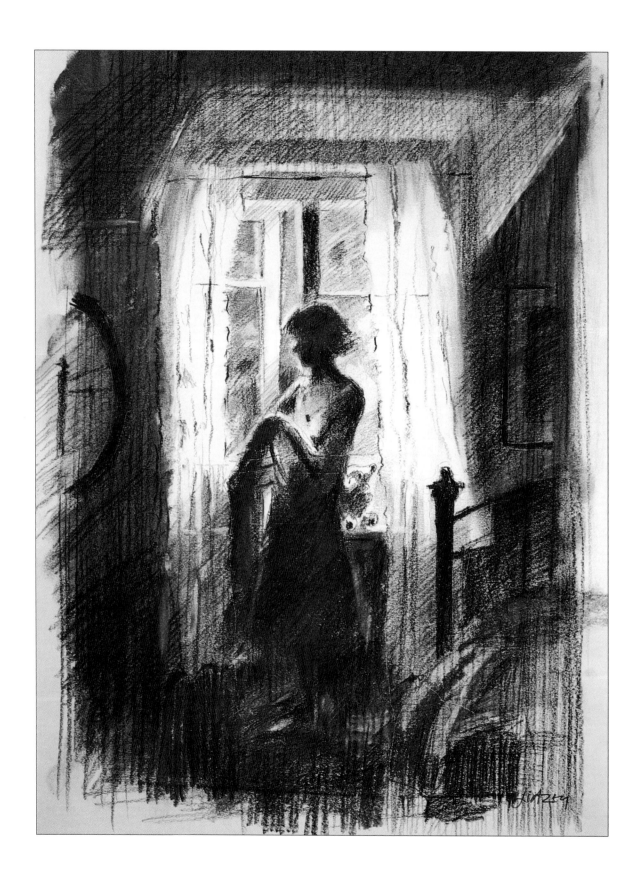

GALLERY

Each artist interprets the human figure in his or her own unique way, and studying these different interpretations can be fascinating, revealing and inspiring. The character of the image will be affected by the intention of the artist, the purpose of the drawing, the nature of the subject and the type of medium and support. Brush drawings in ink or watercolour have a soft and flowing quality, pastel and charcoal are bold and vigorous, while a carefully rendered drawing in hard pencil can seem cool and clinical. You will find it rewarding to study the work of other artists whenever you can, and remember that there isn't a single 'right' way of drawing the figure – there are lots of right ways.

Elsie Dressing at the Dell
John Lidzey
46 x 30cm (18 x 12in)

In this study of a figure seen *contre jour* (against the light), the cool, dim interior contrasts with the sunlight outside. A waxy black Conté pencil has been used to create a range of tones from light grey to a deep, velvety black. The white of the paper stands for bright sunlight falling on the pale, gauzy curtains.

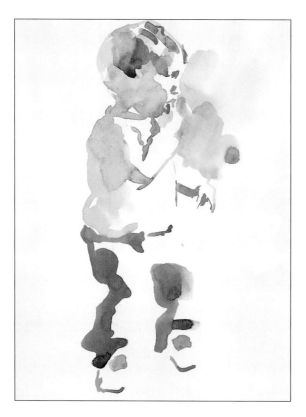

Tom, Watching TV
Susan Pontefract
20 x 15cm (8 x 6in)

The only time children are still is when they are asleep, so you have to work fast to capture them on paper. The artist's confident handling of watercolour allowed her to capture her child's hesitant stance, the transparency of his skin and the character of his clothes and shoes with a few economical brushmarks.

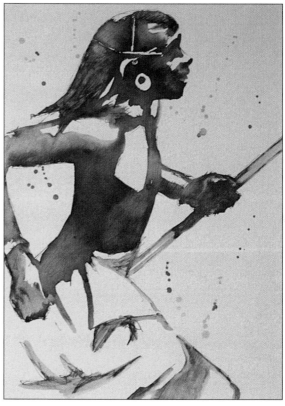

Masai Warrior
John Cleal
41 x 30cm (16 x 12in)

The directness and speed with which this artist works is evident in this vigorous pen and wash study, and echoes the energy of the lean, running figure. The cropping of the figure as it moves into the picture space, and the counterpointed diagonals of the torso, limbs and spear all contribute to the pervading sense of movement.

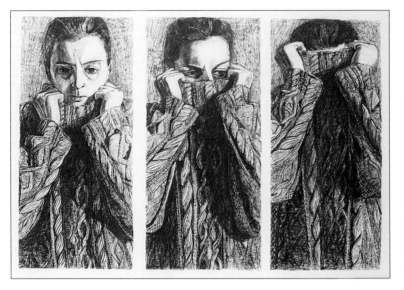

Up Over my Head
Sarah Cawkwell
122 x 162cm (48 x 64in)

In this unusual triptych, the artist has combined close observation, meticulous detail and tight cropping to transform an everyday subject into an arresting image. She uses the linear and tonal qualities of charcoal to describe the complex patterns and textures of the woman's pullover – which in turn suggest the form beneath the clothing in a subtle but completely believable way.

Young Dancer
Michael Whittlesea
41 x 30cm (16 x 12in)

Pastel is a wonderfully flexible medium. Here, the artist combines acute observation and understanding of the figure with sensitive but bold handling of the medium. He uses a confident line to define the figure, scribbled lines for the net tutu and colour skimmed on with the side of the stick for the leg warmers. Energetically applied splashes of colour draw attention to the ballerina's head.

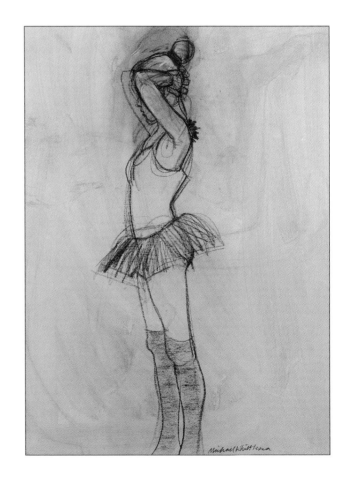

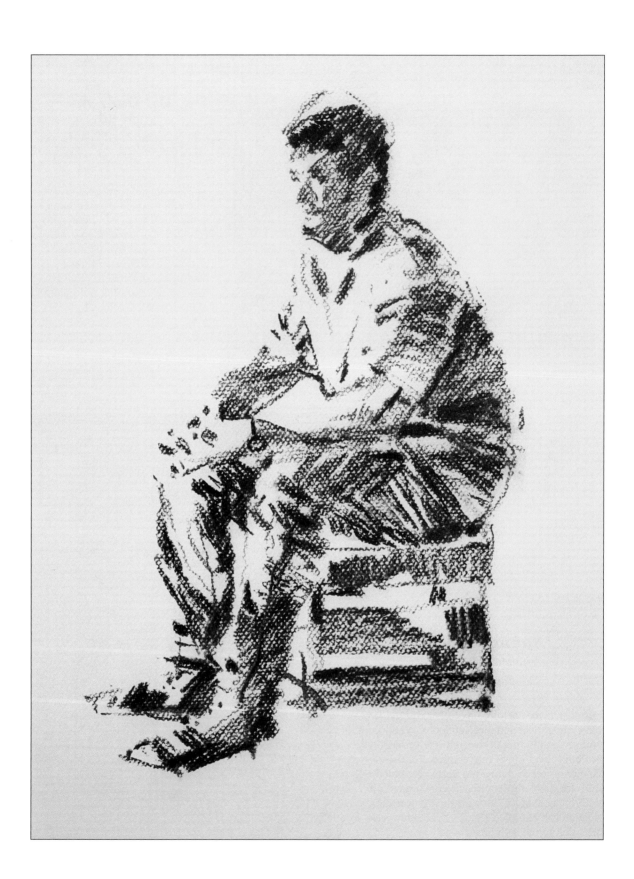

Project
1

DRAWING IN LINE AND TONE

There are two principal ways of drawing – in line and in tone. Both methods are useful and both will help you to understand the figure in different ways. Line drawing is the most demanding of the two, because it is so economical. You have to look at the subject intensely and edit rigorously and, for this reason, line drawing is an excellent exercise for the beginner. In a tonal drawing, on the other hand, you dispense with line and simply record the areas of light and dark on a subject. Again, this method really forces you to look, and will help you to understand the bulk and roundness of the figure. But the most satisfying aspect of this approach is the ease with which even an absolute beginner can produce a convincing drawing when working in tone. The projects in this exercise introduce you to both methods and use charcoal as a drawing tool because it encourages you to work boldly and broadly.

Male, Seated
Charcoal on tinted paper
55 x 46cm (21½ x 18in)

LINE OR TONE?

The most sophisticated and demanding drawing technique is line drawing without shading. A line is a way of representing the edge of an object or a form, or the junction between areas of colour or tone. In reality, of course, there are no lines around a figure, so you have to work very hard in order to summarise the subject using this rather artificial device.

Pure outline drawing has a flat, two-dimensional quality which is often exploited in cartoons, comic illustrations and some animations. Most line drawings also include contour lines that go around and across the body, following the rise and fall of the surface to give a sense of the volumes of the form. You can also suggest depth and form by varying the quality of the line, using thin, light marks on the edges which catch the light and darker, thicker lines where an edge is in the shade. You can add tone by using hatching and stippling techniques.

The advantages of line are the speed with which you can work and the way that it forces you to distil the essence of the subject. But it is a very unforgiving technique and you'll find that, because errors and inaccuracies really show, you are forced to be rigorous. However, the best line drawings have a spare, fluid beauty which cannot be matched by any other technique.

Drawing in tone involves an entirely different process, and you will be surprised to find how easily you can produce a figure which has a convincing solidity. When light shines on a figure, the side which is turned away from the light source, or sources, will be in shadow. The areas between light and dark are called 'half-tones'. Tone describes the lightness or darkness of a thing or a colour. It is the contrast between the lights and darks and the distribution of the 'half-tones' that allows us to understand form.

Practise drawing the figure using line only, tone only and a combination of both techniques. The finished images will have very different qualities, but perhaps more importantly, each process will help you to understand better the different aspects of the figure.

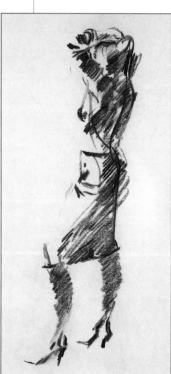

This figure, drawn in pure tone using charcoal, describes the light falling on the body and the solidity of the form.

The same figure drawn in pen and ink using outline, contour lines and loosely hatched tone has a lively and expressive quality.

A Line Drawing Exercise

Materials and Equipment

• CREAM TINTED DRAWING PAPER, OR WHITE CARTRIDGE PAPER • THIN STICK OF CHARCOAL, PLUS A CHARCOAL HOLDER (OPTIONAL) • FIXATIVE

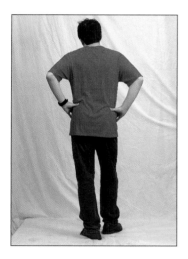

For your first line drawing, ask the model to take up a standing pose with his back turned towards you. This will avoid technical problems like foreshortening, and you won't be distracted by trying to get a facial likeness. However, you will find that back views are just as characterful as frontal views. If you can, work standing at an easel, at least 2.4m (8ft) away from the model, so that you can see the entire figure without distortion, and give yourself ten minutes for this exercise.

MALE, BACK VIEW

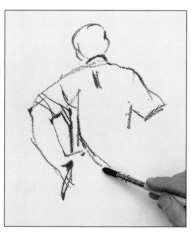

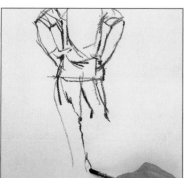

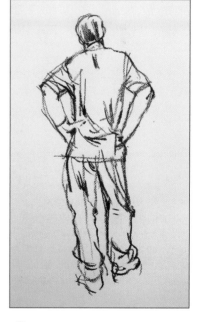

1

Position yourself so that you can look at the model and then at the drawing by simply shifting your gaze. Study the figure carefully and plot the head on the paper, checking that the entire figure will fit within the sheet. This is an outline drawing, so look for the edges of the torso and the arms. You don't need to stick to a continuous line – broken and repeated lines give the drawing a lively quality.

2

Look at the spaces between the arms and torso, and between the legs – if these 'negative' shapes are correct, your drawing is probably on the right lines. Draw the folds on the back of the tee-shirt, as these give a clue to the underlying forms. Vary the pressure on the charcoal to produce thick and thin lines.

3

Suit the line to the subject's character. Here, the artist has used a solid, vigorous line to suggest the heavy quality of the model's jeans. The folds in the fabric and the lines around the bottom of the trouser leg capture the heavy drape of the material. Try to mentally 'feel' the nature of the surfaces and fabrics you are drawing.

LOOKING AT DIFFERENT VIEWPOINTS

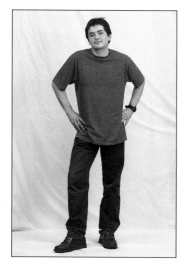

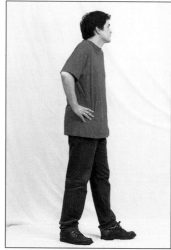

These line drawings should be made quickly, so ask the model to hold each pose for five minutes – set a timer or an alarm clock and stop drawing whether you have finished or not. After the first pose, ask the model to keep a similar stance, but to change position so that he is sideways on. Then start another drawing immediately, on the same sheet of paper. Choose simple standing poses similar to the ones shown; you will have to learn to cope with minor shifts of the head and hands, particularly if you use an inexperienced model.

MALE, FRONT AND SIDE VIEWS

1

This drawing has to be done very quickly, so take a long, hard look at the model and begin to draw the head, shoulders and torso, noting the angles they make against each other. Try to suggest that shapes continue around the image, and that the figure has another side. Don't erase lines, simply redraw them if they are incorrect.

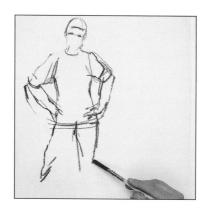

2

Let your eyes roam around the figure, constantly checking and rechecking the relationship between one area and another – the tilt of the head, the angle of the leg, the distance between the feet. Imagine the figure beneath the clothing. Note, for example, where the knees should be, and see how this point relates to the folds in the fabric.

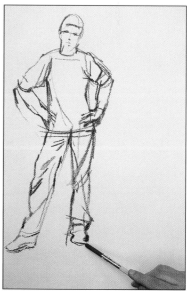

Materials and Equipment

• CREAM TINTED DRAWING PAPER, OR WHITE CARTRIDGE PAPER • THIN STICK OF CHARCOAL, PLUS A CHARCOAL HOLDER (OPTIONAL) • FIXATIVE

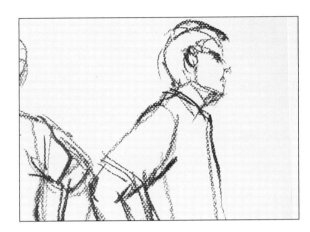

3

Ask the model to turn to the side and adopt exactly the same pose as before. Start another drawing on the same sheet of paper if there is room. Take a deep breath and plunge in. Start with the head, establishing the slope of the jaw and the eyes, and the angle of the neck. Notice the way the neck sits into the front of the shoulders and projects forwards. Establish the angles of the upper arm and forearm, the curve of the shoulder and the sleeve. The best way to give volume to your figure is to 'feel' the shapes as you draw them. Concentrate on their roundness, solidity and bulk.

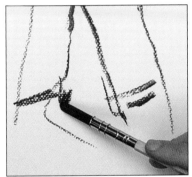

4

Establish the line of the legs, then use a bolder line to capture the drape of the heavy jean fabric.

5

Drawing with line only will force you to edit and decide what is really important. The figures have been simplified so that only the most essential features are shown. Notice how the creases in the jeans help to establish the character of the fabric, while the seams convey the structure of the garment as well as the form beneath. Lightly spray the finished drawing with fixative in a well-ventilated room or outdoors.

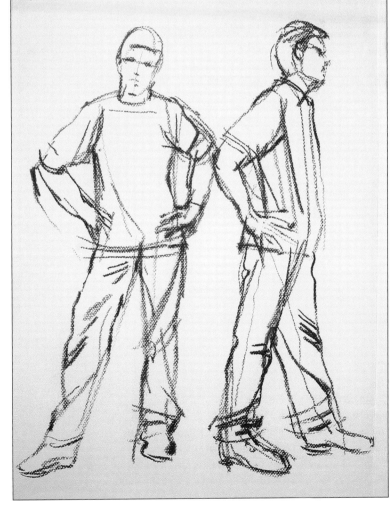

AN EXERCISE IN TONE

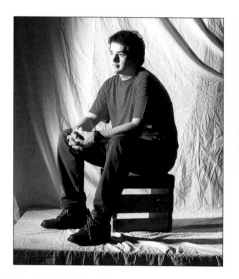

For this tonal exercise, you need a strongly lit figure, so place the model by a window or use a spotlight to direct light from one side. A seated pose provides interesting shapes and interlocking areas of light and dark.

Materials and Equipment

- SHEET OF CREAM TINTED DRAWING PAPER, OR WHITE CARTRIDGE PAPER • THIN STICKS OF CHARCOAL, PLUS A CHARCOAL HOLDER (OPTIONAL)
- FIXATIVE

MALE, SEATED

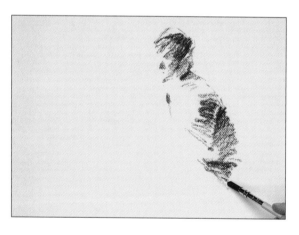

1

At first, it can be difficult to see tone because colours, patterns and reflected light cause confusion. If you screw up your eyes, you will find it easier to see the distribution of lights and darks across the surface. Start by simplifying the tones, looking for the lightest and darkest areas. Use the tip of the charcoal to hatch in the dark tones on the back of the head and torso, noting the dark shadow that the head casts on to the shoulder.

2

Continue hatching in the dark tones, allowing them to travel around the form. Put in patches of dark tone on the face, the forearm and the torso. If you draw exactly what you see, you will find that features and forms begin to emerge as if by magic from the jigsaw of light and dark shapes. Use brisk, spiky marks where the thigh is in shadow to suggest the pull of the fabric.

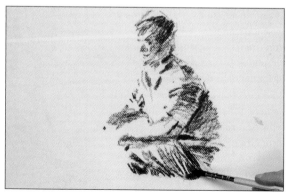

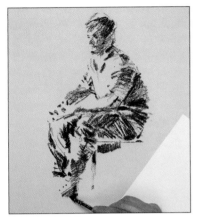

3

Add areas of darker tone around the waist, on the inside of the far leg, on the trousers and on the back of the foot. Place a sheet of paper under your hand to prevent smudging, if you wish. Continue surveying the figure through half-closed eyes, comparing the tones across it. Look for areas that are the same tone and check that the contrasts between areas of light and dark are correct. Draw exactly what you see rather than what you 'know' to be there. This exercise is about pure observation.

4

Block in the areas of dark and mid tone on the shoes and the crate on which the model is sitting. Stand back and assess your drawing from a distance, comparing it with the subject. Use an extra-thin stick of charcoal to add details like the seam on the trousers, the shadows and creases on the trousers, and the darkest tones on the hair and face.

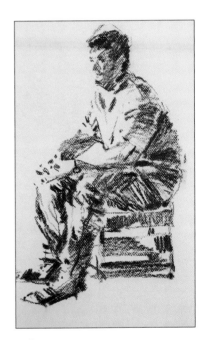

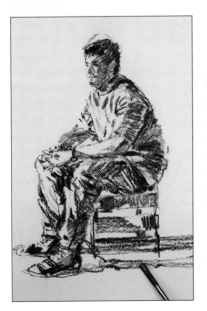

5

Your eyes should travel from model to drawing and from one part of the drawing to another, constantly assessing the tonal values. Work across the entire drawing, making adjustments here and there. Cast shadows are important, because they provide information about the surface on to which they fall, and about the direction and quality of light. Here, the shadows establish the horizontal surface of the floor, and they are dark and crisp because the light is strong and directional.

6

You will probably be surprised to find how easy it is to create an accurate, solid and convincing figure drawing by organising the areas of light, dark and mid tone accurately. Practise working in this way whenever you can – you will soon develop a feel for the volumes of the figure and this will be carried into all your drawings and paintings.

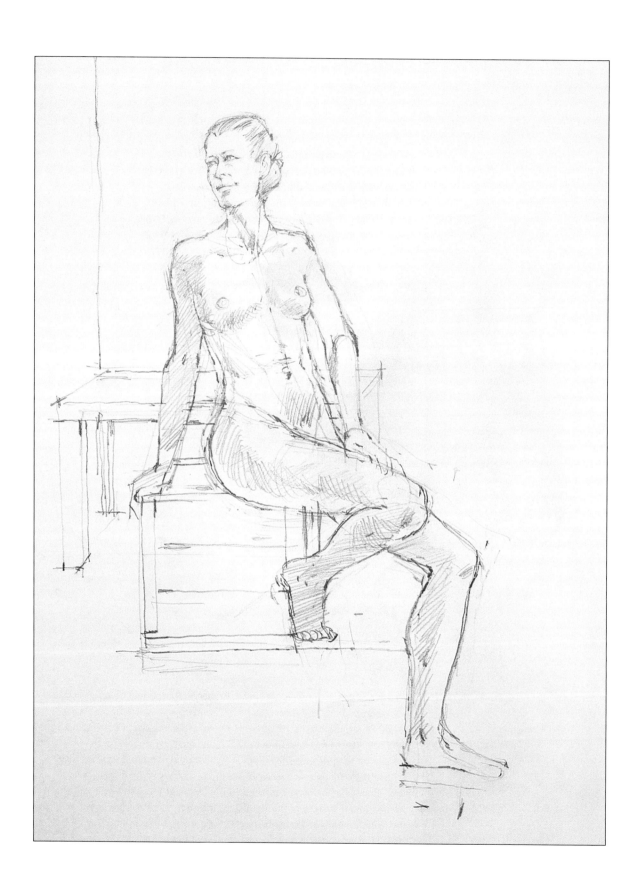

Project
2

DRAWING ACCURATELY

Based on close observation, 'objective' drawing is analytical and enquiring. This approach allows the artist to discover and describe the appearance of the subject, and to create an illusion of three dimensions on a two-dimensional support. It is the foundation of all traditional Western art. Learning to draw anything, whether it is the figure or a cup and saucer, is really about learning to look and see. That sounds simple, but unfortunately we are often led astray by what we 'think' we remember about the human form. So we know that legs and arms are cylindrical, the head sits on top of the shoulders and the hand consists of four separate fingers and a thumb. But, if they are seen in perspective, legs and arms cease to be cylinders, the head actually projects from the front of the shoulders, and the hand is often seen as a single, compact shape. Drawing from life forces you to look again, to question every mark, and to unlearn what you think you know.

Seated Nude
Graphite on watercolour paper
56 x 38cm (22 x 15in)

IMPROVE YOUR ACCURACY

The impact of an objective drawing depends on the accuracy with which you reproduce the image. Your pencil can be used to take precise measurements, to check proportions and angles, and to transfer this information to the drawing (see photographs below). Keep your arm straight to maintain a constant distance between the pencil and your eye.

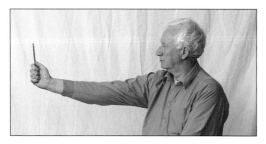

To check relative proportions of the body, hold a pencil vertically out in front of you, closing one eye. Align the top of the pencil with a key point, then slide your thumb down to align with another key point.

Another useful technique to maintain accuracy is to look for vertical and horizontal lines and alignments, and see which parts of the body a line would pass through or touch if it were extended. The centre of the face, the centre of the front torso and the spine are key lines, so indicate their location and see where they fall in relation to the shoulders, limbs and background.

You can also use edges in the background to locate the figure. If the model is standing in front of a door or a window, for example, notice where architectural points impinge upon the figure and pay special attention to lines that appear on either side of it.

Negative spaces are spaces between and around the figure or other objects. Study them carefully, noticing their precise shapes, and draw those rather than the 'positive' shapes. Because negative shapes are abstract, you will be more objective and will draw what you actually see rather than what you assume you know, so you are likely to build up a more accurate figure with a pleasingly uncontrived quality.

If you are worried about the proportions of a drawing, try turning it on its head – this gives you a new viewpoint, helping you to see flaws to which your eye has become accustomed. Reversing the image in a mirror has a similar effect. And remember to stand back from your drawing from time to time so that you can view it from a distance.

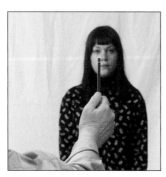

Left: Once you have established a measurement between two key points, such as the top of the head and the chin, you can check this against other body measurements.

Right: With your arm extended, lay the pencil along the slope of the shoulders to check the angle. Transfer that angle to the paper.

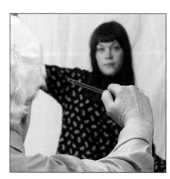

PROPORTIONS OF THE FIGURE

Because we take our own form for granted, drawing the figure can be full of surprises. We tend to assume the head is bigger than it is and the hands and feet are smaller, so it can be disconcerting to find that the hand covers the face from chin to hairline, and the foot is a similar length to the head.

The other revelation is the sheer diversity of the human form. There are the obvious differences between male and female, and adults and children, but you'll find that there are variations in height, body weight, shoulder width and length of leg, too. Nevertheless, it is useful to work with a set of ideal

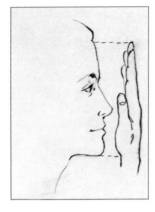

The hand covers the face from the chin almost to the hairline.

proportions, because most people can be fitted into the standard pattern with some adjustments.

In the 'average' human, the head fits into the standing figure approximately seven to eight times. The upper torso, from waist to the neck, is about two heads high and the pelvis about one head high. The legs are approximately the same length as the head and trunk, with the thighs and the lower legs being about two heads each. If the arms are hanging by the side, the tips of the fingers will reach halfway down the thigh. The shoulders are about three heads wide and the pelvis is about one-and-a-half heads wide.

In general, the female figure differs slightly from the male. In the male the hips are narrower than the shoulders, whereas in the female they are about the same width. In the female the pelvis is longer, but the legs are shorter.

A baby's head is large in proportion to the rest of the body. Throughout childhood, the rest of the body grows much more than the head, so that by adulthood, the figure's proportions have radically changed.

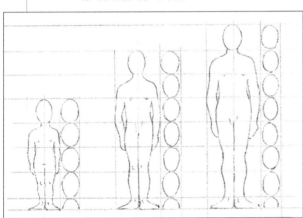

At a year old, a child's head is still quite large in proportion to the rest of the body. The legs are relatively short, so the centre point of the figure falls at the stomach.

By eight years' old, the head has enlarged slightly and the legs have lengthened so that the mid-point of the body now falls just above the hips.

In the average adult, the head fits into the body approximately seven-and-a-half times. The legs account for about half the height of the figure.

A Visual Reference

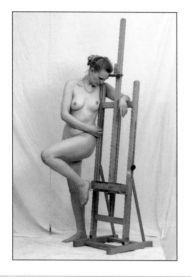

Use a piece of furniture or an architectural feature as a reference against which to plot a figure drawing. Here, an easel provides a support for the model as well as a grid of lines to assist the drawing process. A plumb line has been pinned to the backdrop to give a useful vertical.

Materials and Equipment

- SHEET OF NOT WATERCOLOUR PAPER
- HB PENCIL

Standing Nude

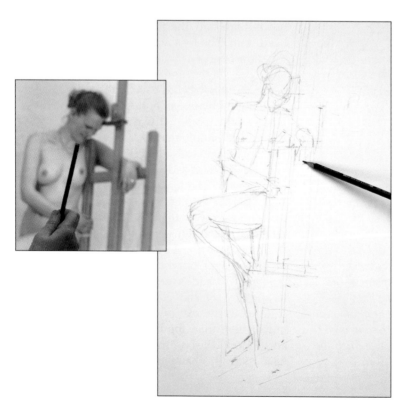

1

The angles of the model's torso and the upright of the easel are key elements of this study, so use your pencil to measure both these angles (see inset) and transfer them to the paper. Measure the slope of the shoulder, the thigh and the horizontal struts of the easel and lightly tick them in. Note the points at which the easel meets the model's body, and the angle between the figure and the plumb line. Measure the model's head and see how many times it fits into the body – just over seven times. These measurements provide a solid foundation for the drawing. Start to sketch in the figure, working lightly.

2

Check the height of the vertical strut of the easel: the distance between the top and the first horizontal is the same as that between the horizontal and the ledge. If you get these measurements right, the figure is more likely to look correct.

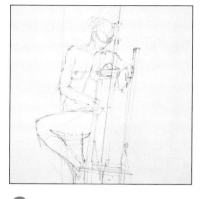

3

Continue developing the drawing, trying to get a broad feel for the pose. Allow your eye to travel over the figure to check horizontal and vertical relationships. Note that the angle of the model's right leg mirrors the angle of the supporting struts of the easel, and the bar she is leaning on aligns with her nipples.

4

Let the model rest from time to time – use chalk or masking tape to mark the position of the feet and hands so that she can resume the pose. If the pose is slightly different after the break, make adjustments to your drawing. The feet are important to the logic of the drawing, so draw them carefully.

5

When you are satisfied that the figure is accurately established, start to add details such as the hands and face. Half-close your eyes and look for the light and shadow. Hatch areas of tone on the stomach, under the breasts, on the thigh and on the raised foot. Finally, apply a tone to the hair, allowing the hatching to describe the way the hair grows.

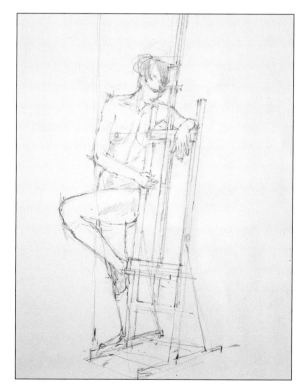

ARRANGING A SEATED POSE

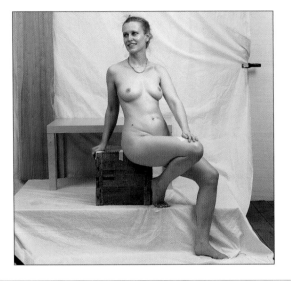

Experiment before you settle on a seated pose. This pose presents the figure as an extended diagonal, with the legs making a series of angles. The props were arranged to produce interesting negative shapes, and horizontal and vertical lines against which to measure the figure. Because the pose is somewhat complex, it is important to mark key positions with masking tape.

SEATED NUDE

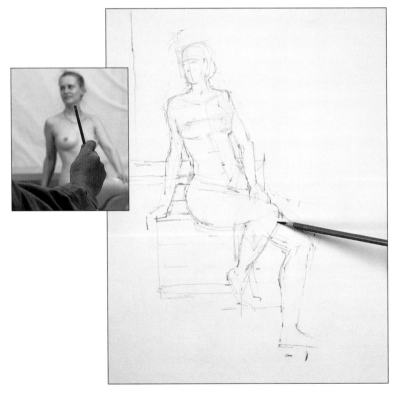

Materials and Equipment

- SHEET OF NOT WATERCOLOUR PAPER
- HB PENCIL

1

Use a pencil to find the angle of the seated figure (see inset), as this is the key to the entire pose. Mark this slope on the paper. Draw the head, indicating the centre line, and check that the angle is correct. Lightly sketch in the horizontals and verticals in the background. Begin to outline the figure, looking for the points at which it meets the background. Check the 'negative' shapes between the arms and the torso, and the angular shapes delimited by the legs.

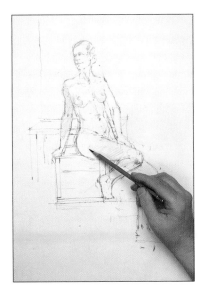

2

Draw the model and the crate on which she is sitting as a single entity. The seated figure does not support itself, so you need to explain how the weight is distributed. Here, the model is taking a lot of the weight on her right hand. Start to add the dark tones on the right arm and under the right breast. Notice that the artist has indicated how the left leg passes behind the right leg – the drawing will be more convincing if you understand what is happening to the hidden parts of the figure.

3

Begin to refine details such as the head and hands. Lay in loosely hatched tone on the torso, following the curves of the form. Draw the far leg of the small table – the obvious perspective creates a sense of space in the drawing. Block in a dark tone on the shin of the near leg.

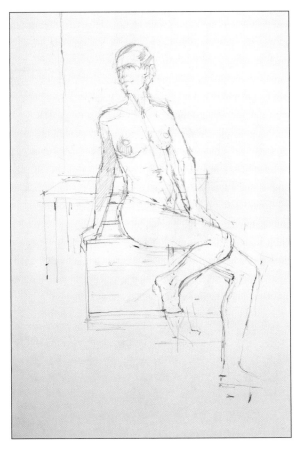

4

Develop the model's head by applying tone under the chin and the lower lip, on the hair and behind the jawbone. Complete the drawing by adding hatched tone on the calves, around the upper thigh and on the inside of the left arm.

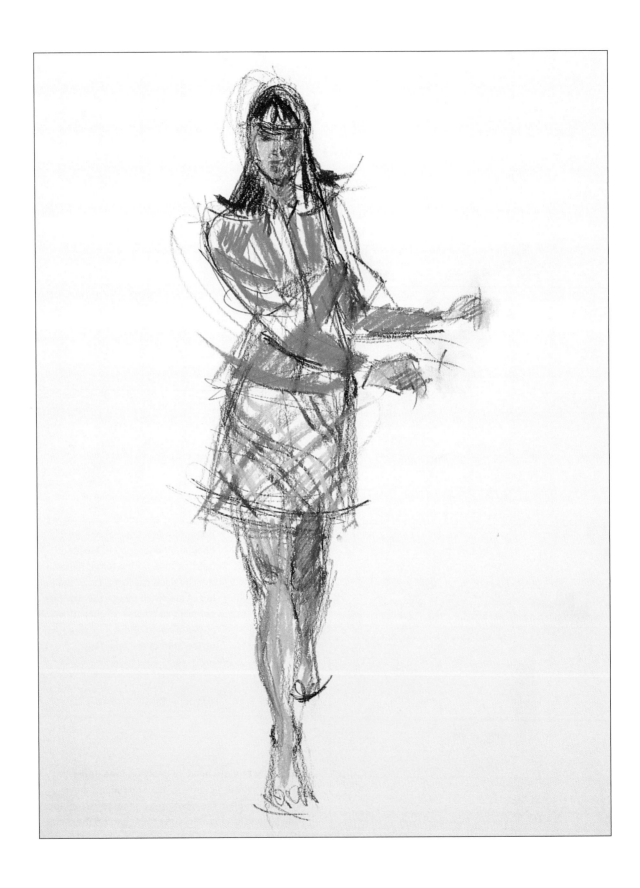

THE MOVING FIGURE

Capturing the figure in motion is a challenge, even for the most accomplished artist. You must learn to draw quickly and capture the essence of a gesture or a movement in a few fluid lines. This is much easier if you simplify the forms in your mind, seeing the figure as a series of solid geometric shapes which articulate against each other in predictable ways. If you practise drawing rapidly from life, you will develop a shorthand which allows you to express movement with a few telling strokes. The projects in this exercise involve drawing from the model, freezing movements mid-action in a way that rarely occurs in real life. These short poses will give you a greater understanding of the figure in motion. Avoid detail, concentrate on how the weight of the body is distributed, and look for lines that imply that the movement will be continued.

Striding Out
Hard pastel on cartridge paper
44 x 35cm (17¼ x 13¾in)

SIMPLIFYING THE FIGURE

To draw a convincing figure, you must create the illusion of a solid form in space. A useful way of understanding the solidity of the figure is to reduce the component forms to geometric shapes. The head can be seen as a sphere, the arms and legs as tapering cylinders, the torso and pelvis as modified cylinders or cubes, and the hands and feet as basically cubic shapes. Because these shapes are simple and familiar, it is easy to visualise them tilted, overlapping or in perspective. If you use them as the basis for a drawing and then apply your knowledge of proportion and the underlying structures, you will be able to draw a solid figure in any position.

If you imagine the human figure as a doll made up of these geometric shapes joined by elastic, you will begin to understand the way in which the different parts articulate against one another and this will give you an insight into the figure in motion. These 'manikins' can be fleshed out to produce a convincing nude or clothed figure. They are also a useful way of investigating what is going on in a difficult pose before you start a drawing.

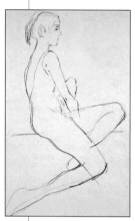

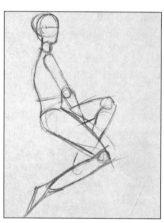

The dancer in this pose (above left) is poised and erect, her weight resting on one buttock, while her legs are very slightly braced against the bench, the floor and each other. The manikin figure (right) reveals the relationship of the main elements of the figure and shows how the legs articulate around the knee joint.

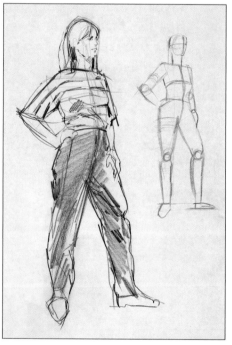

The swing of the pelvis and the slight bend in the left leg are the key to this pose, as shown in the manikin figure.

CAPTURING MOVEMENT

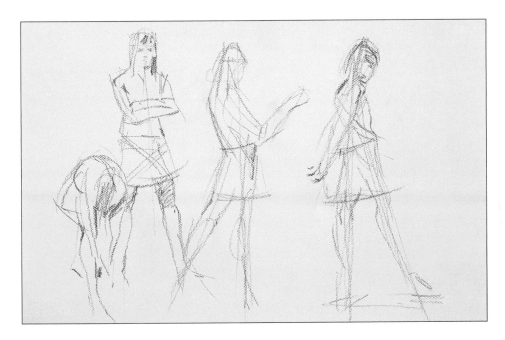

Drawing the moving figure requires many skills. You must be able to simplify the forms, find the lines that sum up the movement and commit poses to memory so that you can complete the drawing when the moment has passed. Above all, practise, work quickly and don't be afraid of making 'mistakes'.

Begin by persuading a friend to model for a series of short poses. Ask her to walk around the room and then stop suddenly, freezing a movement. Start with five-minute poses and reduce the time as you become more proficient. If you want to sketch people going about activities such as shopping or playing sports, you need to get something down in about ten seconds.

Work on a large sheet of paper and use a medium such as charcoal, chalk or pastel which allows you to work freely and boldly. Ideally, stand at an easel – this encourages you to use big

Do a series of quick warm-up exercises on a sheet of paper. Short poses force you to reject non-essential information and focus on the key directions and rhythms.

movements from the elbow and the shoulder, rather than finicky gestures from the wrist. Study the pose carefully and then start to draw, looking for the direction of the motion, the distribution of weight and the centre of gravity. If some of your lines are inaccurate, simply redraw them. The build-up of lines will suggest movement and vitality.

Apply the three-dimensional forms of the manikin figure as you draw. Use ellipses and contours to suggest the volumes of limbs and torso, and visualise what is happening on the far side of the figure. Try to understand the logic behind the pose, the action of the joints and how compression in one area is balanced by stretching in another.

POSES SHOWING MOVEMENT

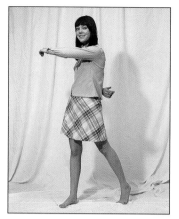

Ask the model to move around and then stop mid-movement. Allow a maximum of five minutes for each of the poses.

Materials and Equipment
- SHEET OF CREAM CANSON PAPER
- CONTÉ CRAYON: SANGUINE

GIRL, TURNING

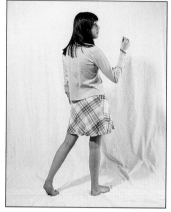

1

Look for the way the figure is balanced – here the weight is on the model's right leg while her body swings around to the right, pivoting at the waist. Work quickly, feeling the flow of the movement and the rhythms of the pose. Simplify the shapes, using an oval for the head and cylinders for the limbs and trunk. In that way, you will capture the volume of the figure.

2

Once you have captured the essence of the pose, start to add superficial details such as the hair, the pattern on the skirt and the dark tone where the knee is in shadow. Indicate the folds in the sleeve – these contours suggest the roundness and foreshortening of the arms.

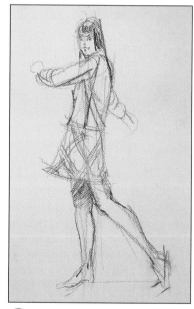

3

The finished sketch captures the energy of the pose. Short poses force you to be selective, and this is good practice for working on location when you have no control over the model.

Girl, Turning, Back View

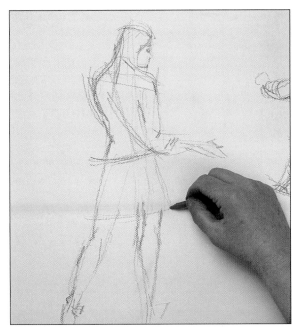

1

Ask the model to turn and 'freeze' another gesture. Look for the line that expresses the main thrust of the pose – in this case, the line down the left side of the figure. Indicate the angle of the shoulders and hips. These are critical as they change as the weight shifts from one leg to the other. Work quickly, looking for the main thrusts and tensions. These mid-movement poses are difficult to hold, so be prepared to adjust the drawing as the model shifts.

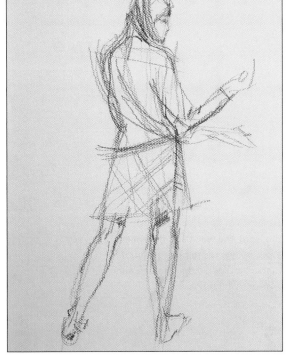

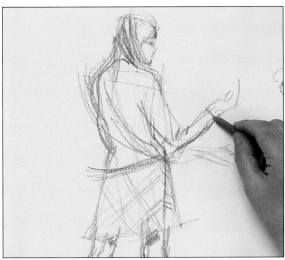

2

Begin to add more emphatic lines, firming up the outlines of the legs and arms, and refining details such as the pattern on the skirt and the hair, all the time searching for the forms and the sense of an implied movement. Allow your gaze to switch back and forth between the model and the drawing.

3

The finished drawing is simple, direct and energetic. The redundant construction lines emphasise the immediacy and energy of the drawing.

STRETCHING AND BENDING

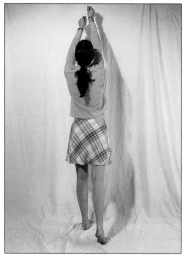

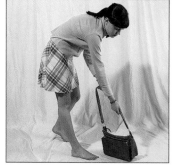

Ask the model to take up a pose that she can hold for at least five minutes. To find interesting and realistic poses, ask her to move around and then tell her to freeze.

Materials and Equipment
• SHEET OF WHITE CARTRIDGE PAPER
• BLACK CHARCOAL PENCIL
• HARD PASTELS: PINK, FLESH TINT, BURNT SIENNA, SAGE GREEN, LEMON YELLOW, BLUE AND ORANGE

GIRL, STRETCHING

1

Use a charcoal pencil to sketch the figure. Forget about detail and concentrate on the proportions and position of the body. Try to see the figure as the linked geometric shapes described on page 40. With the pencil, check the relative positions of key elements such as the head, the waist and the knees. Work boldly, using quick gestural marks that follow the stresses and tensions of the pose.

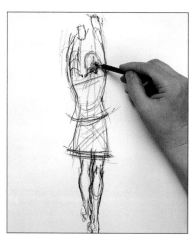

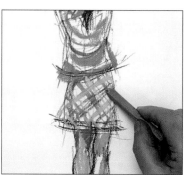

2

Using a pink pastel stick, describe the folds on the sleeves and the back of the model's blouse. Rub flesh tint on to the hands and the legs, and add burnt sienna for the shadows on the legs. Use the pink, sage green, lemon yellow and blue pastels to complete the pattern on the skirt.

3

The vigorous finished drawing captures the essence of the stretching figure perfectly. The lively lines reflect the speed with which it was made.

GIRL, BENDING

1

Using a charcoal pencil, indicate the main rhythms of the pose. Work quickly with flowing lines that follow the direction of the movement. Look for the telling lines: here, they are the curve of the model's back and the line of the right, supporting leg. Don't use an eraser, simply redraw inaccurate lines – multiple lines and a blurred outline all add to the sense of movement.

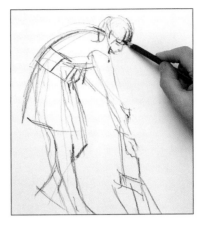

3

Complete the skirt plaid with blue, sage green and lemon yellow pastel. Use burnt sienna for the shadows on the model's legs and for her bag. Add a touch of orange where the bag catches the light. The finished image captures the essence of the movement with great economy.

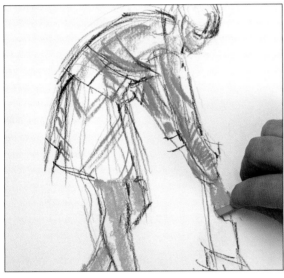

2

Suggest the colour of the blouse and the skirt plaid with a few brisk strokes of pink pastel, using the side of the stick to block in general colour and the tip to lay in the folds and stripes. These swinging lines are wonderfully energetic and enhance the sense of motion in the drawing. Apply flesh tint on the face, hands and legs, warming it with a little pink.

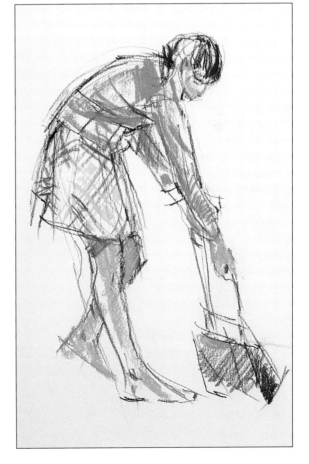

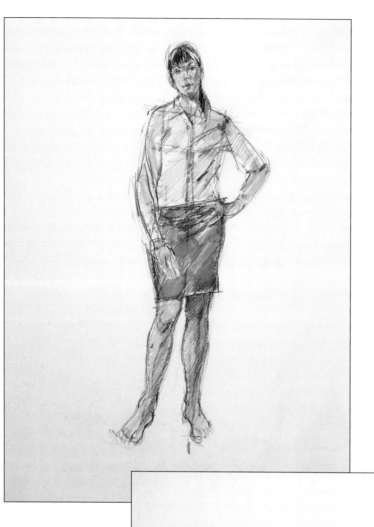

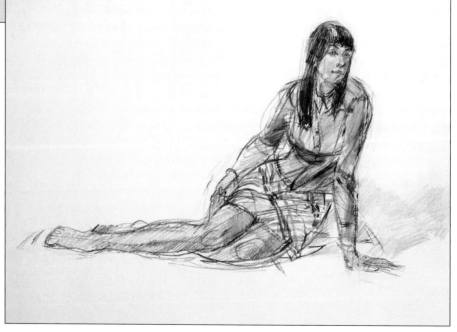

Project

4

BONES, MUSCLE AND BALANCE

A basic understanding of anatomy – in particular, of the skeleton and the muscle groups and how they change with every action – will enable you to draw the nude and clothed figure with confidence and conviction. The way that fabric drapes around the figure is largely dependent on what is going on underneath – a good drawing should make you aware of the figure under the clothing. The skeleton provides a rigid framework and is overlaid by muscles and fatty tissue, the whole package contained in an envelope of skin. In some places, the bony structures are near the surface and determine the form; in others, it is the soft tissues that create the contours. These are also the factors that create the differences in shape between individuals, men and women, adults and children. If the figure is to stay erect, the muscles must work against each other, keeping the body in balance. Capturing these often fleeting moments of equilibrium is important if a drawing is to look stable and convincing.

Girl, Standing
33 x 50cm (13 x 19in)

Girl, Sitting
56 x 51cm (22 x 20in)

*Graphite and water-soluble
coloured pencils*

THE SKELETON

The skeleton is a lightweight framework of bones, held together by muscle, cartilage and tendons. From the artist's point of view, the spinal column is the most important structure as it is the axis around which the other bones are grouped and its position is the key to many poses.

The most notable feature of the spinal column is its flexibility. It isn't straight, but curves out in the shoulder area, inwards towards the waist and out again over the pelvis before tucking in and out at the coccyx. These curves act as shock absorbers and define many aspects of posture.

Although there is only a little movement between one vertebra and the next, the cumulative effect over the entire length of the spine allows for bending backwards, forwards and side to side, plus twisting movements. These movements are made possible by the powerful muscles of the back.

The top part of the skeleton consists of the ribcage, at the top of which the hoop of collar bones and shoulder blades provides an attachment for the arms. The pelvic girdle, attached to the lower end of the spine, is a heavy and fairly rigid structure designed to carry the weight of the upper body and allow it to be supported on the lower limbs.

The limbs consist of long bones. The upper arm fits into a shallow socket in the shoulder blade and the two slim bones in the lower arm meet the upper arm at the elbow joint.

The rounded heads of the thigh bones sit in deep sockets in the pelvis. Note that the hip joints are on the outside of the pelvis, so that the thigh bones slope in towards the knees – this effect is more pronounced in women who tend to have wider pelvic bones.

The skull is balanced on top of the spine. All its plate-like bones are fused except the lower jaw bone which articulates against the rest of the structure from points just in front of the ears.

The hands and feet are complex structures consisting of many tiny bones. The hand is heavily jointed to provide maximum flexibility, while the foot bones are wedged tightly together and bound with ligaments to give the foot both flexibility and strength.

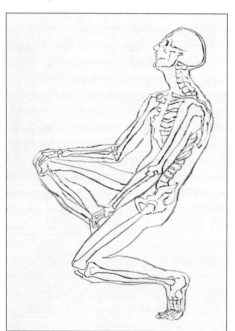

The skeleton provides the basic architecture of the body and gives it a solid underpinning.

THE SOFT TISSUES

The bony skeleton defines the broad structures and dimensions of the body, but the appearance of the figure is also determined by layers of muscle and fatty tissue. In some places the muscular tissue is bulky and dominates the surface area, while in others, bones come close to the surface.

Muscles work in pairs, providing power and leverage for the body. The musculature of the body is complex, consisting of layers of large and small muscles which perform specific tasks. Although you can draw the figure effectively without becoming an expert on anatomy, you should be aware of the way that some muscles affect the shape and surface forms of the figure.

The upper part of the torso is quite bony in character. If you run your hands over that area, you will find that the collar bone, breast bone, ribs and the bones in the shoulder are only thinly covered. The area between the rib cage and the pelvis is soft and fleshy and is capable of considerable movement. Notice the furrow that runs down the front of the torso to the base of the rib cage, and the fleshy mound of the abdomen. The pectoral muscles emanate from the breast bone and insert into the shoulder – in women they are partially masked by the breasts.

On the back, a furrow runs the entire length of the spine, with the powerful muscles of the back radiating out from this line. The fleshiest part of the back is the buttocks, which are formed by several muscles.

When the arm is flexed, the biceps and deltoid muscles bulge and become more apparent. The form of the legs is

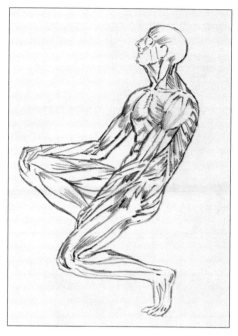

The skeleton is enveloped in layers of muscle and other soft tissue that smooth the outline and create fleshy masses in certain areas of the body.

defined to a large extent by the hard-working muscles that almost entirely mask the thigh bones and create the typical rounding on the back of the calves. At the front of the leg, the shin bone is relatively unprotected.

The most convenient way of familiarising yourself with human anatomy is by getting to know your own body. Run your hands over your arms or make some exaggerated movements and notice the way that the muscles lengthen or bulge. Stand in front of a mirror in a strong light and observe the fleshy masses on the abdomen, buttocks, arms and legs.

A POSE IN EQUILIBRIUM

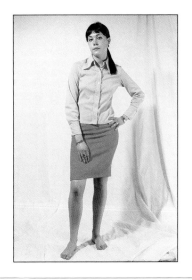

Ask the model to stand with her weight on her left leg and her hand on her hip. Automatically, the left hip will swing out and up, and the other hip will drop down. The shoulder on the left side will also drop slightly. These adjustments all help to keep the body in balance.

Materials and Equipment

- SHEET OF CARTRIDGE PAPER
- 7B PENCIL • WATER-SOLUBLE COLOURED PENCILS: PINK, ORANGE, RAW UMBER, FLESH TINT, VENETIAN RED, CRIMSON

GIRL, STANDING

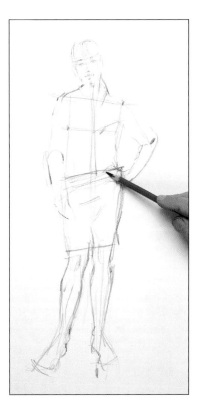

1

Using a 7B pencil, start by establishing the central axis and the opposing slant of the shoulders and hips. These angles give you the structure of the pose. Try adopting the pose yourself and notice how one part of the body acts as a counterweight to the other.

2

Develop the drawing with vigorous lines, keeping in mind the model's underlying forms. Simplify the main elements – the arms are cylinders, the legs are tapering cylinders and the knees are convex domes on the surface of the leg. Use heavier lines and scribbled shading for areas of dark tone. Develop the facial features and hatch some light shading to give the face form.

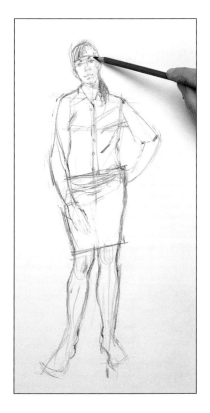

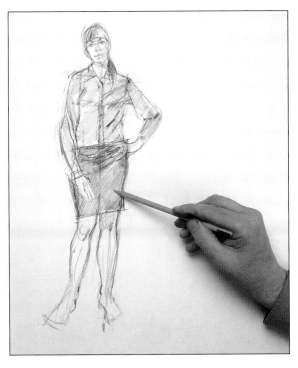

3

Using water-soluble coloured pencils, hatch pink on the blouse and a combination of orange and raw umber on the skirt. Soften the coloured pencil marks in places by blending them with a little water applied with a brush or with the tip of your finger.

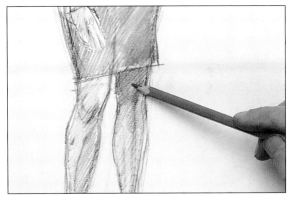

4

Apply a light flesh tint on the face, hands and legs, and warm the inside of the calves with a little Venetian red. Add shadow at the top of the leg in raw umber. Don't overwork the coloured pencil – the white paper shining through the hatching has a lively, shimmering quality which solidly applied colour would lack.

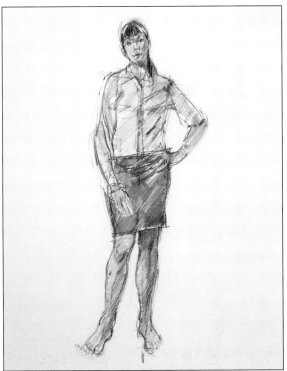

5

Refine the drawing a little further by adding more detail to the face – a touch of flesh tint on the cheek that is catching the light, some crisp detail in 7B pencil around the eyes and mouth, and a touch of crimson on the lips. While the face should capture the character of the individual, it is important that it remains in harmony with the rest of the drawing.

LOOKING AT BALANCE

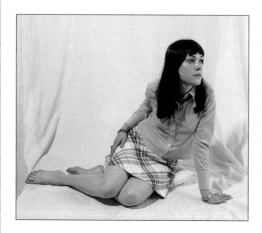

Balance is important even in the seated figure. In this pose, the spine curves to the side but the head remains over the centre of gravity. Use masking tape or chalk to record the model's position.

Materials and Equipment

• SHEET OF NOT WATERCOLOUR PAPER • 7B PENCIL
• COLOURED PENCILS: BURNT UMBER, PINK, FLESH TINT, DARK BLUE, GREEN, CRIMSON, VENETIAN RED, YELLOW

GIRL, SITTING

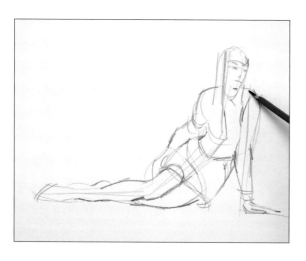

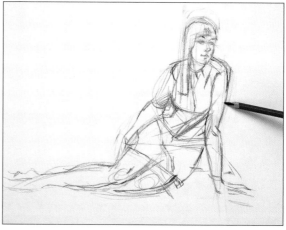

1

Using a 7B pencil, block in the outlines of the main segments of the body: head, ribcage, pelvis and limbs. Note the location of the spine as this is the key to the pose, and notice, too, how the left side of the body is extended while the right is compressed. The legs present a challenge in perspective as the thighs project forwards. If you check relative measurements with your pencil and draw what you see, you will draw the foreshortening accurately.

2

Develop the drawing, looking for the relationships between one part of the body and another – the way that the head is balanced above the torso, for example, and the point at which a line extended from the head would meet the floor. Try to visualise the skeletal underpinning – the tilt of the shoulders and pelvis, and the foreshortening in the ribcage. A hard line suggests the tension in the muscles of the left arm and shoulder, while a softer line is used for the relaxed right arm.

3

Indicate the shadows and folds on the blouse, and the way the pattern on the skirt curves around the thighs. Details such as seams, cuffs and hems provide clues to the underlying structures. Add dark tone on the hair and warm it with a touch of burnt umber. Apply pink to the skirt and blouse, changing the direction of the marks to follow the surface planes or the tension on the cloth.

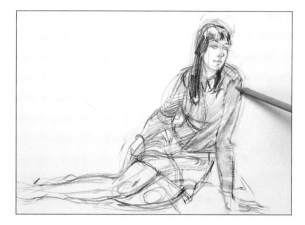

4

Lightly hatch flesh tint on to the face, hands and legs. Elaborate the pattern on the skirt with dark blue and green coloured pencils. Note how the lines rise and fall as they travel across the undulations of the thighs, revealing the underlying forms.

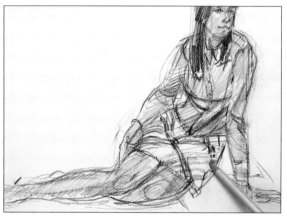

5

Develop the face with touches of burnt umber, flesh tint and crimson. Use flesh tint, raw umber and Venetian red for the skin tones on the leg, using the pencil marks to indicate how the surface planes change direction. Complete the plaid pattern on the skirt, add a touch of yellow to the cushion, and lightly hatch in the shadow cast by the model. Although the pose appears complicated, it is simple to draw if you combine an understanding of the underlying structures with careful observation.

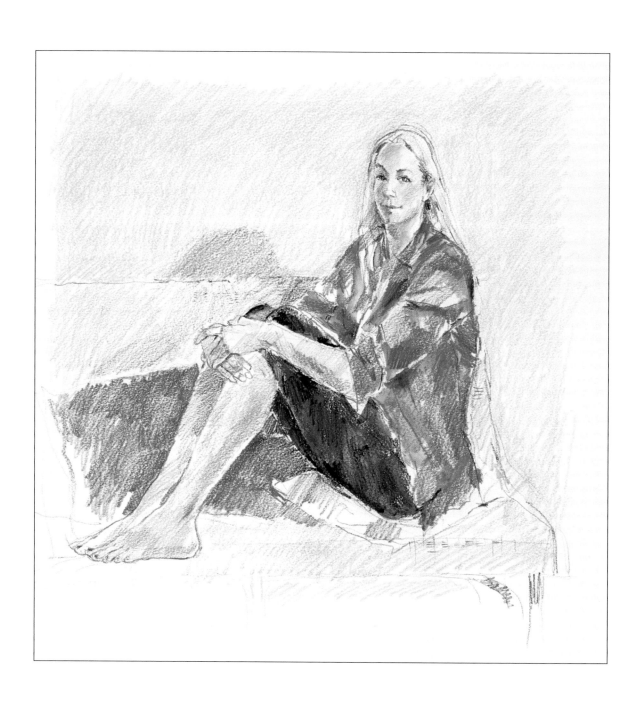

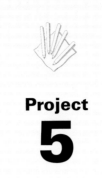

5

HEADS, HANDS AND FEET

The head is the part of the body that most expresses the individuality of a person. For beginners, the need to find a likeness can be daunting. However, if you understand the basic structures, then look hard and measure, you will find that not only is it easy to produce a convincing image, you can also get a good likeness. The basic proportions of the head are illustrated on the following pages. Study them and then observe your own face in a mirror.

Hands can also present a problem for the less experienced artist, but if you look carefully, reduce them to basic shapes and work from life, you will soon be able to draw hands that are three-dimensional, convincing and expressive. In this study, the artist started by treating the hands as simple shapes, adding details, tone and colour as the rest of the drawing progressed.

Feet, too, are easy to draw if you understand their volumes and underlying structures. Because hands and feet are quite complicated shapes, there is a temptation to put in too much detail which upsets the balance of the drawing. In this study, the hands and feet are indicated with a few deft touches and sit comfortably within the composition.

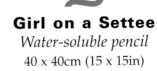

Girl on a Settee
Water-soluble pencil
40 x 40cm (15 x 15in)

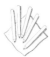

LOOKING AT HEADS

The skull is a bony structure to which the facial features are attached. The eyes are spheres embedded in the hollows of the eye sockets. They are surrounded by the eyelids, the upper lid being more apparent than the lower lid. When drawing the upper eyelid, use a heavy line to indicate the thickness of the lid, and a shadow under the lower lid to suggest the depth of the lid and its angle to the cheek.

The nose is a wedge jutting out from the face. It is narrow at the top and flares out to a wide base. The bone of the nose stops short of its tip which is soft and fleshy; some noses come to a shapely tip, others are bulbous. When drawing the face from the front, a touch of shadow under the nose will make it seem to project from the face. The appearance of the nose changes as the face dips forwards or tilts backwards, and this movement also affects how much of the nostrils is visible.

The mouth is an expressive feature which gives a face much of its character. It is also an important clue to mood. The bottom lip is lighter in tone than the upper lip because its plane faces up to the light. A touch of shadow under the bottom lip will help to give it form. In profile, the upper lip tends to jut forward beyond the lower lip.

The ears can only be seen fully from the side, so usually they are seen in perspective. They equal the nose in length, aligning with its base and top.

The chin is a convex mass on the surface of the head, creating a furrow between it and the lower lip. The chin, which varies from person to person, is another important defining characteristic.

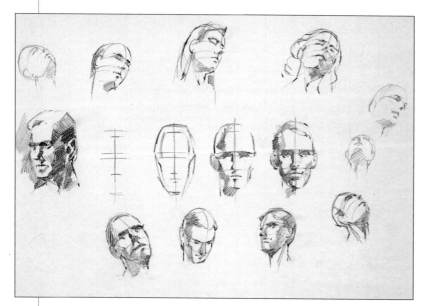

The head is basically an egg-shape with the broader end at the crown, the nose providing a central axis. The eyes are positioned half-way between the chin and the top of the head and are about an eye-width apart. The eyebrow aligns with the top of the ear and the nose is about the same depth as the forehead. The lines of the eyebrow, eyes, nose and mouth tilt as the head is lifted or lowered.

DRAWING HANDS AND FEET

Hands are flexible and complex structures. You will find it easier to tackle them if you reduce them to simple shapes. Look for the basic structures – the roughly five-sided shape of the palm, the two separate masses of the hand proper and the thumb, and the planes of the clenched fist. Move your hand and notice the range of wrist movements. Lay your hand and arm flat on a table and you'll see that the hand is broader at the fingers than at the wrist and that the wrist slants up from the hand to join the arm. When the hand is fully extended, the fingers converge to a point below the middle finger.

Make a series of drawings of your own hands in different positions. A mirror will extend the possible viewpoints. Simplify the shapes, trying to see the hand as a single unit rather than an assemblage of different elements. Place the hand you are drawing in a strong light – the shadows and highlights will reveal the surfaces and contours. Use straight, hatched lines for the planes and curved shading for the curved surfaces.

If you stretch your hand fully, you will see that the tips and joints of the fingers lie along a series of curved lines, and the thumb aligns with the

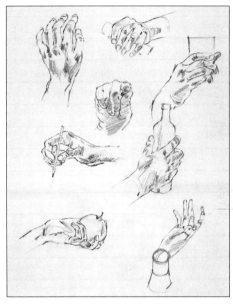

Sketch your own hand in as many different positions as possible. The model hand (bottom right) articulates at the joints and is a useful drawing aid.

second joint. Keep these relationships in mind as you are drawing.

The foot is perfectly designed for movement and support. Study the sole and note the points of contact with the ground – the heel, the ball, the toes and the outside rim. The ankle is higher on the inside of the leg than the outside, and the top of the foot forms a plane which splays out and slopes down from the inner ankle and instep.

Use a mirror to make a sheet of drawings of your own bare feet from as many different angles as possible. Notice the relationship of the foot to the leg and how the shape of the foot changes as you shift your weight.

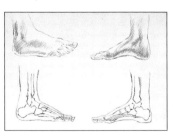

Seen from one side, the foot is in contact with the floor along its entire edge, but the inside edge is raised over the arch.

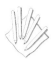

A SEATED POSE

Ask the model to sit with her feet up on a settee or bench and her arms clasped around her knees. This pose has many advantages: the model is comfortable, the flexed arms and legs make interesting angles, and the hands and feet are clearly visible. Costume and colour are an important part of a figure study. Here, the crimson blouse and cushions provide a vibrant contrast to the blue trousers, the delicate colours of the hair and skin, and the cane of the settee.

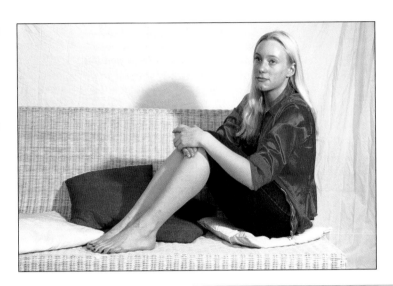

GIRL ON A SETTEE

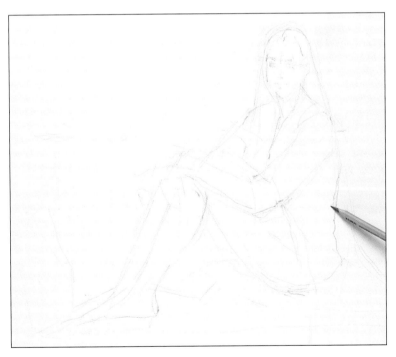

Materials and Equipment

• SHEET OF NOT WATERCOLOUR PAPER • WATER-SOLUBLE COLOURED PENCILS: BURNT SIENNA, CRIMSON, ORANGE, DARK BLUE, GREY, LIGHT BLUE, SEPIA, CARMINE, YELLOW OCHRE, INDIAN RED, FLESH TINT • NO.3 WATERCOLOUR BRUSH

1

Decide how you are going to position the image within the support. This pose produces an almost square composition. Start to draw with a burnt sienna water-soluble pencil, working lightly but freely. Use your pencil to check proportions and angles, especially the slope of the arms, legs and back, and the tilt of the head. Tick in the line of the eyes, the mouth and the centre of the head.

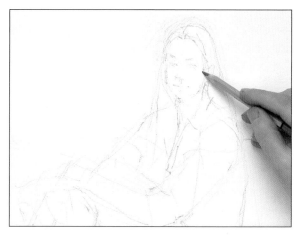

2

Develop the drawing with the same burnt sienna pencil. Use light lines while you are searching for the image and more emphatic lines once you are sure that you have got it right. You can also vary the weight of the line to reflect the character of the edge you are drawing – use crisp, dark lines between areas of highly contrasted light and dark such as the hairline, the collar and the opening of the blouse and lighter lines for folds in the fabric. Add more detail to the head – the dark tone under the nose and chin and between the lips, for example. Lightly indicate the pupils.

3

Apply hatched tone on the shaded side of the face and neck. Sketch the hands with a few lightly applied lines, suggesting the location of the knuckles and the individual fingers. Shade the fingers of the left hand, treating them as a single block of tone. To render the shiny, reflective surface of the satin blouse you will need a selection of cool and warm reds, leaving the white of the paper to stand for the highlights. Use a crimson water-soluble pencil to apply loosely hatched patches of colour in the darkest areas of the fabric.

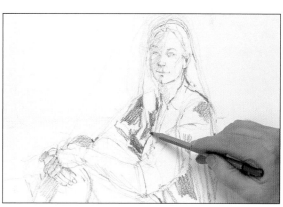

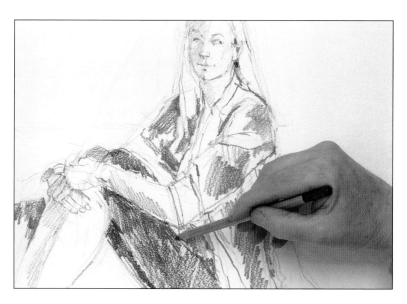

4

It is good practice to advance all areas of the drawing at the same pace, so apply some crimson to the cushion and add touches of orange to the blouse. Use the burnt sienna pencil to indicate the shadow under the left forearm, then start to block in the dark blue of the trousers.

5

Study the feet carefully and then use the burnt sienna pencil to refine the drawing. Notice the way the feet slope down from the ankle and then flatten out into the toes. Indicate the areas of tone under the ankle, between the legs, and along the edge of the foot. When you are satisfied that the drawing is correct, draw a more definite outline with the burnt sienna pencil.

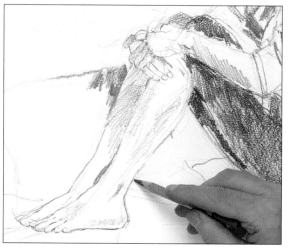

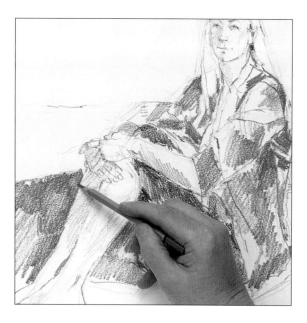

6

Use a grey pencil with a sharp point to draw the eyebrows, the edge of the upper eyelid and the pupil. Use a light blue pencil for the irises. Indicate the outline of the settee with a sepia pencil, then add colour to the red cushion with the crimson pencil.

7

Add touches of carmine to the jacket. Apply a little colour to the hair with a yellow ochre pencil, then use the same colour to hatch a light tone on the forehead, the cheeks and the neck. Use the grey pencil to define the hairline and shaded area under the hair. Dip a No.3 watercolour brush in water and use it to soften and blend the colour on the face and neck – don't overdo this. While the brush is still loaded with this colour, apply a delicate wash to the left arm and hand.

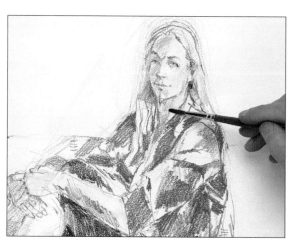

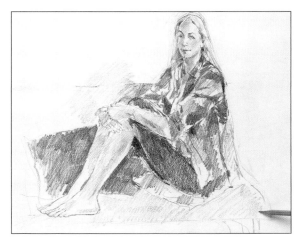

8

Work Indian red into the red of the blouse, then add touches of grey for the darkest areas. Allow the drawing to dry and then hatch flesh tint on the arm and on the face. Apply yellow and orange to those areas of the cushion that are catching the light. Hatch grey on the cushion the model is sitting on. Use yellow ochre to scribble some local colour on to the cane settee, then return to the grey pencil for the cast shadow on the wall behind the settee.

9

Dip the No.3 watercolour brush in water and start to blend the blue of the trousers and some of the hatched areas of the blouse. Don't overdo the blending – it is the combination of line and wash which gives this medium its attractive quality. Water-soluble coloured pencils are really best for small areas of wash or for softening lines. If you want to use the full range of watercolour effects, choose watercolour paint.

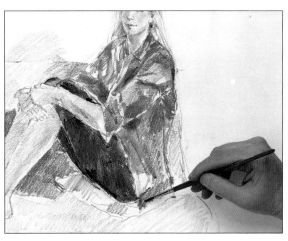

10

Use the sepia pencil to suggest the leg of the settee and the weave of the caning. You could leave the picture at this stage, or use the grey pencil to add a light overall tone to the background. In the final image, the figure of the girl is accurately drawn and beautifully rendered in a combination of hatched pencil techniques and blended washes. The various shapes, textures and blocks of colour also work as an abstract composition.

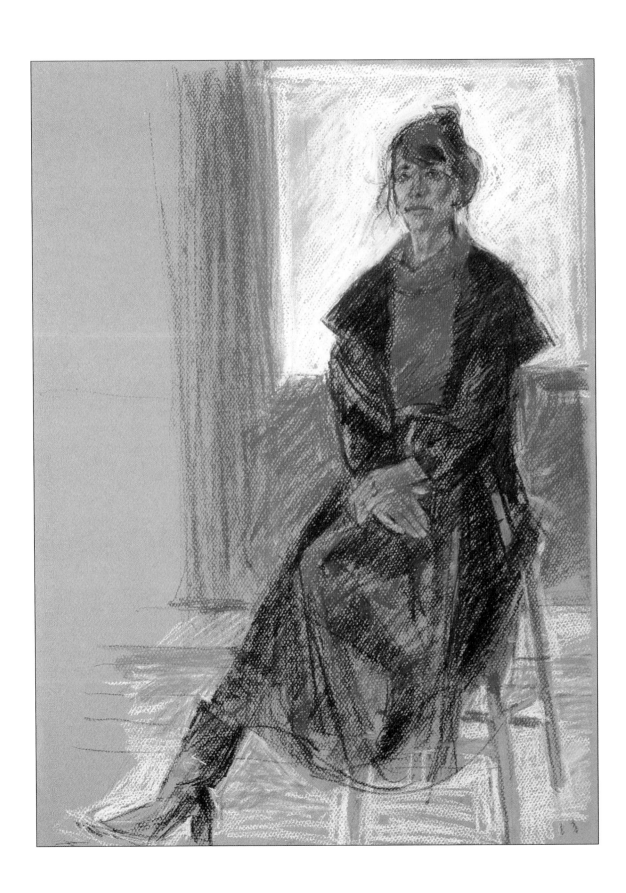

Project
6

LIGHTING THE FIGURE

Light is the means by which you discern forms in the world about you, but it also allows you to introduce atmosphere into a drawing or painting. Light is an integral part of the subject in a figure study, establishing a mood, holding disparate elements together, emphasising forms here, rendering them ambiguous there. Change the lighting and you change every aspect of the image. A bright spotlight shining on to a figure creates contrasts of tone and a sense of drama, while softly dappled light and flickering shadows produce a quieter, more mysterious mood. Bright light casts crisp shadows, while the shadows cast by diffuse light have softer, less defined edges. Artists often use backlighting to combine drama and mystery in a study. By placing a figure against a window, as shown left, the silhouette is revealed, often with great clarity, while the rest of the figure is cast into a shadow. This near-silhouette effect is called *contre jour*.

Seated Woman, *Contre Jour*
Pastel pencil and hard pastel on tinted paper
38 x 55cm (15 x 21in)

LEARNING TO USE LIGHT

When you are setting up a figure study, it is important to consider how the light will affect the composition and the mood you want to achieve. For an investigative drawing, you will need a combination of light sources – an overall light so that you can see the entire figure, with a side light to reveal the surface forms with greater clarity. But if you want to create a more intriguing image, you could choose to illuminate the figure from behind or with a directional light from one side. With the more exaggerated light effects, the shadows become an increasingly important element in the composition.

Daylight is generally preferred by artists because it shows colours at their truest. If you are working by natural light, remember that it will change throughout the day, so you either have to work quickly, make a few reference sketches or photographs, or return to your drawing or painting at the same time on another day. Very bright light can be filtered through muslin or blinds. Fascinating effects can be achieved by allowing light to shine through slatted blinds so that bands of light and shadow drape themselves across the undulations of the form.

The advantage of artificial light is that it is predictable and controllable. It can be brightened or dimmed, directed on to the subject or bounced off an adjacent surface. An adjustable desk light or spotlight can be used to create a dramatic directional light.

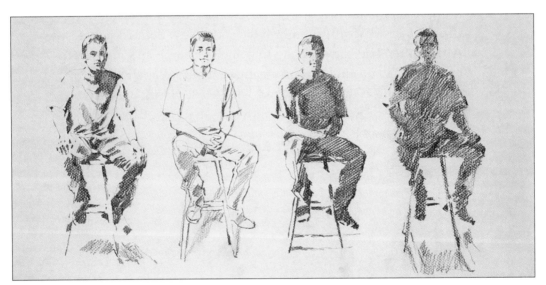

Light from above gives a fairly even distribution of highlight and shadow and the details of the figure are easy to read.

Light from the front flattens the form and provides little contrast of light and shadow, but the facial features are clearly visible.

Light coming in from the left throws the right side of the figure into shadow. Side light can be atmospheric and informative.

Light coming from behind emphasizes the silhouette. The figure drawn and painted contre jour *has an ambiguous quality.*

SETTING UP A *CONTRE JOUR* POSE

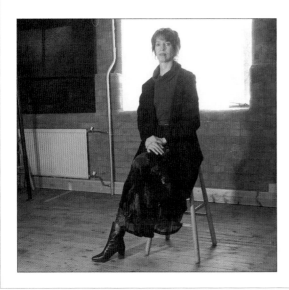

Position the model so that the main light source is behind her, but make sure there is enough overall light to illuminate the front of the figure as well. The silhouette is an important element in this composition, so find a pose that creates an interesting shape on the page, and choose dark, flowing garments that emphasize the silhouette.

SEATED WOMAN, *CONTRE JOUR*

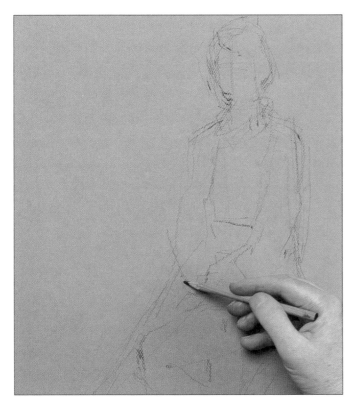

Materials and Equipment

- SHEET OF TINTED PASTEL PAPER
- CHARCOAL PENCIL
- PASTEL PENCILS: BLACK, BLUE, CRIMSON, YELLOW
- HARD PASTELS: WHITE, VENETIAN RED, GREY, BLACK, CYCLAMEN, FLESH TINT, RAW SIENNA, NAPLES YELLOW, SCARLET, VANDYKE BROWN, GOLD, BRIGHT PINK, RAW UMBER

1

Using a charcoal pencil, block in the main outlines of the figure. Check proportions and angles with your pencil. Use the verticals and horizontals in the background to locate the components of the figure accurately.

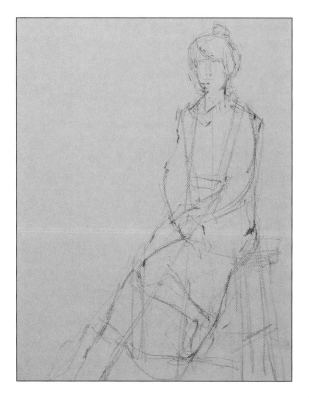

2

Organize the figure on the paper so that it makes a satisfying composition. Here, the model is placed to one side to create an asymmetric design. The predominant vertical of the perched figure is counterpointed by the diagonal of the outstretched leg. Develop the drawing, looking for the way the different parts relate to each other and to the stool. Check these relationships by extending lines from one part of the drawing to another. Consider the way the figure is balanced and visualise the body under the clothing.

3

Once the figure is broadly set out, you can begin to develop the facial details. Add a dark tone in the eye sockets, alongside the nose, on the upper lip and under the lower lip. It is useful to have a recognisable face at this stage, but don't take it too far or it will cease to be consistent with the rest of the drawing.

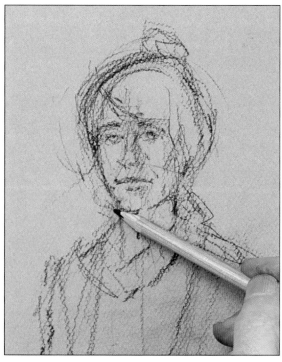

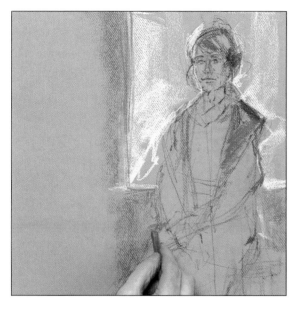

4

Using a pastel stick, scumble white over the screened window area. Use the stick to cut back into the silhouette, crisping up the outline. Block in the brick wall in Venetian red. Add touches of grey and black to the coat and to the model's hair. Because the support is a good mid-tone, the image feels more resolved than it would if you were working on white.

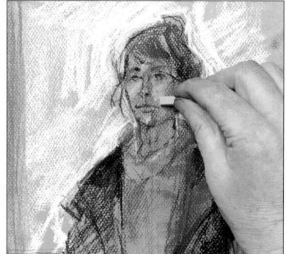

5

Scumble more white over the window area – the broken colour creates the luminosity you need for the light source. Hatch in the black of the coat, apply a glaze of Venetian red to warm the face, and add the cyclamen of the model's pullover. Start to develop the skin tones using flesh tint and raw sienna.

6

Apply a glaze of Naples yellow to the hands and then refine the shapes with the black pastel pencil and a little Venetian red. Apply black around the hands so that you are using the colour of the coat to define their outline – drawing the negative shapes is often more accurate than drawing the positive, and gives a more subtle result.

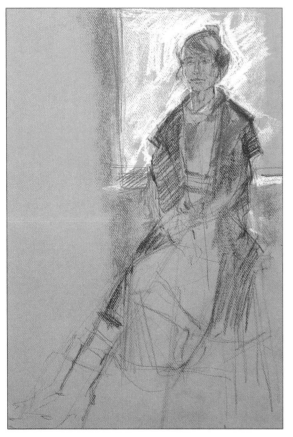

7

Stand back and study the picture from a distance, comparing the drawing with the subject. Block in the lower part of the model's flowing garments – sketching the position of the legs underneath will help you to produce a more logical drawing. Add touches of grey and scarlet to the jumper.

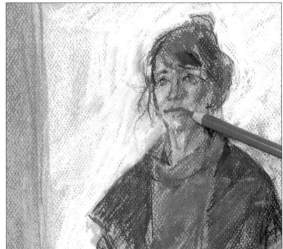

8

Don't focus on one part of the drawing, but try to keep the figure and the background progressing together to produce a more coherent, harmonious result. Add more scumbled white to the background and then develop the face with pastel pencils, using blue for the eyes and crimson for the lips. Pastel pencils are useful for detail, because they can be sharpened to a fine drawing point.

9

At this stage the colours are a little vibrant, so apply darker tones to create a more muted effect. Apply Vandyke brown over the brick wall and use the same colour on the face, hands and jumper. Sketch the stool with a yellow pastel pencil – it is important to the logic of the picture to describe how the model is supported.

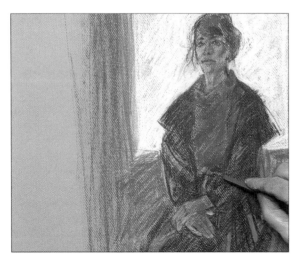

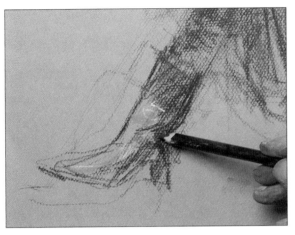

10

Add white and grey for the highlights on the shiny surface of the leather boots. Then apply the darkest tones, using the black pastel pencil. These touches of light and dark give just the right amount of detail.

11

The floor is quite light in tone compared to the rest of the picture. Use a pale colour like Naples yellow to block in the floor, taking this light tone around the stool, so that it is drawn in negative. The colour of the paper stands for the local colour of the stool.

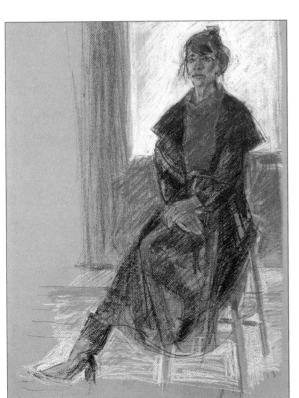

12

Add a few tiny touches of brighter colour to show where the light catches the edge of the figure – a touch of gold in the hair, a sliver of bright pink on the collar. Hatch a little raw umber on the floor at the base of the wall, which is darker because it is not fully illuminated. The completed figure is suggested rather than accurately described. It is these hints and suggestions, the concealing and revealing of forms, that make *contre jour* such an appealing lighting effect.

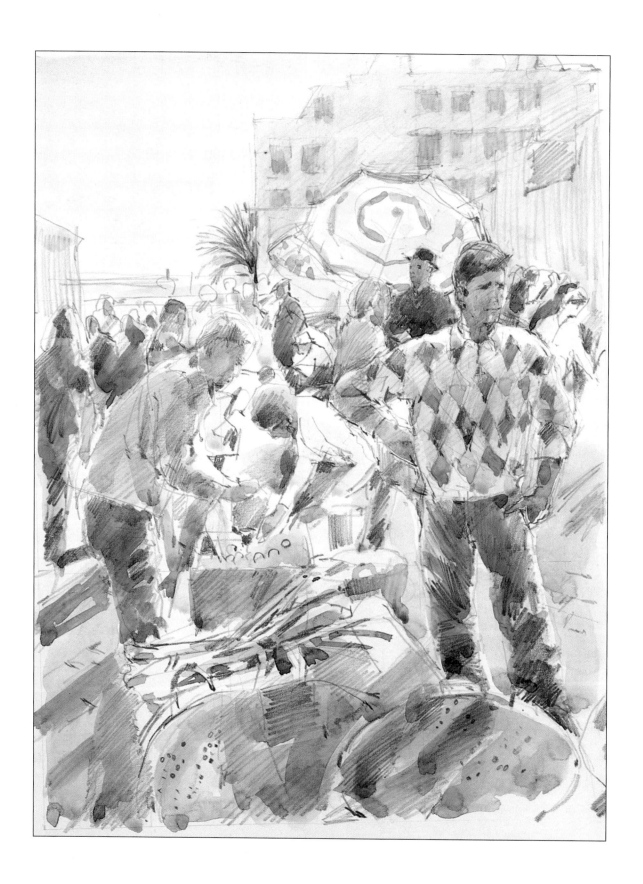

Project
7

DRAWING GROUPS OF PEOPLE

Drawing from a model posing in mid-movement is one thing, drawing people moving about amidst the hustle and bustle of a public place – a market, a restaurant or a station, perhaps – is quite another. But if you are to use your figure drawing skills to produce scenes from everyday life, you need to collect 'live' reference material. Get into the habit of using a sketchbook and take every opportunity to make drawings of people going about their business. You will find that your drawing skills will improve immeasurably, and you will build up a source of fascinating material on which to base drawings and paintings. Use your camera to provide back-up information – photographs are useful reference for back-grounds, colour and detail, but it is the images that you have actually drawn that remain fixed in your memory.

Market Scene, Portugal
Pencil and watercolour
32 x 40cm (12 x 16in)

SKETCHING A CROWD SCENE

In this rapid sketch, the artist has managed to encapsulate the stance and character of the main figures in just a few lines, giving them individuality even though they are not drawn in any detail. The busy market atmosphere is suggested with just a few scene-setting objects such as fruit and vegetable boxes and scales. Areas of tone denote cast shadows.

A small sketchbook is one of the artist's most useful possessions. Keep one in your pocket and work in it when you are waiting for a train, sitting in a bar or visiting a market. In locations such as these, you will often find unusual characters and interesting poses.

In a busy place like a market, people are constantly moving about, so you must look intently and try to capture the scene as quickly and economically as possible. Ignore details and observe the principal thrusts of the figures – the angles of the torso, head and limbs. At first your sketches will be rudimentary, but with practice you will get better at selecting the significant features, and your visual memory will improve, so that you can complete the sketch when the person has moved on.

When you are more confident, you can start to place people in a setting. If a person is weighing out vegetables, show the scales, the stall and some of the background. Add a few clues to the perspective, so that you have a stage

on which to put your characters. If you can sit somewhere comfortable – in a bar or café, perhaps – you can work in a large sketchbook. The format allows you to make a series of studies without constantly turning the page.

For drawing, use simple, portable materials such as a pencil, a fountain pen, a biro or a fibre-tipped pen. A few coloured pencils are useful for dashing

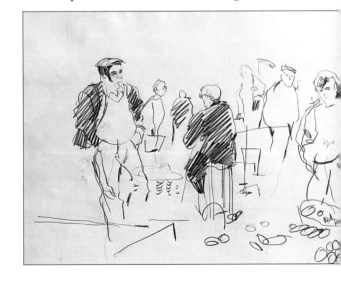

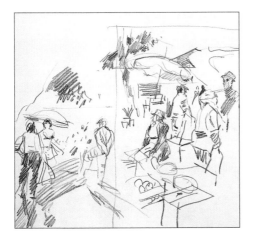

Here, two unrelated sketches have been placed side by side on the same page. Details such as benches, parasols, plants and shadows have been dashed in at great speed, but they tell the story very effectively.

in scribbled colour – even a few clues will help you to recall the colours in the scene. You can also annotate the sketch. Practising artists' sketchbooks are full of colour notations that are meaningful only to them.

Light is an important element of any drawing or painting, so, if you have time, make a quick thumbnail study of the distribution of light and shadow across the scene. Half-close your eyes and hatch in the areas of dark tone, paying special attention to any shadows that might be important in a

composition. Make a note of the position of the sun, the time of day and the weather conditions if relevant. You will find this information helpful if you develop the sketch into a more resolved drawing or painting. You could also use a camera to take a few overall reference shots of the scene.

When you want to progress to a more detailed drawing of a scene, you can transfer your sketch to another support by using a grid of squares or rectangles. Draw the grid directly on to the sketch or draw it on a sheet of acetate and lay that over the sketch. Now draw a grid on the support to which the image is to be transferred. It must be the same shape as the original and be divided into the same number of squares. If you want the new drawing to be larger, make the squares bigger than those in the original. Then copy the drawing, square by square.

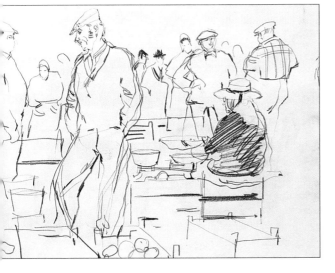

This is one of many drawings that Albany Wiseman made at the market in Lagos in Portugal. He was staying nearby and returned several times to draw. Using both pages of a landscape format sketchbook gave him a broad working area.

USING REFERENCE MATERIAL

This project is based on sketches made on location in Portugal together with a colour photograph taken at the same time. Around the main sketch the artist has made additional studies of figures and background details. He has drawn a grid of nine rectangles over the sketch, so that he can transfer it accurately to the support used for the project.

MARKET SCENE, PORTUGAL

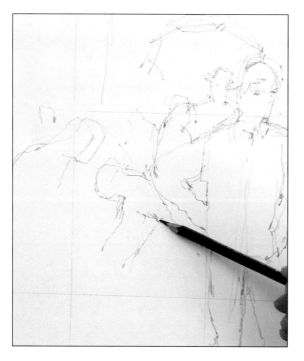

Materials and Equipment

- 300GSM (140LB) HOT PRESSED WATERCOLOUR PAPER
- PENCILS: 4B AND 6B
- WATERCOLOURS: CERULEAN BLUE, VENETIAN RED, RAW SIENNA, FRENCH ULTRAMARINE, ALIZARIN CRIMSON, CADMIUM YELLOW
- SQUIRREL WASH BRUSH

1

Draw a grid of rectangles over the sketch and then draw a similar grid on the paper. Remember that, to avoid distortion, the picture area must have the same proportions as the original sketch. Using a 4B pencil, copy the sketch rectangle by rectangle. Work in a logical way from the foreground to the background or from the centre to the edges. This will make it easier to assess how the image is working as a composition. Work carefully but freely, so that the final drawing captures the energy of the original.

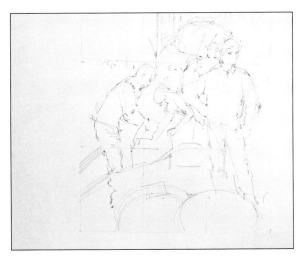

2

Once you've got the main features down, transfer details by eye using the original sketch, the photograph and your memory. Remember that you don't have to follow the original sketch slavishly. You can make additions and other adjustments if these will produce a better picture. Use your imagination or take elements from another sketch or photograph. At this stage, important components of the composition have been established – the bending figure on the left and the standing figure on the right create a broad triangle with its apex in the striped parasol near the top of the image.

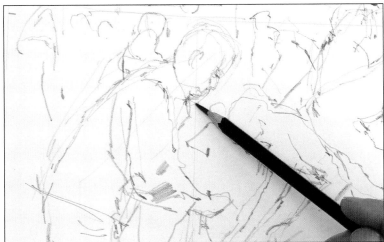

3

Start to suggest the figures in the background, ensuring that they diminish in size as they move away from the foreground. Crowd scenes are potentially confusing, so it is important to have a firm compositional structure and a lucid sense of space and recession. Begin to add detail to the faces and clothing in the foreground to help bring this area into sharper focus and resolve the spatial relationships.

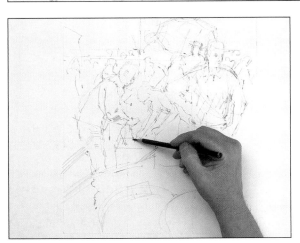

4

Work across the drawing, developing the key figures and the context, thinking all the time about how the image works as a composition. Sketch in the buildings in the background and suggest the diamond pattern on the pullover worn by the standing figure on the right.

5

Using the sketch and the photograph as a guide, start to hatch in areas of tone. Work lightly at first, as you can darken these areas later if necessary. The man seen in silhouette against the backlit parasol is a key focus in the composition, so start by applying tone to this figure. Don't concentrate on just one part of the drawing. The image will be more coherent if you work across the entire surface, developing it as a whole rather than section by section.

6

Use hatched tone to suggest the patterns of light and dark falling across the image. Tone can also be used to suggest the solidity of objects and figures. Shadow applied to the end of the stall-holder's crate gives it three-dimensional form, while a dark tone on his arm suggests its roundness and volume.

7

Work across the drawing, applying areas of mid tone. Stand back and assess progress so far. The drawing is broadly established, but it lacks emphasis and detail. Using a 6B pencil, start to build up the dark tones on the man beneath the parasol, in the shaded areas between figures, on dark hair and in the darkest diamonds on the standing figure's pullover.

8

Develop the faces and clothing as well as the fruit, vegetables and nuts in the foreground. Think of the composition as a series of receding planes and reserve the greatest detail for the areas in the foreground. The standing figure on the right is nearest to the picture plane, so put more detail into the pattern on the pullover and the creases and folds in the jeans. The bending figure on the left is further away and should be described with lighter tones and less detail.

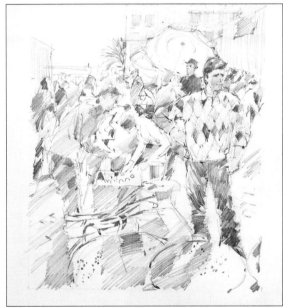

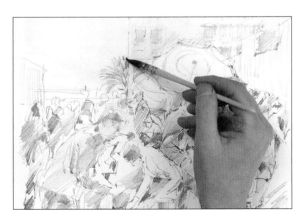

9

The drawing is now complete, so you can begin to enliven it with transparent washes of watercolour. Watercolour adds glowing colour and also fixes the drawing. Using a squirrel wash brush, mix a pale wash of cerulean blue and lay this over the sky area.

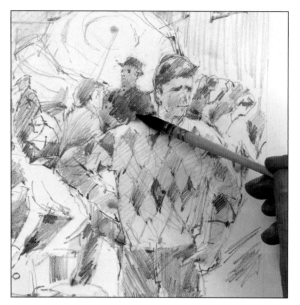

10

Using the same cerulean blue wash, but varying the intensity, lay a cool blue tone over the areas of shade and cast shadow in the drawing. Allow to dry.

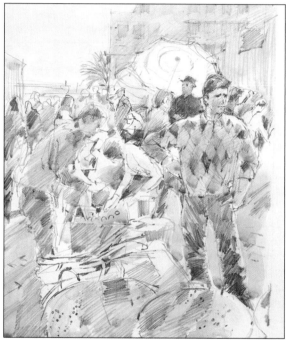

11

Mix Venetian red, cerulean blue and raw sienna to give a warm ochre tone and apply this to the sunlit areas in the drawing. Contrasting warm and cool colours is a powerful way of suggesting light and dark in an image.

12

Mix Venetian red and raw sienna to give a warm flesh tint. Apply this very loosely to the faces and hands of the foreground figures as well as to a few in the background. Use a darker tone of the same colour for the barrels of nuts in the foreground. Mix French ultramarine with alizarin crimson to paint the dark shadows on the jeans of the main figures, adding the same cool colour to the cast shadows throughout the image.

13

The clothes on the main figure on the right are painted in more detail than those on the other figures. The strong diamond pattern on the pullover, in particular, creates foreground interest. Use alizarin crimson for the crimson diamonds, applying the colour loosely.

14

Apply stripes of alizarin crimson to the parasol. This provides a visual link which leads the eye from the figure in the foreground to the parasol in the background. Complete the image by applying touches of cadmium yellow to the standing figure and the parasol, and a mix of French ultramarine and cadmium yellow to the leeks in the foreground. The image is now complete. Although it has been created in the studio from sketches and photographs made on location, it retains the energy and freshness of the original sketch.

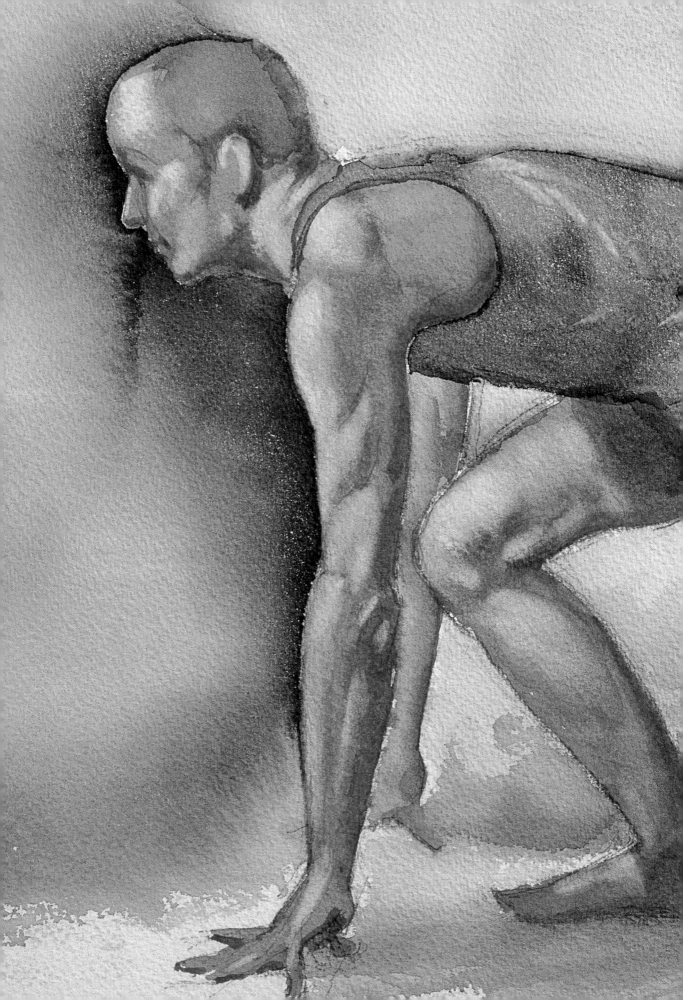

HUMAN
ANATOMY

INTRODUCTION

The human figure has been an important part of world art since the first prehistoric attempts to create images. At the zenith of their cultural and artistic achievements, the Ancient Greeks (7th–5th century BC) made great advances in the depiction of the human form. Sculpture was then the most important medium, and those carvings and bronzes that have survived demonstrate the Greeks' great skill.

Among the works of Pheidias, who lived in the 5th century BC, are the two great sculptures of Athene and Zeus in Olympia. Pheidias's work demonstrates the Greeks' understanding of how the human body worked – and how it should be represented.

We can recognize similar contemporary criteria for the perfect muscular male form also esteemed in Ancient Greece. However, the criteria for the female form has differed throughout history, and is certainly different now compared to when the Greeks created their works of art. The famous *Venus de Milo* – a 1st-century BC Greek statue discovered on the island of Melos in 1820 – shows that the ideal woman of that time was of a fuller build than is idealized in our modern society and is an example of the advanced anatomical knowledge of the Ancient Greeks.

In the Rome of antiquity (750 BC–AD 500), athletes, warriors, soldiers and gladiators were all at the heart of Roman culture and there are many sculptures from Roman times that bear witness to the importance of physical perfection.

The long period between the end of the Roman empire and the start of the Italian Renaissance in Florence in the 14th century produced very little in artistic terms; but by the time the Renaissance was in its stride, the human form was once again at the centre of high art. As always, religion was able to provide a suitable outlet for the depiction of the human form and although the worship of a Christian God was based more on the spiritual than the physical, Christ was in the main portrayed as a well-built man. Indeed, most characters portrayed in Renaissance paintings are shown with rather well-nourished bodies.

It was at this time that there began a more scientific inquiry into the workings of the human body, which extended into the dissection of corpses. Michelangelo (1475–1564), for example, risked a death sentence when he secretly dissected a human body by candle-light, in order to extend his anatomical knowledge. Interfering with dead people

was illegal at that time – even if the purpose was a search for knowledge.

Leonardo da Vinci (1452–1519), the quintessential Renaissance man, made a whole series of anatomical drawings from a flayed figure to further medical knowledge as much as that of art.

During the Italian Renaissance, the study of anatomy assumed great importance. Paintings were full of characters wearing little or no clothing. In the early stages of composition the artist would envisage a variety of poses from his imagination, establish the scene with the relationship of one figure to another and then require the models to enact the scene for the final work.

As studio practice, this continued until the 19th century, but with the start of the Romantic period in the late 18th century, the subject matter for paintings gradually shifted towards nature. The last historical subjects on a grand scale were made during the Neo-classical period (19th century) by painters such as Jacques Louis David (1748–1825) and Jean-Auguste-Dominique Ingres (1780–1867). These were artists who wanted to keep the spirit of the

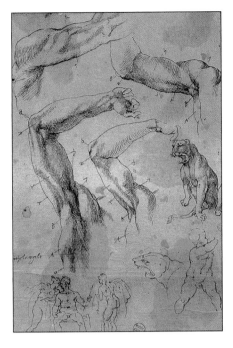

Arms Studies

Michelangelo Buonarroti (1475–1564)

Michelangelo's many anatomical studies gave him an excellent eye for the human form - he even risked a death sentence by carrying out an illegal dissection on a human body.

Renaissance alive and believed that the highest form of art was based upon the figurative image. Perhaps the last great classical painting that used heroic images of anatomically accurate construction was Théodore Géricault's (1791–1824) giant masterpiece *The Raft of the Medusa* [4.9 x 7.2m (16 x 23½ ft)], painted in 1819. Géricault took the quest for realism in anatomy one step further than ever before by making studies of recently executed victims of the guillotine. By the middle of the 19th century the study of anatomy survived as part of a typical art school education. The days when knowledge of anatomy was an intrinsic part of an artist's vocabulary were drawing to a close.

The growth of Modernism in the 20th century saw a revolution in working practices. No longer was it essential to understand the construction of the body. In fact, the appearance of people in a painting might not even be human. However, in the 21st century there are some major artists, such as Lucian Freud (born 1922) and David Hockney (born 1937), who are concerned with the human figure as a central theme.

How the Body Works

Aknowledge of how the body is structured and moves is essential for an artist who wishes to capture accurate depictions of human beings. This chapter provides a basic grounding in essential anatomy.

Although the study of anatomy can assist an artist in painting and drawing from life, it should never become a formula, and the portrayal of an individual should always take precedence. However well an artist might understand human anatomical construction, the way muscles appear on the surface is not always obvious – even in quite muscular people. This is due, in part, to a thin layer of fat called the panniculus adiposus, which is present in even the slenderest person or muscular super-fit athlete. Only in cases of extreme malnutrition and emaciation is this layer not present. Secondly, muscle development differs greatly between individuals, depending upon how they use their body. For instance, the muscle formation of boxers, runners, weightlifters and foot-ballers will all appear quite different on the surface.

Body builders of the type who go in for the 'Mr Universe' competitions are completely different once again. Here, a special programme is followed that deliberately targets specific muscles and consequently can enhance them beyond anything that natural activity or normal exercise can achieve.

We also have to consider the differences between the sexes. Broadly speaking, women have up to 30 per cent more fat than men, which can greatly affect how the muscles appear on the surface. Also, generally speaking,

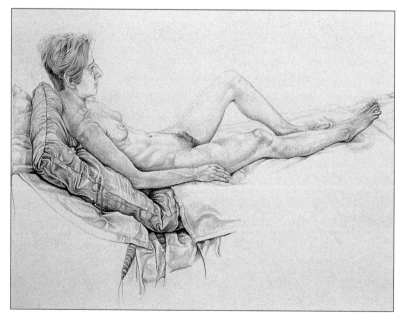

Although we all have the same basic building blocks, individuals differ superficially. To the artist, these differences define the individual.

The Skeleton

The human skeleton is a framework to which the muscles are attached. In all animals, the skeleton is directly related to the type of actions that the creature performs. This has been determined by millions of years of evolution and adaptation to the sorts of tasks that creatures needs to perform in order to survive.

The skeleton also has the important function of protecting vital organs. The skull, for instance, provides a hard, bony case to protect the brain. Likewise, the ribcage protects the lungs. For our purposes as artists, all we need to know about the skeleton is how it moves and which muscles attach to which bones.

Most bones are held together by muscles that are attached by tendons. It is the way in which these muscles link together various bones that defines our movements.

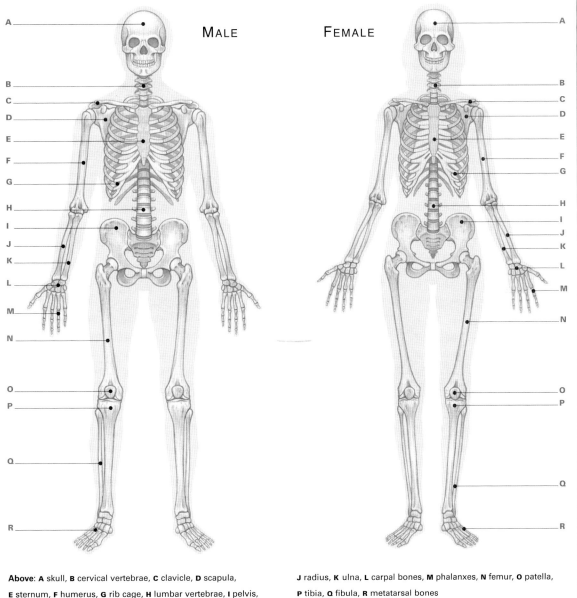

MALE FEMALE

Above: A skull, **B** cervical vertebrae, **C** clavicle, **D** scapula, **E** sternum, **F** humerus, **G** rib cage, **H** lumbar vertebrae, **I** pelvis, **J** radius, **K** ulna, **L** carpal bones, **M** phalanxes, **N** femur, **O** patella, **P** tibia, **Q** fibula, **R** metatarsal bones

women tend not to perform as many manual tasks as men and therefore have less muscular development. However, in the modern world, where stereotypical role-play between the sexes is in decline, it is best to approach all situations with a very open mind.

As a figurative artist, to be able to work with knowledge of the structure of your subject is obviously an advantage and reduces the tendency towards copying or drawing in a way that ends up being over-literal. Understanding the construction of a subject, whether it is a boat or a human being, will always enhance your work.

THE HEAD AND NECK
The muscles of the head and neck can be seen to a large degree on the surface. It varies greatly between individuals,

but muscles such as the zygomaticus major, orbicularis of the mouth, masseter and buccinator, are all instrumental in creating facial expressions. Each of us uses our facial muscles quite differently, and will therefore have a bias towards some muscles being more developed than others. For instance, trumpeters have enormously developed buccinators because of all the blowing they do. People who smile a great deal usually have a prominent zygomaticus.

The most important neck muscle for artists is the sternocleidomastoid. This connects from behind the ear to the collar bone. It is the main anchor of the head to the shoulders via the neck, and can be seen on virtually anyone regardless of the degree of fat they have on their body. Also apparent in certain situations is the platysma.

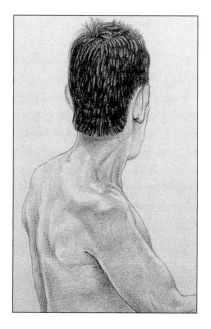

In this image the sternocleidomastoid muscle in the neck is clearly visible. This is one of the defining muscles for the artist.

This is a thin, sheet-like muscle of the neck. Wincing and expressions of terror make this muscle quite pronounced.

At the base of the neck is the trapezius muscle. This connects from the back of the skull to well down the spine. It also forms the principal muscle of the shoulder and has an overall shape similar to a diamond. Weightlifters and boxers can have extremely well-developed trapezius muscles.

The other important muscle of the shoulder is the deltoid. This is a powerful muscle and is

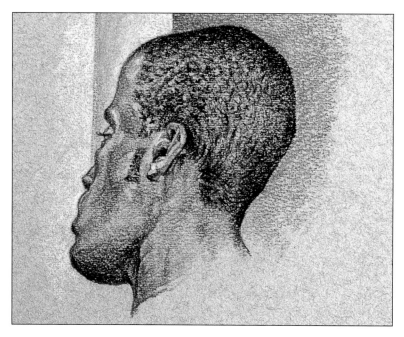

We all use our facial muscles in different ways. This can cause us to develop certain muscles while neglecting others.

The Muscles

In simple terms, all muscles connect from one bone to another so that when those muscles are tensed they can either pull those bones together or push them further apart. For every muscle movement there is another set of muscles to assist in doing the reverse. To make sense of the technical sounding Latin names, it is useful to understand the meaning of the following terms:

Abduction This describes the movement away from the body, e.g., lifting the arm upwards.
Adduction This is the opposite of the above: movement towards the central axis.
Extensor This is a muscle that contracts to straighten or extend a joint.
Flexor This is a muscle that contracts to bring together the two parts it connects.

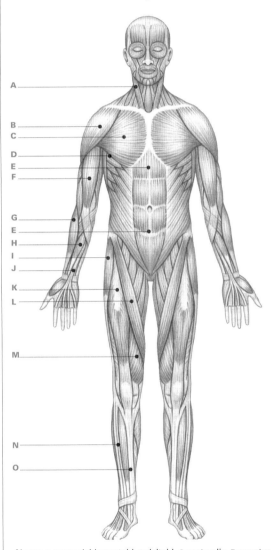

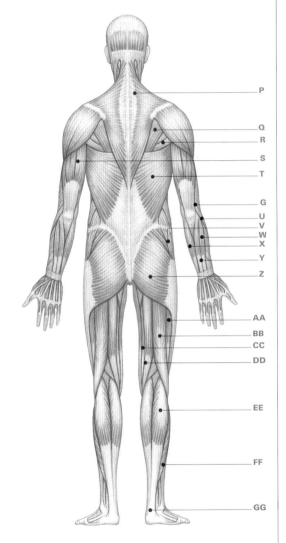

Above: A sternocleidomastoid, **B** deltoid, **C** pectoralis, **D** serratus anterior, **E** rectus abdominis, **F** biceps, **G** brachioradialis, **H** flexor carpi radialis, **I** tensor fascia latae, **J** palaris longus, **K** rectus femoris, **L** sartorius, **M** vastus medialis, **N** peroneus longus, **O** tibialis anterior, **P** trapezius, **Q** infraspinatus, **R** teres major, **S** triceps, **T** latissimus dorsi, **U** extensor carpi radialis longus, **V** gluteus medius, **W** extensor digitorum, **X** flexor carpi ulnaris, **Y** extensor carpi ulnaris, **Z** gluteus maximus, **AA** vastus lateralis, **BB** biceps femoris, **CC** semimembranosus, **DD** semitendinosus, **EE** gastrocnemius, **FF** soleus, **GG** tendon calcaneus

in constant use when the arm moves, as is the great abductor. In fact, most of the muscles of the arm are fairly easy to see on the surface. This is because even in the least sporty or active of individuals the arm is in fairly constant use and consequently the accumulation of surface fat is kept to a minimum.

THE UPPER ARM

As the name implies, the biceps has two heads and is the muscle that is usually associated with power and strength when flexed. The biceps are the flexor of the forearm.

The brachialis is a deep, powerful muscle that lies between the biceps and triceps and is a strong flexor of the elbow. It can usually be seen on the surface as a bump just below the deltoid on the outer side of the upper arm.

Occupying the whole of the back of the arm is the triceps, which, as its name implies, has

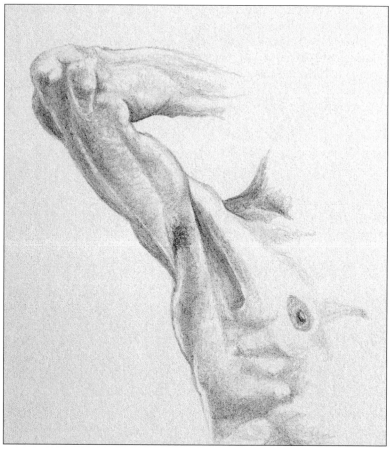

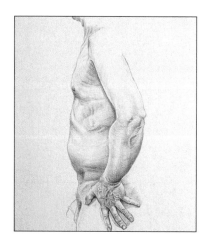

The inside of the forearm contains the finger flexors and the outside flexor for the forearm itself.

three heads. It is the principal extensor of the forearm and can easily be seen on the surface, especially when it strains, for example to lift a heavy object.

THE FOREARM

The muscles of the lower arm are numerous and complex in action. Unlike the upper arm, where the muscles are fewer but longer and perform actions of strength, the lower arm governs the movements of a much finer and more precise nature.

These muscles can be split into two groups: those that arise from the inner side of the

The armpit is formed principally by two muscles, the pectoralis major and the latissimus dorsi. When the arm is raised, these muscles are particularly visible.

humerus and those that arise from the outer side. Those that originate from the outer side are much higher than those arising from the inner, giving the forearm its characteristic curve. You will also notice that as the muscles become tendons at the wrist, the forearm is also slimmer than higher up nearer the elbow, where the fleshy ends originate. All of these tendons

connect to the phalanxes and metacarpals to perform a wide variety of dextrous movements.

THE TRUNK

The muscles of the trunk can also be divided into roughly two types: those that are long and thick, like the erector spinae group, and those that are broad and sheet-like in form, such as latissimus dorsi.

Along with the biceps, the other muscle associated with strength and fitness is a well-defined rectus abdominis. The rectus abdominis is a long, flat muscle extending the whole length of the abdomen. It begins at the pubic crest and inserts into the cartilage of the fifth, sixth and seventh ribs. This muscle is responsible for bending the trunk forwards and is used in sit-up exercises.

At the back, the erector spinae muscles extend the whole length of the spine and fill the groove either side of the spinal column. These muscles connect from the pelvis and sacrum all the way up to the cervical vertebrae. Although not truly superficial, these muscles are important to the artist because their effect can always be seen in the form of a furrow down the centre of the back.

At the top section of the thorax, the erector spinae is covered by the trapezius and below by the latissimus dorsi. The latissimus dorsi muscle is the wide muscle of the back and at its outer edges it forms a thick ridge that can be seen to great effect in many athletes.

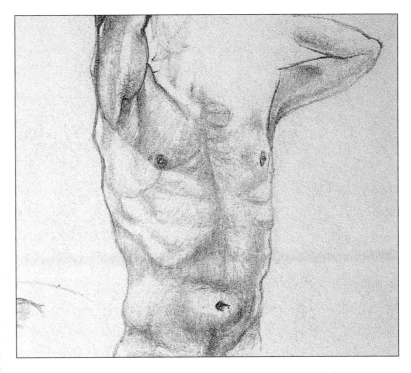

At the front, on the chest lies the pectoral muscle. With the latissimus dorsi, this forms the armpit over either side of the ribcage. On muscular males, the pectoral can achieve very good definition because of the part it plays in moving the arm. Boxers and weightlifters can often develop this muscle so much that the individual fibre strands can be seen. On the female, however, this muscle supports two-thirds of the mammary gland (in the breast) so it figures far less, although it is always evident as an important part of the armpit form.

Beneath the armpit and directly between pectorals and latissimus dorsi is the serratus anterior, otherwise known as the fencer's muscle. The bumps that appear on the surface are

The front of the body is defined by the ribcage, the pectoral muscles and the rectus abdominis, which runs from the chest to the pelvis.

often mistaken for ribs in thin people but when this muscle is developed, as it is in boxers, who are constantly performing lunging movements, there is no mistaking it for the ribcage.

Because of the way the serratus anterior attaches to the ribcage, it produces an interlacing effect with the external oblique. This is a large sheet-like muscle that attaches to the top of the iliac crest of the pelvis and is easily seen on the surface in most males. It is generally less visible in females, however, because at this point on the hips there is usually a greater fatty covering than on males.

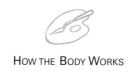
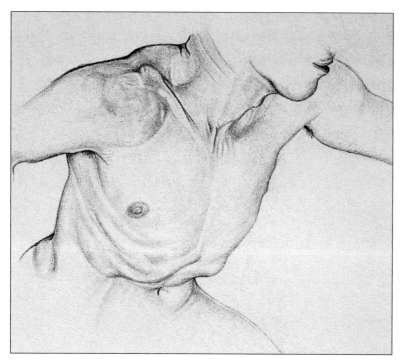

These muscles run the whole length of the femur bone arising from the pelvic area and join in a mass of tendon at the patella, or kneecap. Together with the other muscles, the rectus femoris serves to straighten the knee and flex the thigh.

Between the femur, pelvis and innermost part of the upper leg is a triangular shape filled by a group of muscles known as the adductors. The adductors longus, magnus and brevis together with pectineus perform the same function, which is adducting the thigh. They would be used, for example, when riding a horse to keep the thighs pressed tightly against the saddle and for bringing the leg, which has been lifted away

At the shoulders and upper back, the deltoid and trapezius muscles are most prominent.

To return briefly to the back, it will be noticed that there is a large area in the centre that is formed by a tendon common to several muscles. This gives great strength to this part of the body, and in muscular individuals it is possible to identify separate muscle movements.

THE UPPER LEG

The buttocks and legs contain some of the longest and most powerful muscles of the body, many of which can be seen superficially. The heaviest and strongest muscle in the body is the gluteus maximus, which is the main muscle of the buttock. It is the large extensor of the thigh and is used for rising from a sitting position and leaping, etc. It is usually a larger muscle in the male although, because of the extra accumulation of fat, the superficial appearance of the female buttock is larger than that of the male.

The gluteus medius muscle is a fan-shaped structure that is a strong abductor of the thigh and is used in such actions as standing to attention. The other important muscle in this region is the tensor fascia latae, which joins a long area of tendon known as fascia latae or the ilio tibial band. The tensor fascia latae runs the whole length of the upper leg, tapering at the end to join at the fibula.

The other muscles of the thigh are the rectus femoris, the inner vastus and outer vastus.

The main feature of the back is the furrow surrounding the spine. This is created by the erector spinae muscles.

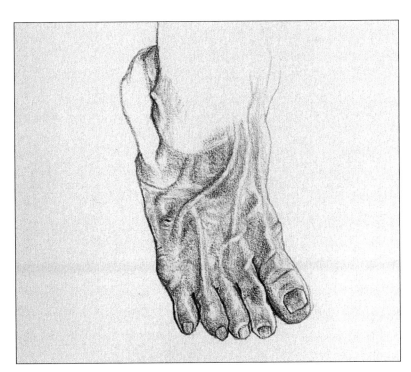

The foot muscles are thin and look like tendons on the surface.

nemius can be seen when it is performing its main job, which is standing on tip-toe. Both these muscles unite at the lower end in the tendon to form the Achilles tendon and attach to the heel bone.

THE FOOT

The muscles of the foot are not very fleshy. They are seen on the surface as tendons that originate from the muscles of the leg as they attach to the phalanxes.

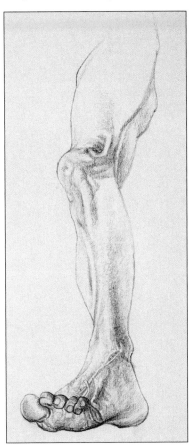

The lower leg is defined by the tibialis anterior at the front and the two heads of the gastrocnemius and their tendons to the rear.

from the body, back again. At the back of the leg, the principal muscles are the biceps femoris, semitendinosus and semimembranosus. These long muscles are the flexors of the knee. When the knee is in a bent position the tendons of these muscles stand out like taut strings. This appearance has earned them the name of hamstrings.

Joining at the same point at the inner side of the knee on the tibia bone are the two last muscles of the upper leg – the sartorius and gracilis. A knowledge of the sartorius muscle is important to artists, because it defines the whole character of the upper leg, as it effectively bisects the whole area.

THE LOWER LEG

There are not very deep muscles in this part of the leg, as the area is mostly occupied by the somewhat sturdy shin bone. At the front, the most easily seen and powerful muscle is the tibialis anterior, which raises the foot towards the leg.

There are two outer muscles in the lower leg, peroneus longus and brevis, which can be seen quite well when performing their function of pointing the sole of the foot outwards.

At the back, in the area known as the calf, there are two muscles, the soleus and gastrocnemius. The soleus is the deeper of the two and runs right underneath the two halves of the gastrocnemius. It can be seen on the inner and outer side of the leg. The two heads of the gastroc-

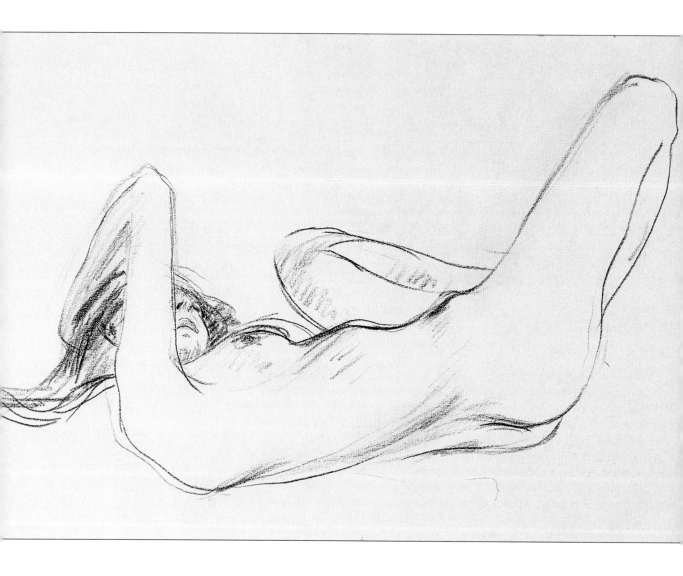

GALLERY

The works shown here demonstrate the degree to which a knowledge of anatomy affects accurate depictions of the human body. From the general proportions of the body to its surface details, anatomical considerations are crucial when drawing or painting the human figure – whatever style you use. The range of styles used here demonstrates that the same knowledge of anatomy does not mean that pictures will end up looking the same. This standard knowledge gives artists the freedom to use their individual styles while still achieving a high degree of anatomical accuracy.

Reclining Nude
Kay Gallwey
30 x 40cm (12 x 16in)

In this stunningly energetic drawing of a reclining woman, the artist has responded to the femininity of the model through the expressive use of line. The hips and raised leg in particular contain a highly sensuous use of linear definition.

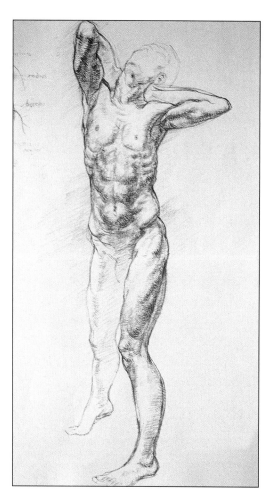

Anatomical Study

James Horton
30 x 20cm (12 x 8in)

This drawing was a deliberate attempt to make an anatomical study. The model was chosen for his well-developed body. The work was a wonderful opportunity to utilize previous knowledge of the geography of the human body in a drawing.

Weights

John Holder
30 x 40cm (12 x 16in)

This drawing demonstrates the relation of biceps and triceps to the lower arm. The tension can be seen quite clearly in the form of parallel bulges running along the arm.

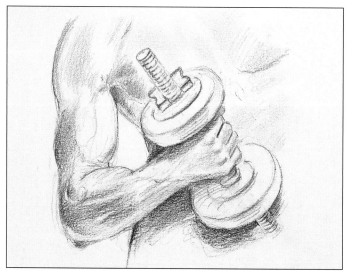

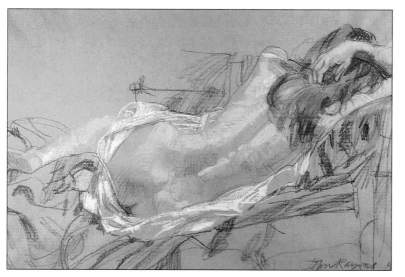

Geraldine

John Raynes
18 x 25cm (7 x 10in)

In this fresh-looking image the artist manages to achieve a balance between free-flowing chalk marks and accurate anatomical representation. This freedom comes with an in-depth knowledge of anatomy, which allows the artist to focus on his art.

Long Thin Man

Paul Bartlett
25 x 17.5cm (10 x 7in)

In this finely detailed, textured drawing in graphite pencil, the artist emphasizes the contours of the body with gentle shading. The bones and surface muscles are prominent in this study, especially on the back. The shoulder blades, spine, erector spinae and latissimus dorsi can all be seen very clearly, while the legs are shrouded in heavy shadow. The fine detail suggests a comprehensive knowledge of anatomy.

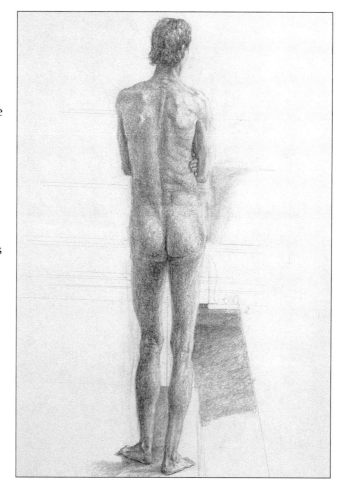

Lynton (seated)

Paul Bartlett
35 x 22cm (14 x 9in)

In this charcoal study the
development of the form
has been taken up to
quite a high and 'polished'
looking level. The
superficial anatomy works
well and there are many
familiar anatomical
landmarks – particularly
in the construction of the
shoulders, chest and thorax.

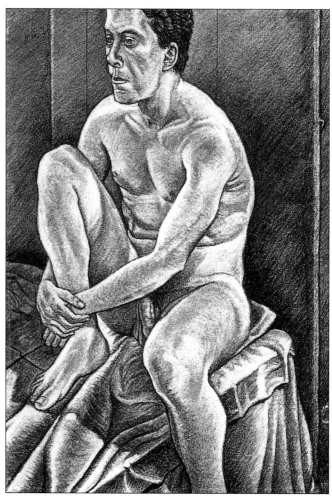

Chest and Arms (seated)

Paul Bartlett
27 x 18cm (11 x 7in)

In this drawing, the folds of
the skin on the chest and
stomach are accentuated
through light pencil strokes
and gentle shading. The
shape of the pectoralis
muscles, ribs and serratus
anterior are suggested
beneath the surface.

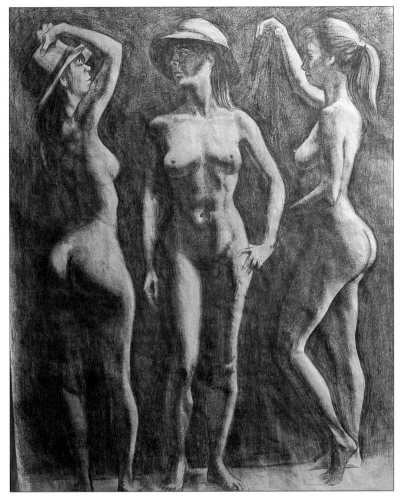

The Three Graces
James Horton
150 x 90cm (60 x 36in)

In this drawing the same model has been used three times. The central figure has excellent definition through the torso. The other figures display the deep curve in the spine typical of the female figure.

Anatomical Study
Byron Howard
28 x 18cm (11 x 7in)

In this pencil sketch the artist shows a detailed knowledge of the anatomy of the male back muscles, which are exposed on the left side. By contrast, the muscle structure provides a framework for the right side of the back, which focuses on the latissimus dorsi.

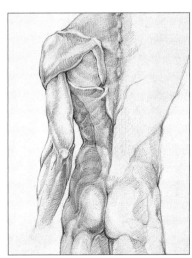

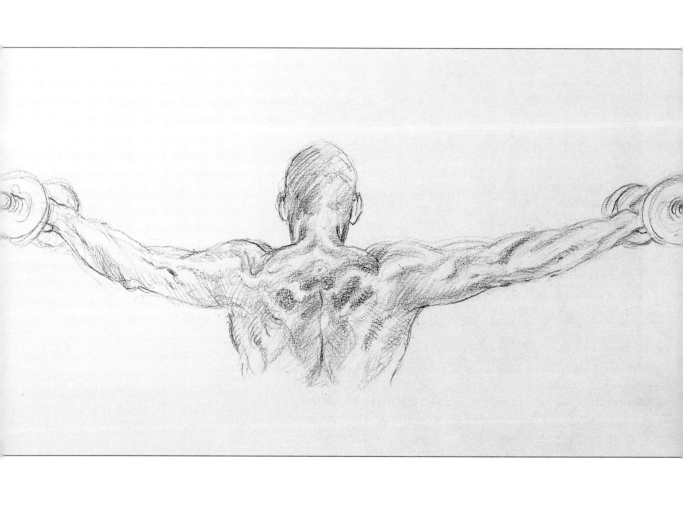

ARMS

The arms are often central to a work of art containing human figures. They are highly expressive in their own right and can be used to convey the mood, intention or inner state of a figure. They can also be used to express abstract subjects such as strength, weakness, anger, passion and so on.

In this project the artist, John Holder, has chosen a pose in which many of the muscles of the arms are visible. Also visible are the muscles of the shoulder, neck and upper back – all of which interact with the arms. John has used pencil for this study, demonstrating how accurate figure drawing can be achieved with a basic two-tone effect.

This project emphasizes how the limbs work using a complex system of muscles and tendons. It also shows how the state of tension and the position of the limb make a huge difference to its general appearance.

John Holder
Weights Study
29 x 42cm (11½ x 17in)
Graphite Pencil

Arms Tensed

The muscle that is enabling the subject to raise his arms is the deltoid, which is the main elevator of the humerus. However, to raise the arm above the horizontal requires the added cooperation of other muscles, namely the serratus anterior under the arms and the trapezius between the arms in the back. The latter can be seen quite well defined in this subject.

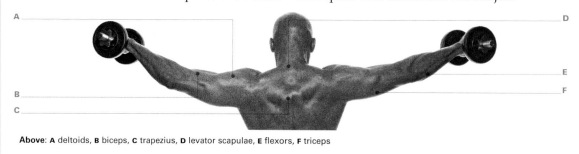

Above: A deltoids, **B** biceps, **C** trapezius, **D** levator scapulae, **E** flexors, **F** triceps

WEIGHTS STUDY

1.

Using a graphite pencil, roughly sketch the general proportions and shapes of the figure, using light strokes from the side of the pencil. To create a freer feel to the marks, hold the pencil further up so that it sits more lightly in the hand.

Materials and Equipment

• PHOTOGRAPH OF OUTSTRETCHED ARMS

• GRAPHITE PENCIL 4B •

SKETCH BOOK • ERASER

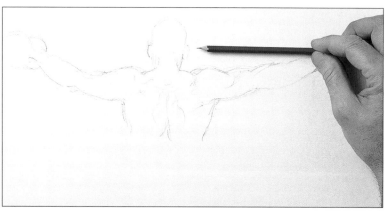

2.

Use your pencil to approximately measure the horizontals – both arms should be of equal length and proportion. The head of the figure and the weights should be more loosely drawn, in order to give greater emphasis to the arms and back. The weights should only be outlined, without shading.

3.

Before proceeding further, check the proportions of the figure. Use heavier strokes to strengthen the outlines and make the figure more clearly defined. Bring to life the features of the back, arms and shoulders with light shading using the side of the pencil.

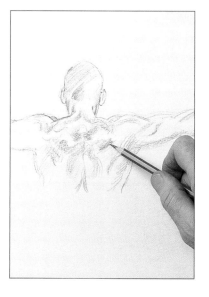

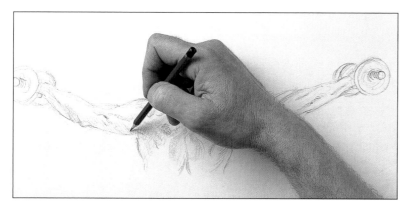

4

The lines of the arms should not be be straight and should be loosely drawn: a series of connecting lines rather than a single line will give more fluidity. Single lines along the bottom of the left arm create the appearance of downward movement.

5

Flowing lines along the right arm create a horizontal movement that emphasizes the outstretched pose. Build up the form using the side of the pencil. Increase the shading in areas of the arms to highlight the muscle tone. Darkening will emphasize the light areas and give greater depth and tone.

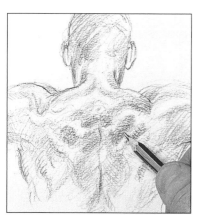

6

Increase the shading on the back so that the white areas establish the highlights of the well-sculptured muscles. Use the pencil like a brush, stroking the side along the paper. Increase the weight to increase the colour and contrast. Soften some of the shading with your finger to give a more natural look.

7

Use an eraser to pick out occasional highlights on the knuckles and back. Follow the curve of the muscles with your pencil to give the image a more fluid look. To finish off, darken the overall outline of the drawing to provide greater definition.

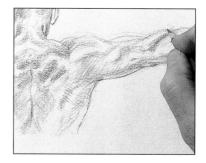

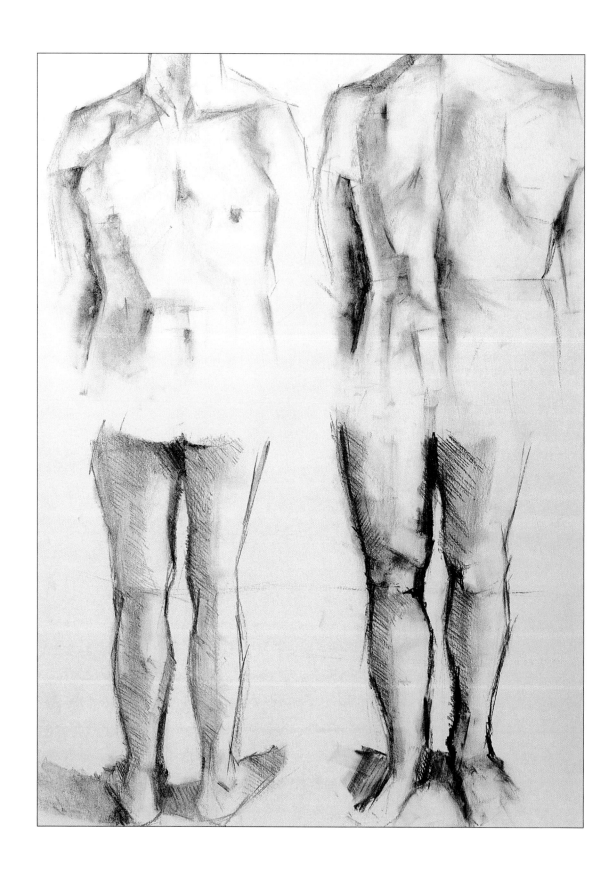

Project

2

TORSO AND LEGS

In this project, the figure is standing, but there is no specific tension or stretching taking place. Therefore the muscles are relaxed and the lines of the figure gentle. The side lighting helps to accentuate surface details of the figure.

One of the key elements to get right in this project is the proportions of the limbs and the torso. The human body is basically a symmetrical object, so make sure that each side of the torso and the two legs mirror each other.

Barry Freeman
Male Study
75 x 56cm (29½ x 22in)
Charcoal

Drawing Torso and Legs

On either side of the sternum are the pectoral muscles, which can cause quite a furrow. Attaching the ribcage to the pelvis is the long and powerful rectus abdominis, well defined in this picture and also known as the 'six pack'. The external oblique always appears as a slight bump just above the iliac crest of the pelvis.

The whole character of the centre of the back is defined by the furrow caused by the erector spinae group of muscles. These attach along the whole length of the spine from the cervical vertabrae to the pelvis. At the top the trapezius lessens the furrow effect as it swathes the erector spinae along with the other numerous muscles of the shoulder and neck region.

The upper leg contains the most powerful muscles in the body. These are all long and thick, with the exception of the vastus lateralis, which is narrower. At the front the diagonal quality of the sartorius is always noticeable.

The contour of the lower leg is defined almost entirely by the gastrocnemius muscle, which has two halves, the inner and outer. These connect with the soleus at the lower end.

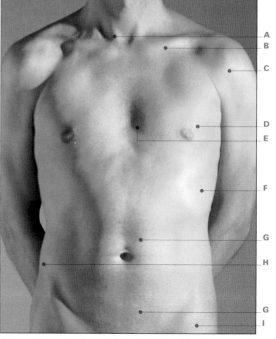

Above: A sternocleidomastoid, **B** clavicle, **C** deltoid, **D** pectoralis major, **E** sternum, **F** serratus anterior, **G** rectus abdominis, **H** external oblique, **I** tensor fascia latae

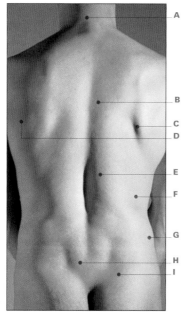

Above: A 7th cervical vertebrae, **B** trapezius, **C** scapula, **D** teres major, **E** erector spinae, **F** lattisimus dorsi, **G** external oblique, **H** aponeurosis of lattisimus dorsi, **I** gluteus medius

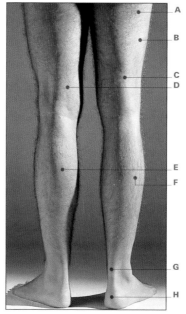

Above: A fascia latae, **B** vastus lateralis, **C** biceps femoris, **D** tendon of semimembranosus, semitendinosus and sartorius, **E** gastrocnemius, **F** soleus, **G** tendon calcaneus, **H** calcaneus

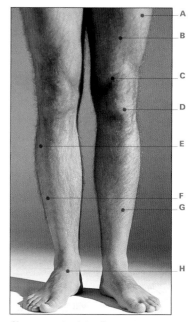

Above: A vastus lateralis, **B** rectus femoris, **C** vastus medialis, **D** patella, **E** gastrocnemius, **F** peroneus longus, **G** tibialis anterior, **H** extensor digitorum longus

MALE STUDY

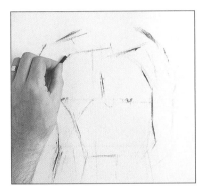

1.

Lightly sketch in the most obvious shapes and lines of the model. At this stage, concentrate on the proportions, marking the nipples, navel and the tops of the shoulders. These are your anchor marks.

Materials and Equipment

• CHARCOAL STICK • MEDIUM

CARTRIDGE PAPER

• ERASER • FIXATIVE SPRAY

2.

Use the point of the charcoal to strengthen the outline and build up shadow on the arm. This will highlight the torso. Criss-cross the chest with charcoal and blend it in with your finger to give soft shadow.

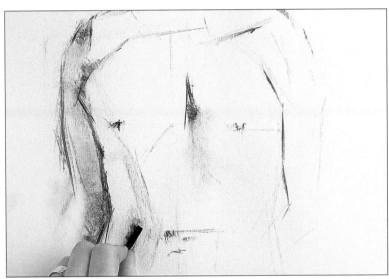

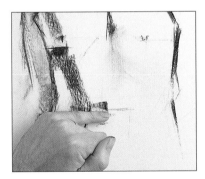

3.

Check which muscles are most evident. Use bold, confident strokes and vary between the edge and point of the charcoal. Make one thick long stroke following the shape of the muscle down to the abdomen and smudge it in with your finger.

4.

Use light strokes on the right, where there is less definition and shadow. Blend the left side, especially around the neck and the upper shoulder.

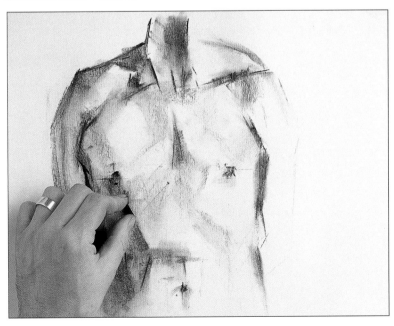

5. ▶

Increase shading on the arm, then blend in the charcoal. Add some very precise lines down the side of the body. Strong dark lines on one side of the body and lightness on the other shows how the light is falling on the torso. Draw light lines to show the ribs, then add shading in between. Rework the abdominal area to bring out more definition.

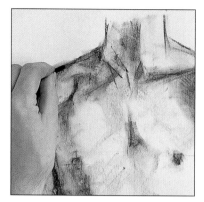

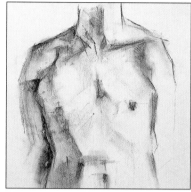

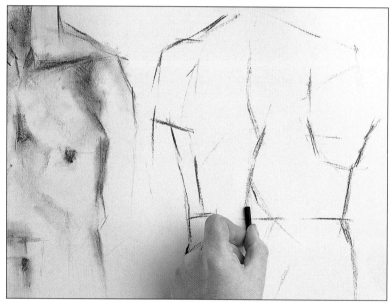

6. ▲

Deepen the centre line of the sternum between the pectorals. Suggest the nipples and belly button with shading rather than specific detail.

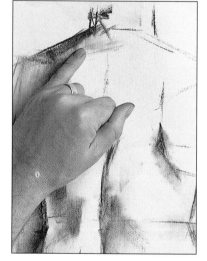

7. ▲

Now move on to the study of the back. Using the previous picture as a guide for proportions, use a long piece of charcoal and lightly sketch in the basic shape – shoulders, spine, arms and shoulder blades.

8. ▶

Use the side of the charcoal to block in the top of the shoulder and shade down the side of the body. Using bold strokes, draw in thick lines to show the main shadows on the back.

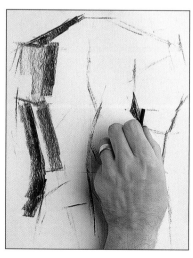

9. ▲

Shade in around the spine. Protect the drawing with a sheet of paper if you need to lean on it – otherwise it will smudge. Blend in the strong lines at the tops of the shoulders to shape the curve.

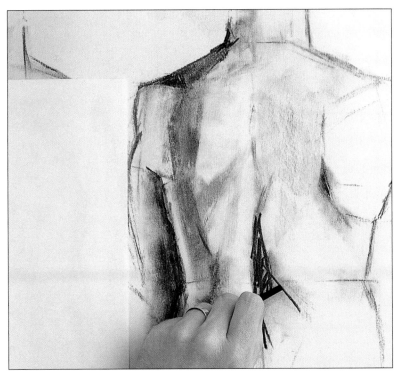

10.

Build in light shades, alternating between short and longer charcoal as appropriate, and leaving the lightest areas as clean paper to show highlights. Notice the soft texture on the back where there are fewer muscles and there is less definition. Shade in the dark shadows of the arms with very dark lines. Draw even darker lines to show the central spine.

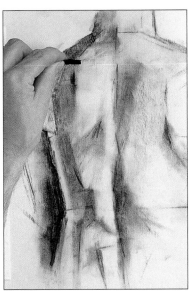

13.

Now draw the backs of the legs. Measure the proportions carefully. Draw a light guideline across to help with the proportions, plus a line down the centre of the calf. After you've sketched one leg, extend the guideline across and sketch in the second leg, using the scale of the first leg to help you. Using the side edge of the charcoal, strengthen lines once the shape is basically correct. Notice the squarish shape of the feet and prominent ankle bone.

11.

Build up shapes and shadows. Notice the definition between the shoulder blades and the softening of the flesh around it.

12.

Check the whole image for areas that could be defined more clearly. Be sure to leave lots of white space for the highlight areas.

14.

Block in the shaded area with the thick side of the charcoal. Use very dark shading on the inner legs, lighter on the outer legs. There is also dark shading on the inner ankles and on the floor between the feet to give the picture a base. Now sketch in lines around the foot and give the toes some darker shading.

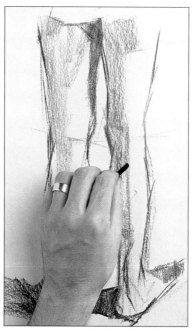

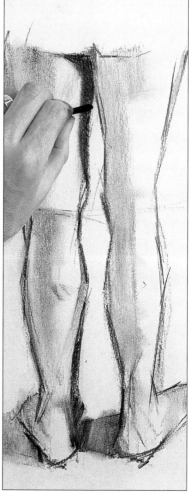

15.

Gently blend in the shading to bring the picture to life. Leave areas of paper white for the highlights. Sketch in the inner edge of the left leg. Notice how the shadow creates the edge. Notice also the angular shape of the ankle bone.

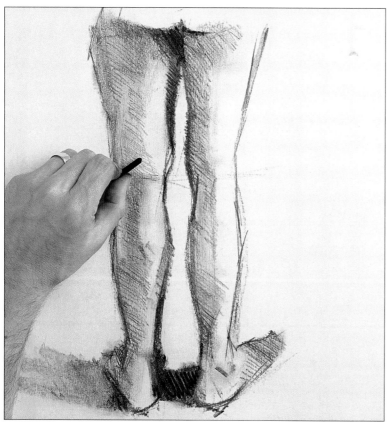

16.

Add final details and build up layers of shadow, using the side of the charcoal to create the dark shading.

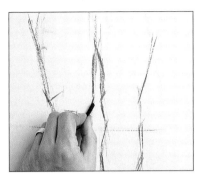

17.

Now draw the front of the legs. Draw a light line across the knees, strengthening it once you feel sure of the proportions.

18.

Now start to sketch in the shadows, using strong lines to show the dark areas between the legs. Draw strong lines around the knee to show the muscle. Use smooth, long strokes to sketch in the lighter areas of shadow. Block in the shadows on the feet to anchor the picture.

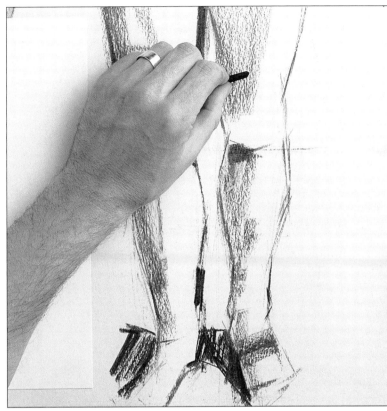

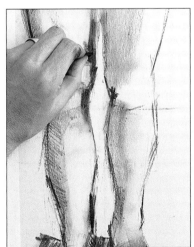

19.

Gently blend in the shading. Vary the direction of the blending so that it doesn't look uniform. Leave clear areas of white for highlights.

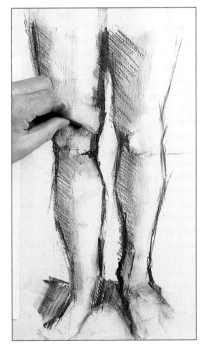

20.

Add the linear shading, following the shape of the shadows. Apply dark shading between the legs. Draw in the shadow around the feet to create a suggestion of weight. Add a few sharper lines across the knee, then blend them in. Finally, spray the picture with fixative.

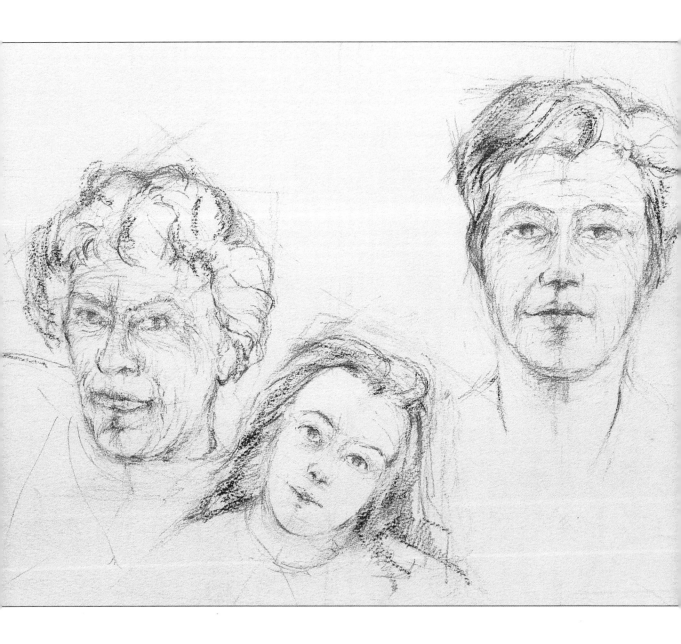

HEADS

This project takes three generations of the same family as its subject. The use of a single colour heightens the comparative effect of the work. The fact that the subjects are all part of the same family allows the artist to focus on the changes caused by the ageing process. These include deep anatomical changes as well as the more obvious surface ones. A knowledge of the anatomical changes that take place over the years of a person's life enables an artist to know what to expect and therefore to capture the features that convey age. A comparative study serves to highlight these features.

Charmian Edgerton
Three Generations
30 x 40cm (12 x 16in)
Red Chalk

Anatomy and Age

The ageing process dramatically affects the outer appearance of the human body. It starts to be noticeable in middle age, causing a number of physiological changes. However, of most relevance to the artist are the weakening of the muscles and loss of elasticity in the skin. This causes features such as the skin to wrinkle and the skin under the eyes to sag.

There are also other changes that occur to the human body with age. In comparing the three heads in this project we notice not only the changes in the outer appearance of the face, but also changes in the shape of the skull itself. When we are born, our skulls are much larger in proportion to the rest of our bodies than when we reach adulthood. This is due to the fact that our brains grow faster than our bodies at this early stage. Human beings are unique in the animal world for the amount of development of the brain and the skull that occurs after birth. A newborn baby has large areas of soft cartilage in place of bone in the calvaria (the domelike part of the skull). As we grow, bone develops over these areas. We start life with bulges on either side of the forehead (the frontal eminences) and on both sides of the calvaria (the parietal eminences). However, the facial areas are much smaller in proportion to the skull as whole. This ratio is what gives babies and children their distinctive features.

THREE GENERATIONS

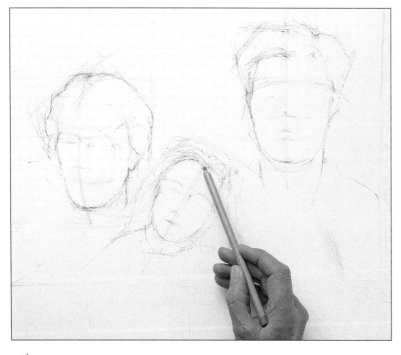

Materials and Equipment

- RED CHALK PENCIL

- HEAVY CARTRIDGE PAPER

1.

First, mark out your paper. Draw a light rectangle, divided down the middle and then cross it off into 16 squares. Make some marker points for the top and bottom of the heads and then draw in some basic egg shapes. Outline the hair and mark in the positions of the facial features.

2. ▶

Look at how the light defines the nose, the brow, the chin, etc. Draw in the basic forms, thinking about the underlying bone structure. Don't draw in the eyes at this stage.

3.

Mark in the dominant eyebrows of the grandmother. Also emphasize the top of the cheekbones.

4.

Mark in the grandmother's eyes. Now move on to the child. Her features are softer and less defined, so use gentler touches.

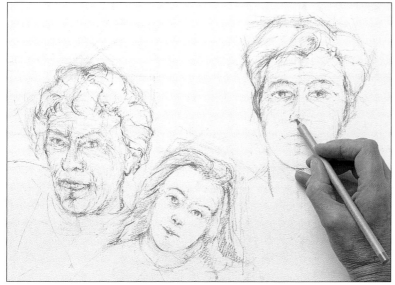

5.

The mother's features have become defined by age, but the flesh has not receded as the grandmother's has. There are more lines to draw than on the child's face, so sketch these in gently first before defining them.

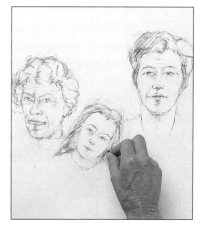

6.

Now that all the basic forms are in place, go over each face defining the detail. The child's face should be fairly free of marks, the mother's slightly more detailed and the grandmother's the most interesting. Pay particular attention to the eyes of the mother and grandmother. Age makes the eyes particularly expressive, as the muscles weaken and the surface flesh droops.

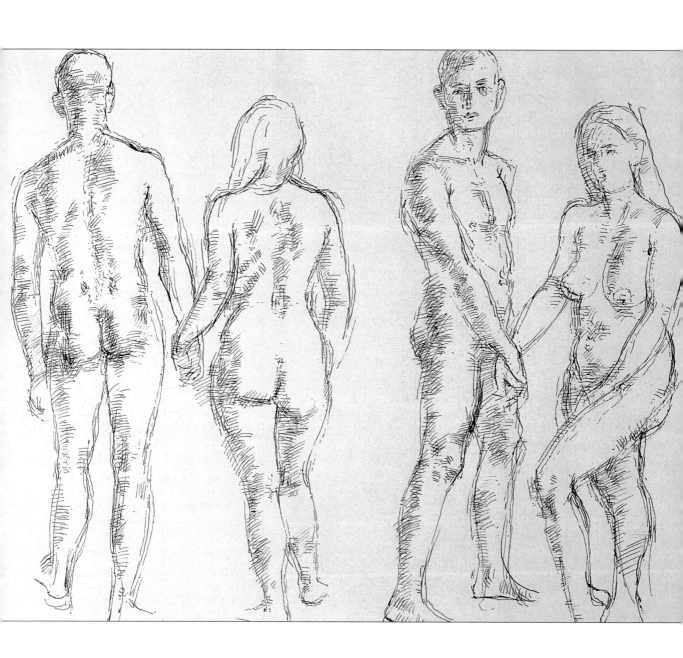

MALE AND FEMALE

This pen and ink project focuses on the visible anatomical differences between the male and female form from both the front and rear views. Although the figures are heavily cast in shadow, light and tone should not be emphasized in this composition, as they are likely to distract attention from the differences in form and anatomy. Both views subtly stress this difference: the man stands straight and static in both photographs, while the woman takes a more active pose, as well as reaching out towards the man to hold his hand.

James Horton
Comparative Study
32 x 48cm (13 x 19in)
Brown Ink

Comparing Male and Female

In this picture we see the most typical differences in superficial anatomy between the sexes. In addition to the height difference between the two figures the most noticeable differences in the overall body shape are the shoulder to hip ratio and length of back to legs ratio.

Notice the steeper angle of the trapezius in the male, as this is generally a more powerful and well-developed muscle. Also the muscles of the hips and pelvis are much more tightly defined compared to the larger equivalent on the female. In these two subjects the gluteus muscles would be much larger in the male, but superficially the female's buttocks are much larger due to the accumulation of fat. It is interesting to note that the contours of the legs are very similar, due to the minimal amount of fat. In this standing pose the muscles are relaxed and there are no specific regions of stress. The spine and pelvis are the principal supporting structures in this position, and the line formed by the erector spinae dominates the back.

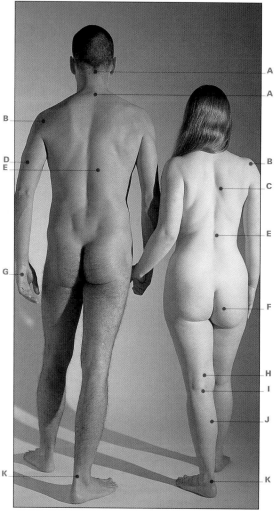

Above: A trapezius, **B** deltoid, **C** scapula, **D** triceps brachii, **E** erector spinae, **F** gluteus maximus, **G** ulna, **H** biceps femoris, **I** common tendon of sartorius, gracilis, semimembranosus and semitendinosus, **J** gastrocnemius, **K** tendon calcaneus

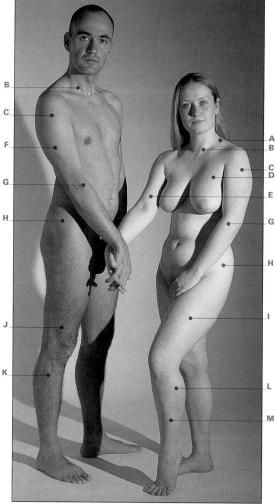

Above: A trapezius, **B** sternocleidomastoid, **C** deltoid, **D** pectoralis major, **E** biceps brachii, **F** brachialis, **G** extensor carpi radialis longus, **H** gluteus medius, **I** vastus lateralis, **J** biceps femoris, **K** peroneus longus, **L** gastrocnemius (outer head), **M** tibialis anterior

COMPARATIVE STUDY

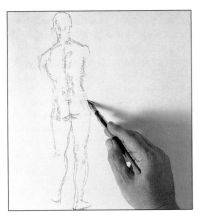

1.◄

Using an old-fashioned drawing nib and brown ink, sketch out the tallest figure first. You need to outline the tallest figure before looking at the relationship between them. The linking place should be sketched first. This provides a central reference point for the whole composition. Sketch in the outline and muscle tone at the same time, beginning with light strokes.

Materials and Equipment

• BROWN INK • OLD-FASHIONED DRAWING NIB • CALLIGRAPHER'S DIP PEN • HEAVY CARTRIDGE PAPER • PENCIL

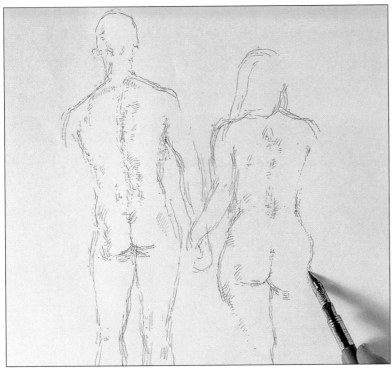

2.◄

Once you have lightly outlined the proportions of the man, work out the proportions of the female. Note the angles of the bodies and plot key landmarks: the curvature of the spine and buttocks, the position of the legs. The woman should have less muscle construction and more fat: do not be tempted to add too much definition to her shape, or you will lose this softness.

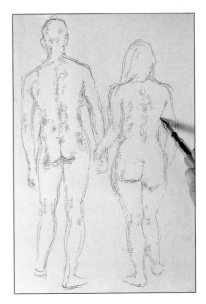

3.►

Strengthen the shape of the composition by re-evaluating the relationships between the different parts of each body and between the two figures. Tracing down the backs and legs will emphasize the natural curve of each body.

119

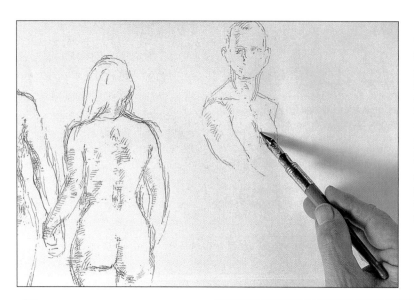

4.

Use the first illustration as a reference point when beginning the front view. Avoid starting too low down, as the two sets of figures need to be in proportion to each other. Start with the tallest figure, sketching out the form lightly, and then building up a series of layers. The facial features are important for the front view: begin by outlining their basic proportions rather than the details, since a simple outline creates a stronger impact.

5.

To sketch the female figure, again begin where the hands link. Look across to get the proportions correct: for example, the man's navel lines up roughly with the woman's left nipple.

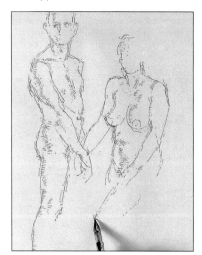

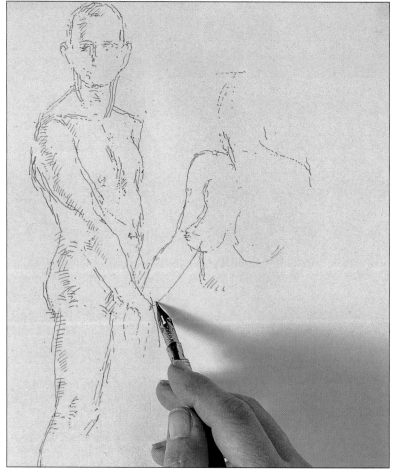

6.

Use the straight edge of a pencil to establish the position of the woman's knee: it lines up vertically with the edge of her right hand, and horizontally with the man's knee.

7.

Great care should be taken when drawing the legs and knees because of the 'negative', undefined space between the two figures. If this space is disproportionately large or small, the figures will not look natural. To avoid problems, do not develop one body area too far ahead of another, but build up the features gradually together.

8.

Once the outlines are complete, pick out the detail and increase the definitions. Make sure the two sets of figures match in tone and style: observe the thickness of the lines and work out which features have been emphasized.

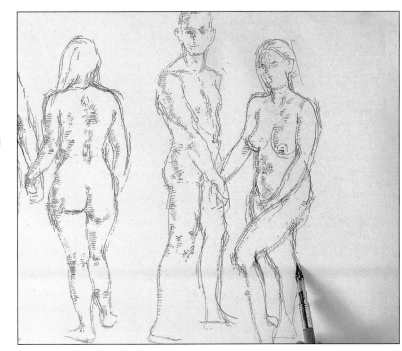

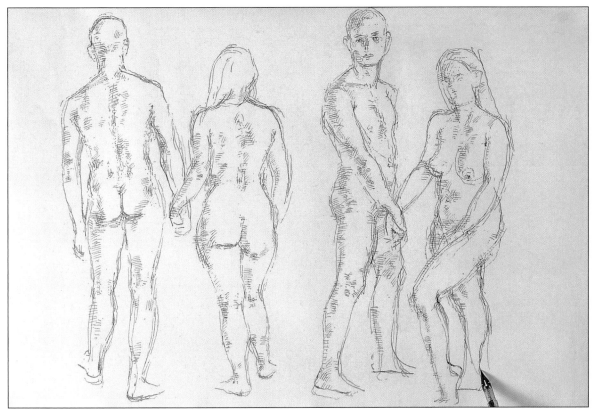

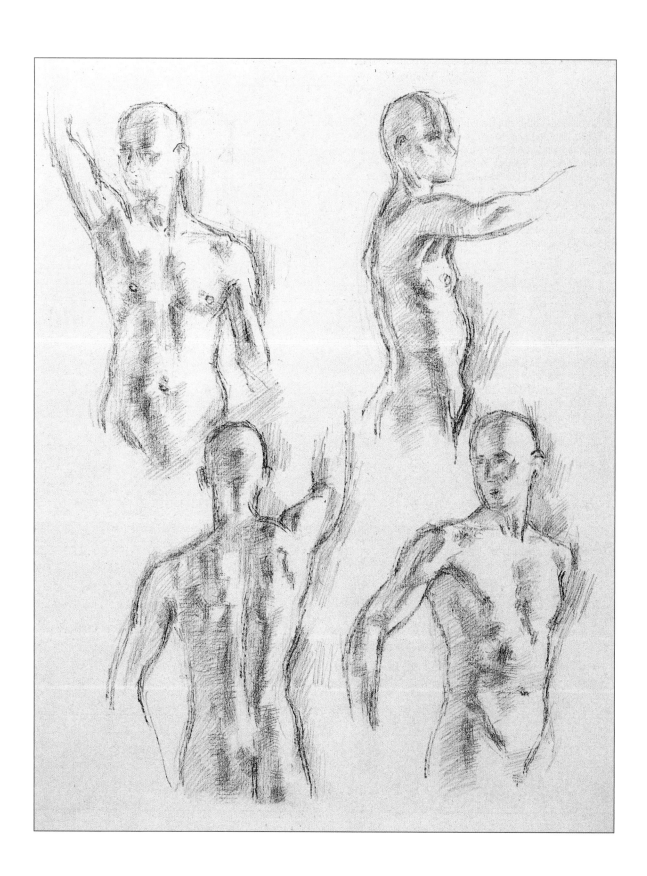

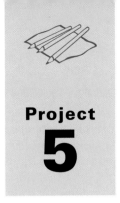

MALE TORSO

In this carefully observed study the artist provides a simple but comprehensive image of the male torso with a series of pencil sketches from front, rear, side and twisted positions. The four views allow the artist to explore the various surface muscles on the chest, shoulders, neck and back simultaneously through using lines and shading built up with a combination of lighter and darker strokes. Generally, the style of shading is loose to suggest the outline of the form and convey a sense of movement. The four illustrations should be viewed as a single composition, and as such, they should be of a proportionate scale and highlight the same parts of the male anatomy.

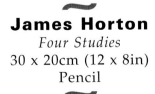

James Horton
Four Studies
30 x 20cm (12 x 8in)
Pencil

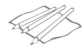

Upper Body Muscles

In order to keep the arm raised, the latissimus dorsi must be extended. With the head turned to one side, the sternocleidomastoid muscle in the neck becomes very prominent – this is especially noticeable on the first and last photographs. A deep furrow is formed on the front of the body, caused by the sternum (breast bone) and the rectus abdominis muscles (stomach). On the rear view, an even deeper furrow down the spine is created by the powerful erector spinae muscles. The pectoralis muscles, by contrast, appear as flatter expanses of flesh.

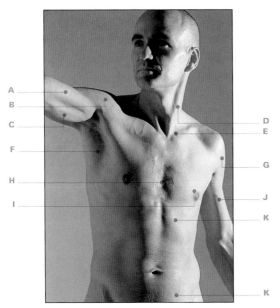

Above: **A** biceps, **B** deltoid, **C** triceps, **D** sternocleidomastoid, **E** clavicle, **F** latissimus dorsi, **G** deltoid, **H** sternum, **I** pectoralis, **J** biceps, **K** rectus abdominis

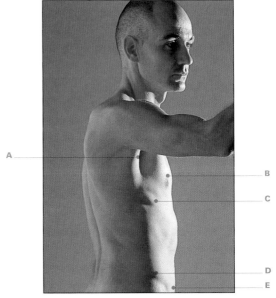

Above: **A** latissimus dorsi, **B** pectoralis, **C** serratus anterior, **D** external oblique, **E** rectus abdominis

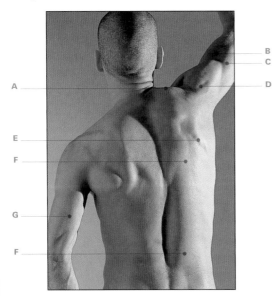

Above: **A** trapezius, **B** biceps, **C** brachialis, **D** deltoid, **E** scapula – showing rotation over ribcage, **F** erector spinae, **G** triceps

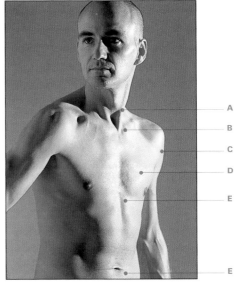

Above: **A** sternocleidomastoid, **B** clavicle, **C** deltoid, **D** pectoralis, **E** rectus abdominis

FOUR STUDIES

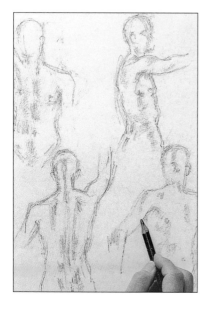

1.

First, roughly position each pose on the page. Lightly sketch in the top left pose first – start from the head and work down the body. Once you have sketched in the first figure, check the scale to see if all four figures will fit. Take your time, as even experienced artists have difficulty calculating the correct scale. You can also overlap the images as a way of linking them together.

Materials and Equipment

- BLACK BEAUTY PENCIL
- ZERKHAL INGRES PAPER

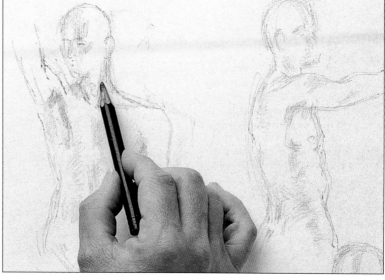

2.

Sketch in the figures with a series of light, short strokes that overlap – this will create a soft, natural outline. Let your intuition and the shape of the muscles guide you with the shading, which can be vertical, horizontal and cross-hatched. Work in the detail of the sternocleidomastoid, the main muscle connecting the collar bone and the back of the head.

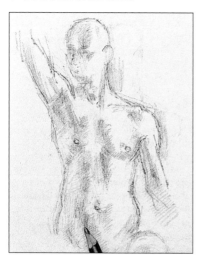
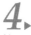

3.

Deepen the shading to show the join between the pectoralis major (the largest chest muscle) and the anterior deltoid (shoulder) muscle. Outline the rectus abdominis, which links the ribcage to the pelvis.

4.

Now move on to the third figure. Begin by shading the back of the head to show the roundness. There are several layers of muscle on the back, some of which appear as surface features. You can begin to shade in the trapezius.

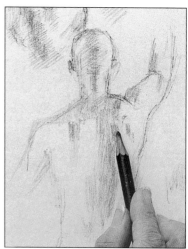

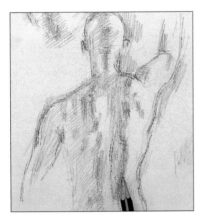

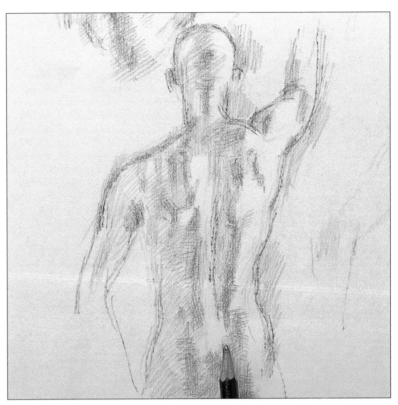

5.

Using vertical shading, emphasize the ridges of the erector spinae down each side of the spine, all the way from the pelvis to the neck. Many of the other back muscles are sheet-like and should be highlighted with shading. Light, diagonal strokes along the outside of the body will suggest the shape of the latissimus dorsi, while a heavier line under the arms will emphasize the teres major.

6.

Add the final detail, deepening the shading. Sketch a very light line down the centre of the back to bring out the posterior median furrow. Leave areas of the paper untouched to emphasize the areas of light. You can also sketch in the beginnings of the gluteus medius (buttocks).

7.

Now move on to the third picture. First define the head (note that it is turned slightly to the right). This side-on pose shows the construction of the armpit, which is formed by the angle of the latissimus dorsi and the pectoralis major.

8.

Down the side of the body there is quite a dramatic contrast. Using some heavy strokes, define the serratus anterior muscles, which are the most heavily shaded part of the abdominal muscles. Lightly shade the shoulder and latissimus dorsi to provide definition. Also, a little background shading will help emphasize the body line.

MALE TORSO

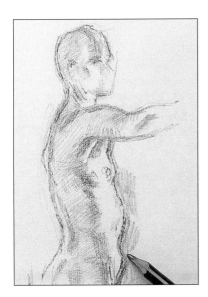

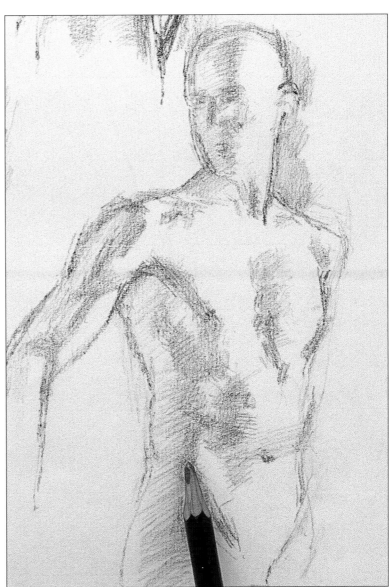

9.

Using light strokes, increase the shading down the back to show the definition between the front and back. Sketch in the buttocks, to link in with the second picture and bring the composition as a whole together.

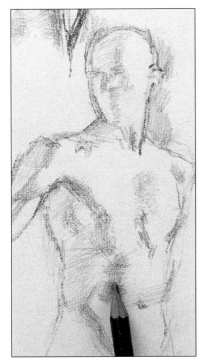

10.

Sketch in the head, using a clear line to mark the sternocleidomastoid and to demonstrate that the head is turned. Shade along the top of the arm to give good definition to the biceps. Lightly shade in the edge of the pectoralis major, cross-hatch the serratus anterior, and very lightly shade the outer edge of the body to show the latissimus dorsi.

11.

Darken around the rectus abdominis – vary the angle of the shading to emphasize the different muscles in this group. Shade in the head, suggesting the features rather than drawing in detail. Shade in the line showing the external obliques along the front of the pelvis. Remember that loose shading adds a sense of movement to the composition.

127

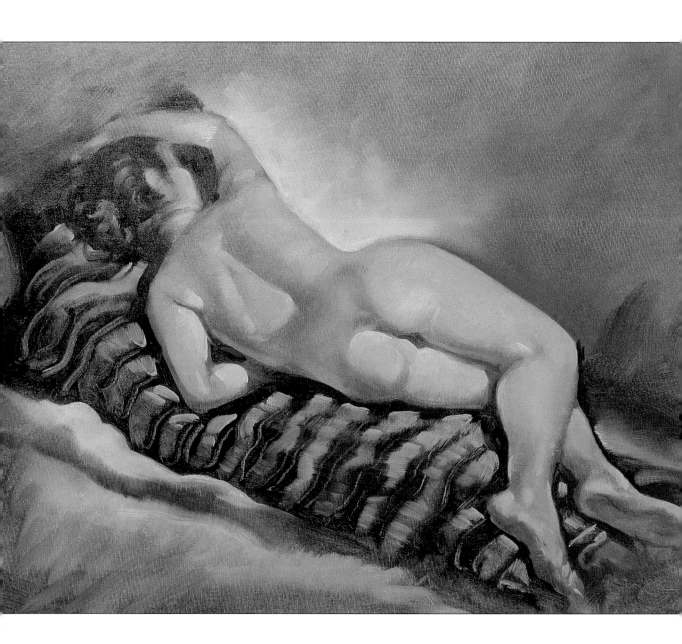

FEMALE RECLINING

In this carefully observed painting the artist makes great use of light and shadow to pick out the surface anatomical details of the subject. This also adds a pleasing variation of tone to the flesh. In this position the weight is distributed along the body and the muscles are in a relaxed state. This results in much smoother forms and lines. The dark background and foreground help to highlight the figure.

John Barber
Nude Study
30 x 40cm (12 x 16in)
Oil Paint

Relaxed Pose

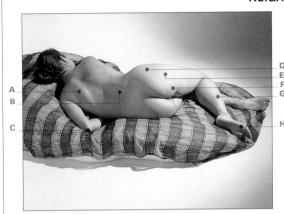

In this position, the pelvis is at a right angle to the horizontal. The thorax, however, sinks back into the mattress leaving the pelvis standing proud. This accentuates the angle from hip to ribcage. Because the arm is pushed under the thorax, the shoulders tilt at a different angle to the pelvis. This means that at the start of the thoracic vertebrae the spine begins to not only move upwards but also forwards.

Left: **A** scapula, **B** start of thoracic vertebrae, **C** ulna, **D** crest of pelvis, **E** tensor fascia latae, **F** gluteus maximus, **G** gastrocnemius, **H** abductor digiti minimi

NUDE STUDY

1.

Prepare the canvas with a thin coat of raw umber. Use a round number 3 hog brush to mark in the basic shape of the figure in raw umber. Use the paint fairly thin; the painting medium is turpentine and linseed oil.

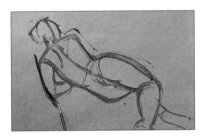

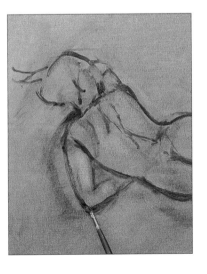

Materials and Equipment

• CANVAS • OIL PAINTS: WHITE, RAW SIENNA, RAW UMBER, ULTRAMARINE BLUE, BLACK
• BRUSHES: NO. 3 HOG, NO. 8 HOG, NO. 3 ROUND BRUSH, NO. 4 FILBERT, NO. 12 FILBERT, NO. 3 ROUND, NO. 4 FAN BRUSH, FLAT BRUSH, NYLON/HOG BLENDER, BADGER BLENDER • RAG
• PALETTE • PAINTING MEDIUM: TURPENTINE, LINSEED OIL

2.

Use a rag to wipe out any mistakes. Take time to make sure the sketch is right, and don't be afraid to redraw sections of the image. Now start blocking in the shadow areas with more raw umber. Block the shadows in crudely: the dark areas will still tell us about the form. When you are happy with the sketch, use the rag to soften all of the lines.

3.

Mix some raw sienna with white on your palette until you have a warm skin tone. Apply this to all the light areas of the body. The raw umber is still wet, so you may get some mixing. Do not drag the paint once it has been applied so as to avoid it blending with the shadow areas.

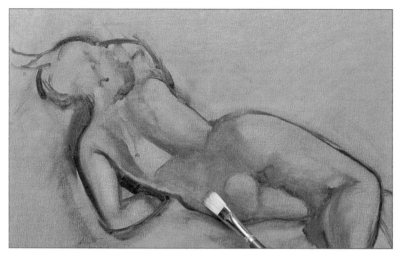

4.

Use a flat brush to apply some more paint to the shadow areas (use the same shadow mixture as before, just a little stronger).

5.

Use a badger blender brush in a flicking action to drag one colour into another. This takes away the hard edges and leaves you in a good position to redefine the form.

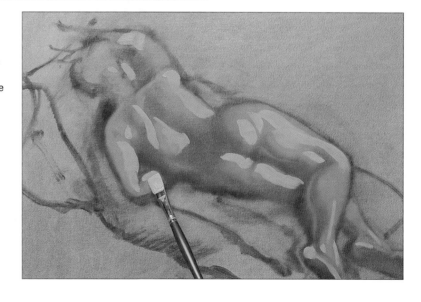

6.

Add more white to the skin tone mixture. Look for areas that have to be lightened. Use a number 8 hog brush, but don't add too much white too early. Use broad brush strokes to map out the overall plan.

7.

Use a badger brush to drag light paint into the shadows and give a sense of form to the body. Try to graduate the edges of the light and dark areas. Now use a nylon or a hog blender brush to tone off the backlighting on the lower thigh and the top of the lower arm.

8.
Mix ultramarine blue with black. Use a flat brush to apply this as a working background colour. Use the corner edge of the brush to mark in the outline of the thigh.

9.
Now mix white with a little bit of background colour. Use a number 4 filbert brush to define the flesh against the background. Half close your eyes to decide where dark and light define the edge of the body.

10.

Now use a number 3 round brush to touch in brighter colour to the highlights on the body. Avoid overdoing this, as the skin might end up looking polished – it should have a matt appearance. Now use a blender brush to ease the light paint into the surrounding areas. Follow the form of the body with the brush.

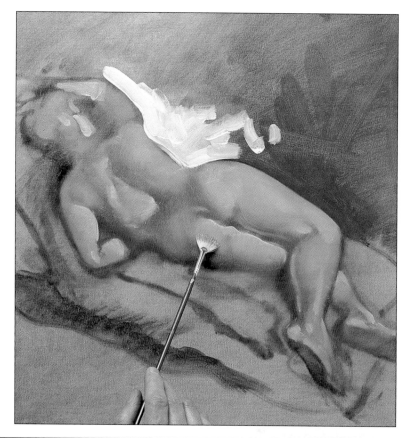

11.

Use a blender brush to tone down the background and create a gradation of light around the body. Use the paint already on the canvas and move it around with flicking actions of the blender brush.

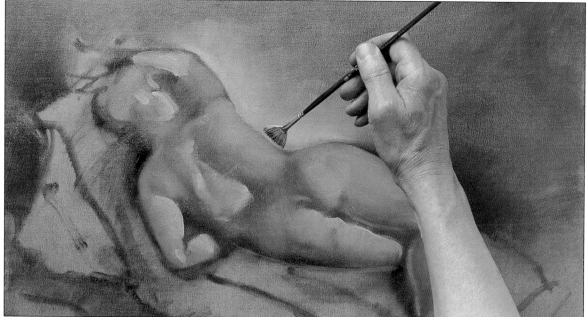

12.

Use a number 12 filbert brush to apply a mixture of ultramarine blue, black and raw sienna for the striped material the model is lying on. Ignore the stripes at this point and just cover the whole area. Start by carefully following the outline of the body as it comes into contact with the striped material.

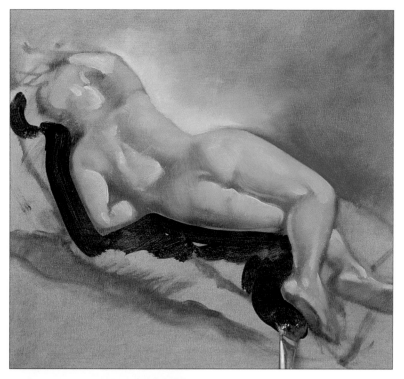

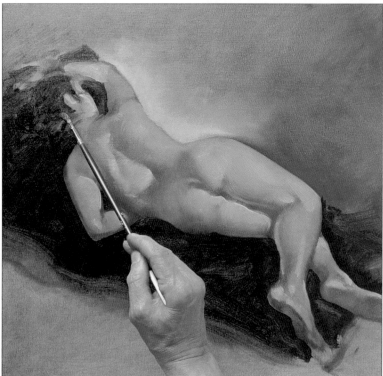

13.

Add black to the blue background colour to mark in the hair with a number 3 hog brush. Use pure black on the parts that you want to look glossy where the light reflects, and then use a blender brush to create a proper sense of form.

14.

Create the stripes by wiping paint off with a rag. Use ultramarine blue and raw sienna to highlight the stripes and accentuate the creases.

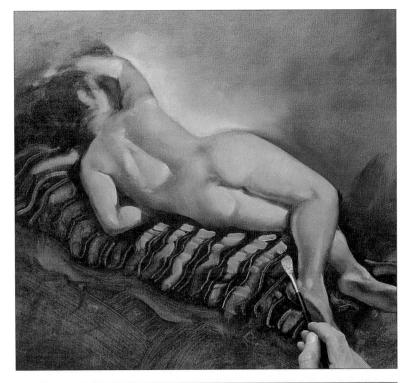

15.

Use a flat number 8 hog brush to mark in the white of the cloth in the foreground. Now return to the figure using a number 4 fan brush to go over the lightest areas once more, accentuating them.

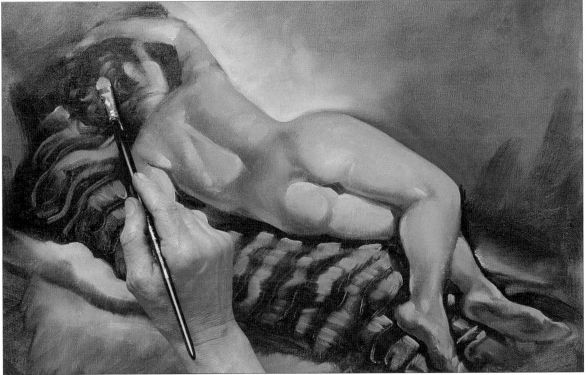

ATHLETE

The figure used in this project is focused and ready for action. Muscles and tendons are in a state of tension, and the whole body seems to point in the direction the runner is about to go. Here the anatomy tells an important part of the story of the picture, as the muscles and tendons display the fact that the figure is ready for movement. The arm in the foreground is especially effective in this role, and the artist highlights this area by making the muscles and tendons evident, to enforce the idea of imminent forward motion.

John Barber
Tensed Muscle Study
38 x 56cm (15 x 22in)
Watercolour

Observing Muscle Tension

In this project the aim is to show tension, the sort of tension that is used just prior to forward propulsion. What is also essential to this position is balance. Here the artist needs to observe and place each limb very carefully or the figure will not balance correctly. The use of horizontal and vertical measurements would be useful in this pose to check on the angle of the limbs. It is also a perfect position for using the negative shapes that exist between the legs and arms to gain extra accuracy.

Right: A deltoid, B triceps brachii, C tendon of triceps, D vastus lateralis, E extensor carpi radialis longus, F extensor carpi ulnaris, G ulna, H lateral malleolus (fibula)

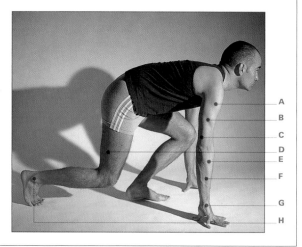

TENSED MUSCLE STUDY

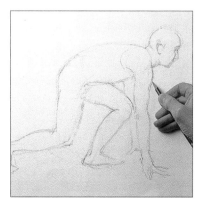

1.

Sketch in the outline of the figure with a graphite pencil. Place the figure in the centre of the paper, with about 2.5cm (1in) outside the drawing to the edge of the paper. This allows for lengthening of the limbs if you make an error in your initial proportions. Note that where the tendons are close to the surface, the outline is quite straight, whereas muscle creates curving shapes.

Materials and Equipment

- ROUGH SURFACE, 120 LB WATERCOLOUR PAPER
- GRAPHITE PENCIL • BRUSHES: ¼ INCH FLAT NYLON, 1½ INCH FLAT NYLON, NO. 10 SABLE
- WATERCOLOUR PAINTS: YELLOW OCHRE, LIGHT RED, VIOLET, RAW SIENNA, BURNT SIENNA, PRUSSIAN BLUE • PALETTE
- TISSUE

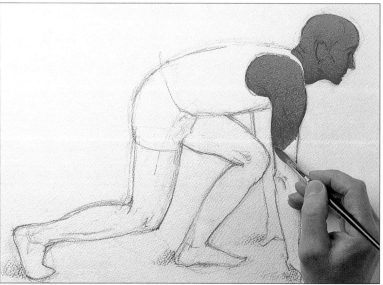

2.

Mix yellow ochre and burnt sienna (slightly more sienna than ochre). Apply this in a flat wash over the flesh areas of the body. Use a number 10 brush with a good point.

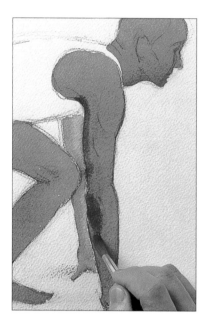

3.

Add a little raw sienna to the mixture and use this to touch in the shadows. Do this while the first wash is still damp.

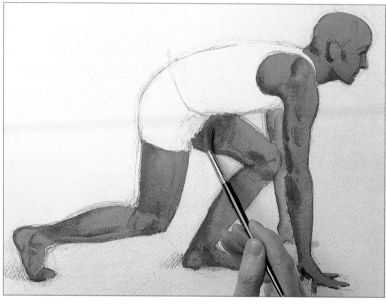

4.

Add some raw sienna to make a deeper tone for the darkest areas of shadow. Apply this to the groin area.

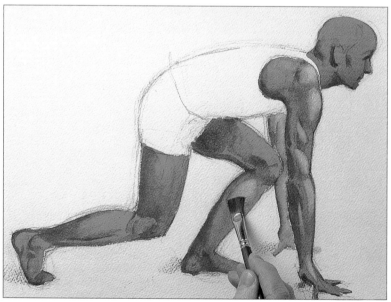

5.

Use a clean ¼ inch flat nylon brush with a flat head dipped in clean water to lift out areas of paint for the highlights. Gently stroke the surface with the wet brush and then blot the area with tissue.

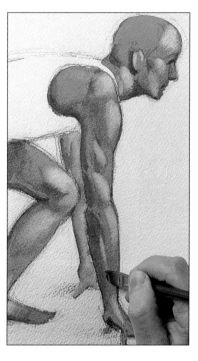

6.

Continue adding highlights until the variations of light and shade give a good impression of the general anatomy of the figure.

7.

Mix a weak wash of Prussian blue and violet for the shorts. Apply this to the whole area and then lift out paint for the stripes and the creases. Use pure Prussian blue for the running vest, blocking in the colour over the whole area.

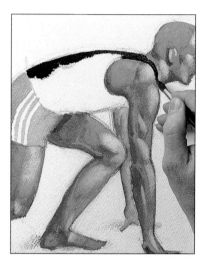

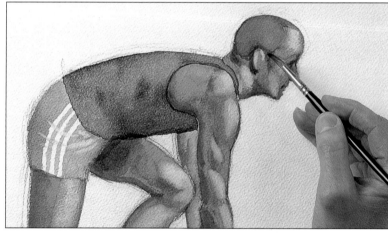

8.

While the paint for the vest is still damp, dab more colour into the area and tilt the paper so that darker paint runs where you want it, creating shadows on the material. Use raw sienna with a little Prussian blue for the cropped hair.

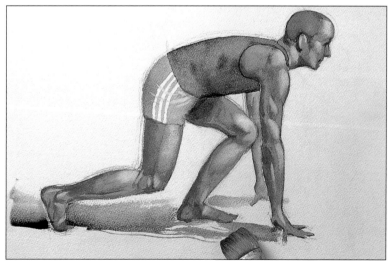

9.

Use Prussian blue with a little violet and light red and lots of water for the shadow under the figure. Let the paint run up to the edge of the area to create a sense of perspective, but try to keep the lines sharp.

10.

Now mix some Prussian blue into the mixture; wait until it is a little dryer, then use it to outline the runner's face and the upper part of his arms.

11.

Now use a 1½ inch nylon brush with lots of water to create the background. Use the wet brush to move the paint already on the page around. Be careful not to allow paint to run back over the figure.

12.

Let the wash go over the legs to focus attention on the arms and face. Finally, add some light red to the area behind the runner.

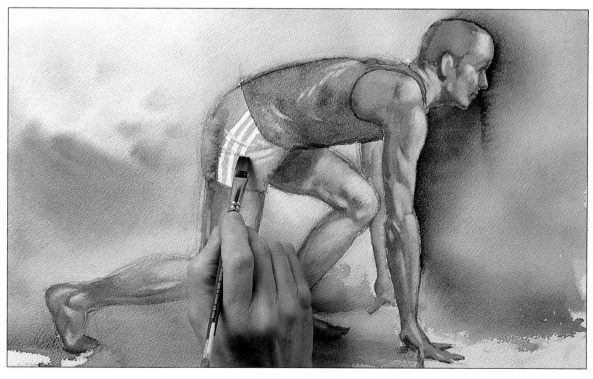

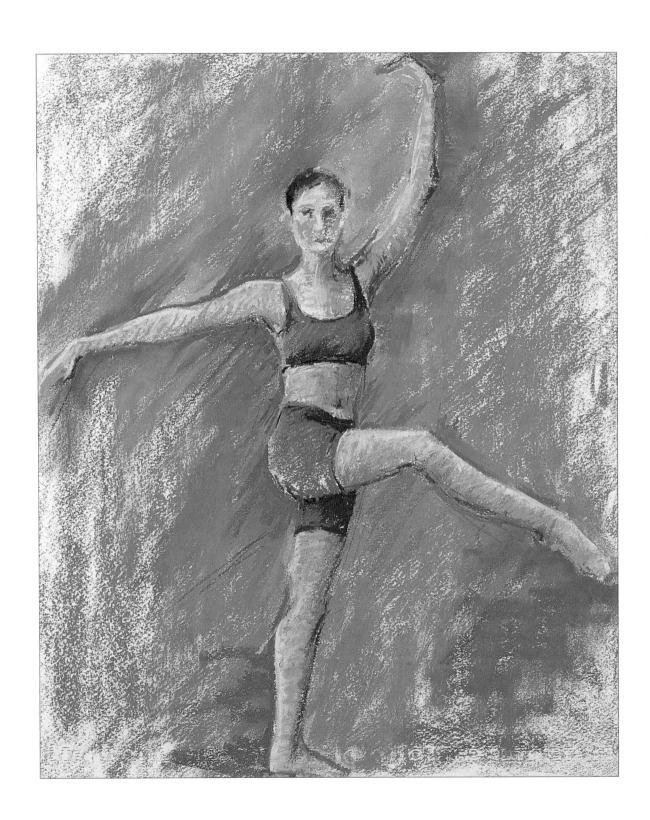

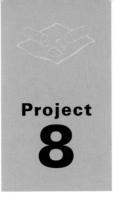

DANCER

The entire weight of the dancer in this project is supported on one leg. Yet she maintains perfect balance while creating graceful shapes with her arms and other leg. This is a study not of the body under tension but of the body used to express grace and poise. An understanding of anatomy is vital here in order to get the proportions of the figure right and to make sure that the pose is recorded correctly. The torso, neck and head are held upright, while the arms and upper leg form curves away from the body. Although the pose looks effortless, muscles and tendons are at work beneath the surface. The artist is careful to pick these out without losing the overall grace of the image.

Charmian Edgerton
Grace
55 x 38cm (22 x 15in)
Charcoal and Pastel

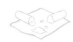

Capturing Poise

To elevate the arms up to the horizontal position, the deltoid in the upper arm is used. In order to raise the arms above horizontal, the trapezius and serratus anterior come into play. The serratus in particular enables the scapula to rotate across the ribcage, which in this case is almost vertical along the humerus.

To raise the leg into this position the muscle group known as the quadriceps femoris is used. As the upper leg is moving towards the centre of the body there will also be some assistance from the adductor group, including the gracilis muscle. In this subject the muscles provide strength and control. The extended arms and leg help balance the supporting foot.

Left: **A** deltoid, **B** extensor carpi radialis longus, **C** radius, **D** humerus, **E** biceps brachii, **F** lattissimus dorsi, **G** flexor carpi radialis, **H** tendon of biceps brachii, **I** pectoralis major, **J** rectus abdominis, **K** patella, **L** tibialis anterior, **M** medius malleolus, **N** lateral malleolus, **O** Achilles tendon

GRACE

1.
Start by dropping a very faint line in charcoal down the centre of the paper. Sketch in the head and the arms in light charcoal. Make sure you get the proportions right.

2.
Use the head to get the size of the body right: the body is about 6½ times larger than the head. Mark a centre line down the body. Continue to sketch the body and correct mistakes as you go. Smudge some of the lines with your finger to give the impression of movement.

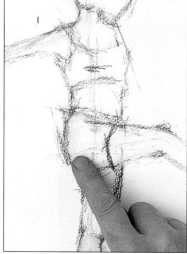

Materials and Equipment

- SMOOTH, WHITE PASTEL PAPER
- CHARCOAL • PASTEL COLOURS: LIGHT YELLOW, CHROME YELLOW, BURNT ORANGE, DARK BURNT ORANGE, BLUE-GREEN, GREEN-BLUE, ULTRAMARINE BLUE, PRUSSIAN BLUE, LIGHT PINK, LIGHT RED, PERMANENT ROSE, VERMILLION, PINK-VIOLET, MID-VIOLET, DARK VIOLET, INDIGO, PURPLE (4, 6, 8), BURNT SIENNA, VANDYKE BROWN •TISSUE
- PUTTY ERASER

3.

When the figure is outlined, go back and fill in some of the detail. When you have all the elements on the paper, brush off the surplus charcoal with clean tissue. Excess charcoal will interfere with the pastel colour.

4.

Fill in the background with ultramarine blue and blue-green pastel. These two colours will complement the skin tones to be used to colour the figure.

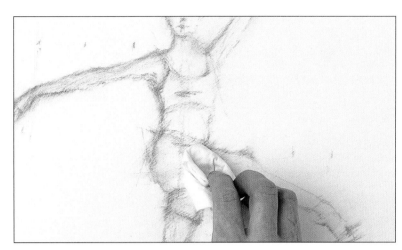

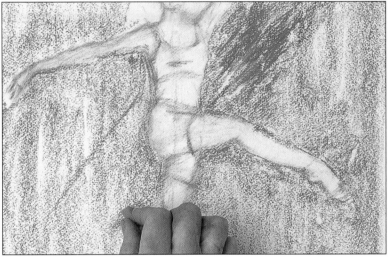

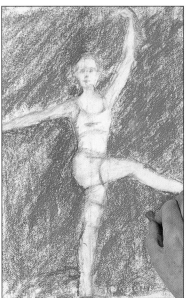

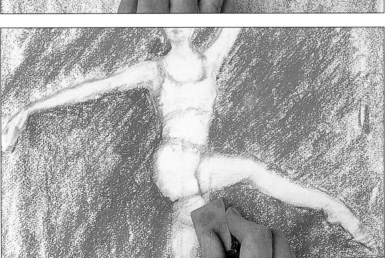

5.

Use the side of the pastels to block in the background colour. Smudge in the two colours lightly.

6.

Use ultramarine blue to block in around the figure. Now use a clean putty eraser to rub out the charcoal lines. Use the eraser as a drawing tool in its own right, following the flow of the body. Don't go over the pastel, as it will just smudge.

7.

Use a very dark purple to colour in the darkest areas of the figure: the top of the head, under the breast, the waist band and the upper thigh of the back leg. Now use indigo to add depth to this tone and put some Prussian blue lightly over the top so that the other colours show through. Now use a lighter purple to colour in the unshadowed parts of the clothing.

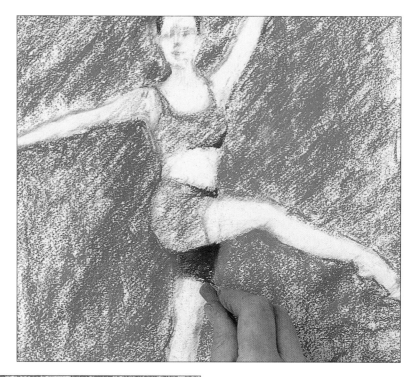

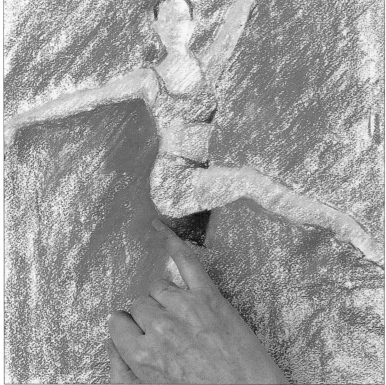

8.

Use a light violet to add the base tone to the skin. Then use a pink-violet pastel to block in the lighter areas and a mid-violet for the mid-tones. Now smooth the background colours around the figure with your finger. This will make the transition between the figure and the colours of the background softer – hard edges will leave the picture lifeless.

9.

Use burnt sienna for the hair and then pick out highlights with Vandyke brown, light red and permanent rose. Use the last colour to highlight areas of the clothing.

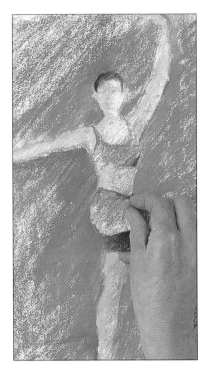

10.

Outline the edge of the figure to emphasize the form. Use a mid green-blue and a mid blue-green. Add some mid green-blue to the background. Use a light pink to enhance some of the highlights on the skin.

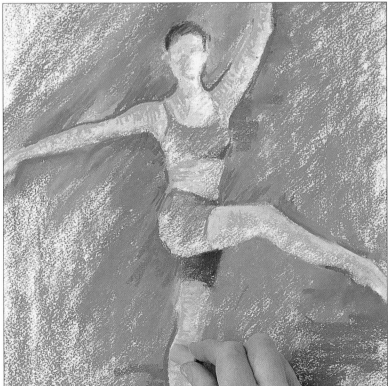

11.

Use burnt orange to start to emphasize the muscles. Work your strokes across the form to show the roundness of the shapes.

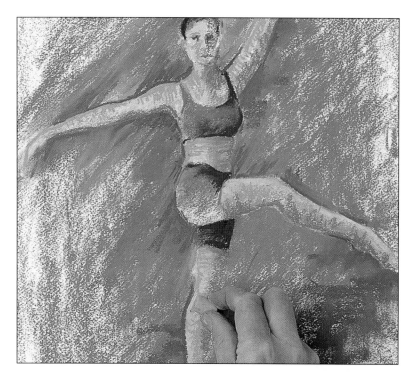

12.

Mark in the eyes with a dark purple. Apply a mid-violet in downward strokes to get a slight cross-hatching effect. Use a dark burnt orange on the underside of the arm, the neck, the underside of the legs and the front of the supporting leg. Add a dark purple to the clothing to show the top of the leg and the shape of the breast. Smudge in the orange tones.

13.

Use a light yellow to accentuate the muscles of the calf, using strong strokes to apply the colour. Continue to accentuate the dark tones with dark burnt orange, particularly the underside of the upper arm and the abdomen. Use some dark violet for the top of the upper leg.

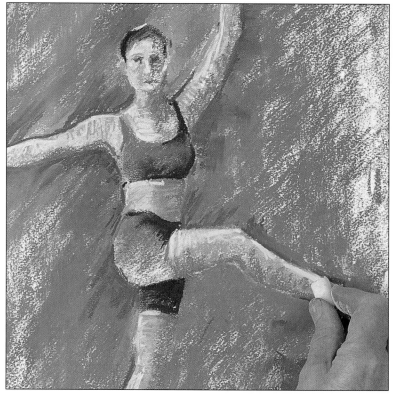

14.

When you approach the completion of the picture do not rub in the colour too much, as this will give the image a flat look. Add the final touches to the background by putting in a few lines of burnt sienna. This will chime with the colours used in the figure.

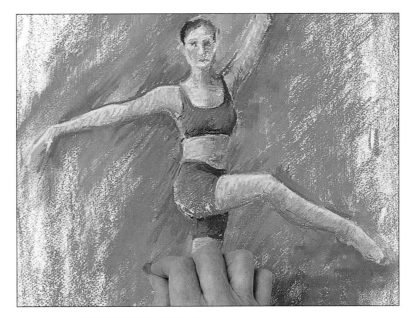

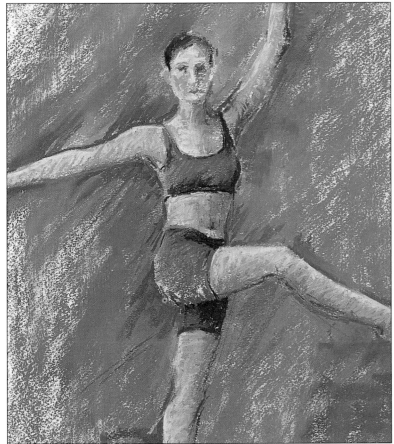

15.

Now mark in the final detail. Use vermillion red and chrome yellow to exaggerate some of the muscles in the stomach area. Use indigo for the navel and for the vertical muscle lines. Vermillion brings warmth to the shadow on the legs as well as to the buttock area.

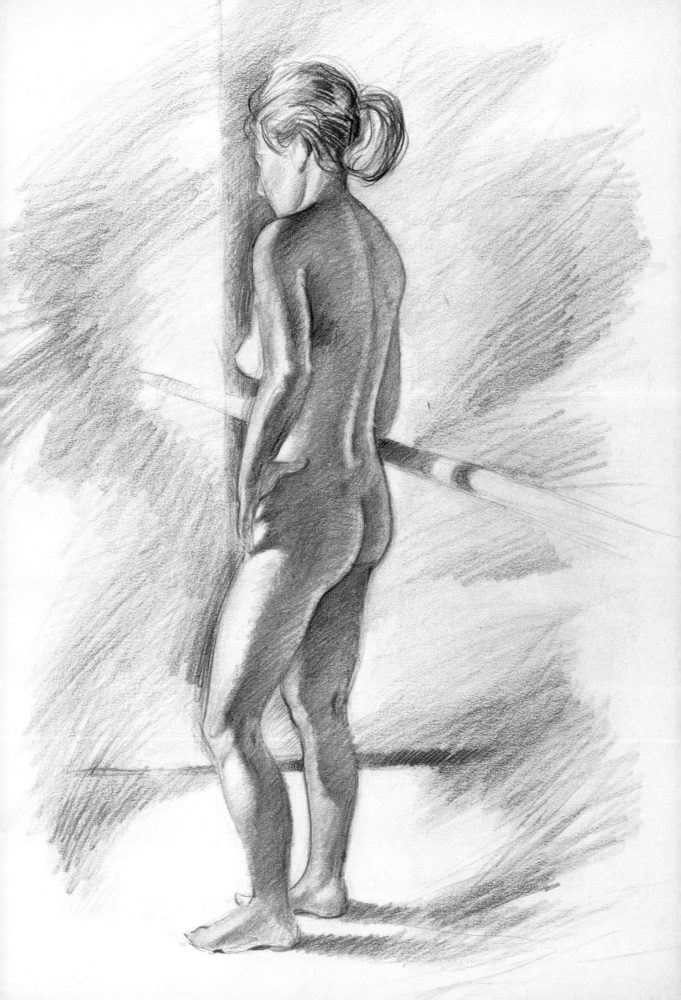

THE
FEMALE
NUDE

INTRODUCTION

The naked female form has moved man to creativity as far back as Palaeolithic times. Throughout Europe and Russia naked female figures, known as Venuses, have been found scratched into cave walls.

In the art of the ancient civilizations the human image is idealized – almost without exception men and women are depicted as youthful, following strict representational conventions. This preoccupation with the idealized human form is most evident in the art of ancient Greece and Rome. In sculpture, painting and the decorative friezes around pots and amphorae, the figure was always depicted as possessing a perfect athletic physique. However, the female figure appears relatively rarely.

The female nude was not a subject to be dealt with during the dark days of war and religious guilt of the early medieval ages. But with the Renaissance in 15th century Italy, art took a giant leap forward. Anatomical investigations by Antonio Pollaiuolo (c1432– 1498) and Leonardo da Vinci (1452–1519), and a greater understanding of perspective, made it possible for artists to treat the figure more objectively, and to create the illusion of three dimensions by positioning the figure convincingly in a two-dimensional space.

Armed with this new knowledge, artists turned once more to the legends of classical antiquity and the female nude was increasingly used as a subject to invest paintings with emotive power and intensity, appearing in many works by such great painters as Michelangelo (1475–1564), Raphael (1483–1520), Botticelli (1445–1510), Titian (c1487–1576) and Tinteretto (1518–1594).

But whilst the nude was used in works by artists as diverse as Rembrandt (1606–1669) in Amsterdam, Tiepolo (1696–1770) in Venice, Velazquez (1599–1660) and Goya (1746–1828) in Madrid, and Ingres (1780–1867) and Delacroix (1798–1863) in Paris, its acceptability relied on its being seen in a classical or mythological context. The naked portrait of a real person was rare. Examples are Helena Fourment as Aphrodite by Rubens, and François Boucher's painting of Louise O'Murphy commissioned by Casanova.

The later work of Ingres can be seen as something of a watershed, with two paintings, although popular, raising a degree of controversy. Both are overt celebrations of naked femininity. These were *La Source,* 1856, and *Le Bain Turc,* 1862.

In 1863, French artist Edouard Manet (1832–1907) caused a storm of controversy

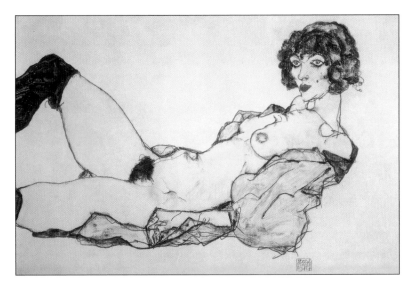

Reclining woman with green stockings 1914 *Egon Schiele 1890–1918*

Drawn towards the end of his short life, this work shows the economy of line and colour with which Schiele was able to capture the pose.

when he exhibited *Le Dejeuner sur l'Herbe* at the Paris Salon des Refuses. The picture, showing two fully dressed men seated with a naked woman, was seen as scandalous. In 1865 Manet exhibited *Olympia*, his reinterpretation of the theme of the reclining Venus, to critical and public outrage, rooted in the fact that the model, Victorine Meurent, who appeared in many of Manet's pictures, was obviously representing a prostitute.

This image of the female nude in real-life situations gained impetus with the pastel works of Edgar Degas (1843–1917) and the oils of Auguste Renoir (1841–1919), both of whom produced a large body of work showing the nude female bathing or at her toilet. Criticism was now much more about technique than content. Renoir and Degas were respected artists and when their pictures of female nudes appeared to the public, a decade after *Olympia's* unveiling, public opinion had sobered.

Degas' bathers showed the female nude going about her toilet apparently unposed and oblivious to the artist and onlooker. These were truthful representations of the female nude, used as a means to explore and experiment with the imagery and problems of composition, colour and technique.

This raw approach is perhaps seen best in the superb drawings and paintings made by the Austrian artist Egon Schiele (1890–1918). His works, although often erotic, disturbingly contorted or pornographic, were superbly drawn. Schiele's main strength was his use of line which searched out the figure's form with a startling fluid simplicity.

The 20th century saw a huge diversification in artistic direction and discipline. Depictions of the female nude still abound, and looking at paintings by Picasso, Stanley Spencer, De Kooning, Wyeth, Philip Pearlstien or Lucien Freud gives an idea of their diversity. The female nude is still a primary subject to test the artist's techniques and powers of representation, as well as being one that inspires creativity.

TECHNIQUES

Painting or drawing, your style will be determined to some extent by the materials and the technique you choose, whether drawing with the fine detail of pencil and pen, or applying the bolder strokes of pastels and oils.

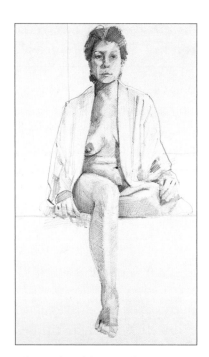

Above Graphite pencil

GRAPHITE PENCIL

The simple graphite pencil is familiar to everyone and is one of the very first mark-making implements we use as children. It is perhaps due to this familiarity that we frequently fail to recognise its wide-ranging potential. Pencil is available in a range of grades from very hard to very soft and the best grades for drawing are the softer grades from HB to 9B.

Pencil is a fast medium. It can also be used to make very considered drawings which build up tone or line slowly. The same is true of the graphite stick, which is simply a pencil with a thick "lead". Another consideration with pencil is that very little equipment is needed to make a drawing. Tone is built up using one of many methods, such as mixing different shading methods together in the same drawing. Here the drawing uses line work and tone, built using scribbled and hatched lines. The tone is then worked on with a putty eraser, knocking it back or lightening it and adding any highlights. Drawings done with soft pencil smudge easily so make sure that you fix them at regular intervals with fixative.

CHARCOAL

Like pencil, charcoal is a quick medium, and is capable of rapidly capturing a pose in line and tone. The possibilities of the material are increased if used with a coloured paper and white chalk, pastel or crayon. Here a mid-grey paper gives a mid-tone out of which the dark charcoal represents the darker tones and the white chalk is

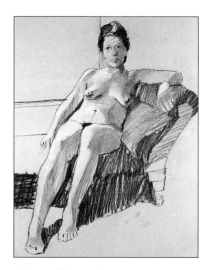

Above Charcoal

used for lighter tones and highlights. Very seductive drawings can be made using this method, which was often used by the old masters. A variation on this method is known as *les trois crayons*, the three crayons. This involves using black, white and sanguine crayons to produce the dark, light, and mid-tones.

HARD PASTEL

In many respects, hard pastel sticks are similar to charcoal. They are capable of producing a similar quality of line but are cleaner as they "take" more firmly to the paper. This makes them more difficult to erase and tone cannot be laid or erased quite as easily as with charcoal.

By varying the pressure applied to the pastel stick, light or dark lines of varying thickness are easily made; this makes

them ideal for drawings which require strong line work. In reality, lines around people or objects don't exist. Surfaces are seen to change, turn or join one another by altering colour, tone or direction and not by ending with a line. Good line drawings try to show this by having a variety of line density and thickness, which is suggestive of these characteristics.

Here the drawing was first made using a series of light, flowing lines which explored and searched out not only the figure's outline but the internal contours. Once these were seen as correct, some of the lines were redrawn and strengthened in order to suggest both shadow and highlight.

Below Hard pastel

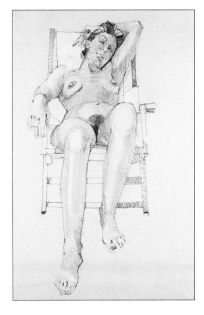

Above Coloured pastel pencil

COLOURED PASTEL PENCIL

Here pastel pencils have been used to produce a drawing which expands on the ideas seen in the charcoal drawing. A paper, the colour and tone of which was sympathetic to the subject, was used to give a light mid-tone base on which to work. Six coloured pastel pencils were then used to lightly draft out the figure and gradually build up the tone and colour, with highlights being added last with a white pastel pencil.

This finished drawing uses a combination of tone and line to successfully describe the form of the figure. Hidden amongst the tone and colour can be seen a few contour lines which give a clue as to the shape and direction of the surface. The same technique can also be used with coloured pencils or soft pastels.

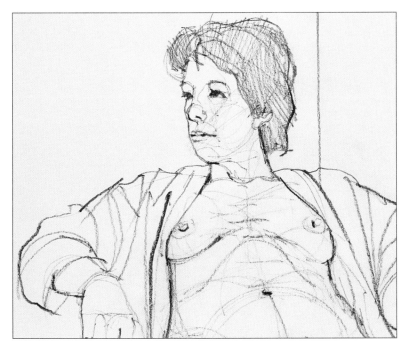

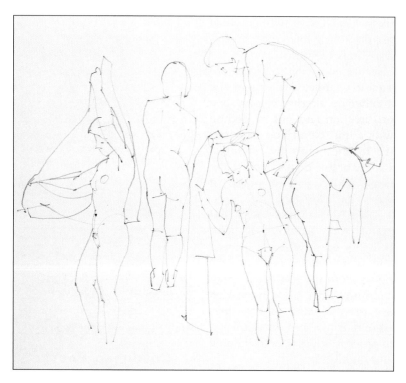

Above Pencil quick poses

PENCIL

Pencil makes the ideal medium for making rapid drawings. Any medium which makes a strong solid mark would also be suitable, including charcoal and graphite sticks. Rapid drawings and quick poses serve several purposes: they force you to draw boldly and fluently and they help develop your powers of observation as, given the rapidity with which the model alters her position, the artist is forced to look for those lines and shapes which represent the pose or position with the most economy. Quick poses are also a useful way of limbering up before attempting to draw or paint the figure proper. The model can keep changing the pose after a few minutes or she can be asked to perform a task. Here the model is seen preparing for and drying herself after taking a bath.

PEN AND INK

Good drawings made with a dip pen and ink have a real beauty but they are notoriously difficult to achieve. Pen and ink is an intimidating medium which can be difficult to correct, and if lines fail to flow freely, they can easily look tired and uninspired. If a pen and ink drawing goes wrong and the mistake is not easily disguised or incorporated, it may be better to begin again. Initially when working with the medium, try working over a light pencil drawing. Do not think of this as cheating; it will simply help keep the work moving in the right direction. Try not to follow the pencil lines but redraw using the pencil marks as a guide. Adding water to the ink will lighten it and can make your initial marks less apparent. Once the figure is fully realised, the ink can be used neat and at full strength. If you have used a pencil drawing as a guide, this can be erased once the drawing is complete. Always allow plenty of time for the ink to dry so as not to ruin the drawing by smudging it.

Below Pen and ink

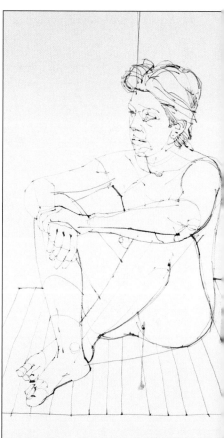

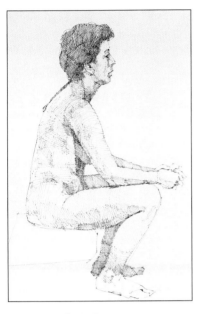

Above Technical pen

The beauty of a dip pen is its ability to make a line that varies in thickness according to the degree of pressure applied to it. Technical pens, biros and some markers make a line of one thickness only. However, these are all capable of making drawings which contain a full range of subtle tone, and lines can appear to alter in thickness by being restated several times. As with the conventional dip pen, mistakes are not easily corrected; working over a light pencil drawing can help. Tone is built up by hatching and cross-hatching a series of lines to build up areas of varying density. The technique is both absorbing and

controllable and is capable of producing very subtle drawings. The technique is also valuable because it teaches how to observe the gentle transition of tone from light to dark. Highlights are left as white paper, whilst very dark or black areas are heavily cross-hatched so that little or no white paper can be seen.

SOFT PASTELS

Soft pastels are mixed and blended in one of two ways. Either they are blended on the support using a finger, torchon or blending brush, or the coloured hues are placed next to one another on the support and

Stretching Watercolour Paper

In order to stop watercolour paper buckling and cockling each time it is wet, the paper should be stretched prior to starting work. You

need a sheet of watercolour paper, a wooden board larger than the sheet of paper, four lengths of gum strip, water and a sponge.

1 Lay the sheet of paper onto the board and wet it with water using the sponge. Do not rub the paper too hard because it is easily damaged when wet. Remove any excess water with the sponge.

2 Take a length of gum strip and wet it. Lay the strip down one edge of the paper and secure it to the board. Do the same along the other three sides.

3 Remove any excess water on the paper, making sure all four edges are secure, and place the board to one side. Let it dry thoroughly before starting work.

157

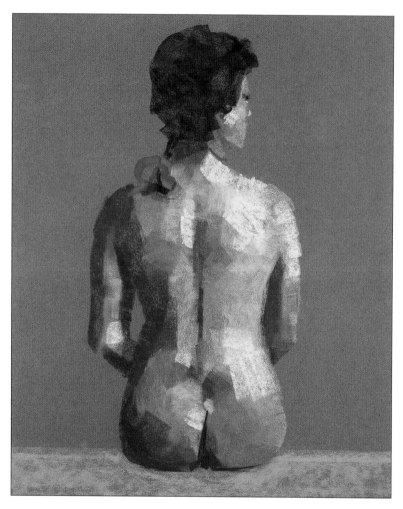

ground which was seen to be sympathetic to the overall colour and gives the work an underlying sense of harmony.

WATERCOLOUR

This is ideally suited for figure painting as the subtle medium is capable of representing the equally subtle transition of colour, tone and light at play on the contours of the naked female figure. Watercolour is usually worked on a white surface, which reflects light back through the layers or washes of paint. Washes are worked "wet in wet" – colours are applied over each other while still wet – or "wet on dry" – each layer is allowed to dry before another is added. A combination of these methods is usually used in any one painting. In this painting of a reclining figure, the lightest tones and colours were applied

Left Soft pastel

Below Watercolour

the mixing takes place optically in the viewer's eye. This was the principle used by the pointillists in the late 19th century. If a limited range of pastel colours are available, this direct approach can result in a very complex work which will enable the marks to keep their freshness and intensity without colours becoming muddy and confused. By fixing between layers of marks the work can be taken to an exceptionally high degree of finish. This simple back view has been done on a coloured

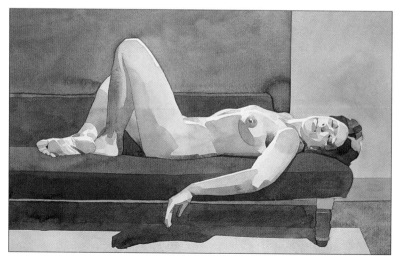

first, with each subsequent colour wash modifying the one beneath. When subtle changes of colour or tone are required, washes are allowed to run together and mix. The darkest colours are painted in last of all. Depending on the paper used, watercolour can be corrected by rewetting areas and blotting off the redissolved paint.

OIL PAINT

Oil paint, despite its reputation to the contrary, can be remarkably easy and clean to use. This small painting was done using only six colours which were mixed with liquin. This is a quick-drying medium and will allow oil paint, which can take up to several days to dry, to be dry enough for overpainting in a few hours. The painting was made quickly on a board prepared with primer and was drawn and painted in under one hour. The painting was then repainted the following day. The figure is seen in the context of a slightly unusual environment, a picture waiting to be painted! An advantage of oil painting is that corrections can be made easily; the wet paint can simply be scraped off and the new paint applied on top. Picture-making possibilities surround us, and unusual ones may crop up several times a day. Keep alert to them and if it proves impossible to produce a picture there and then, make a note of the idea for future.

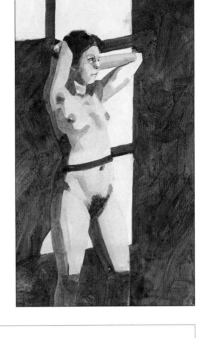

Right Oil paint

You can buy wooden paintboxes which will keep everything clean and tidy – and in one place!

Priming Canvas and Board for Oil Painting

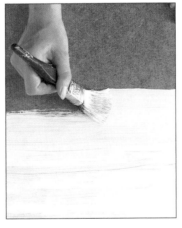

1

If using MDF or the smooth side of hardboard, first key the surface with a sheet of sandpaper. Using an acrylic primer, work across the board or canvas until it is totally covered. Allow to dry thoroughly.

2

Once dry, repeat the process, working the brushstrokes at an angle to the brushstrokes used in the first coat. The process can be repeated several times depending on how smooth the surface is intended to be.

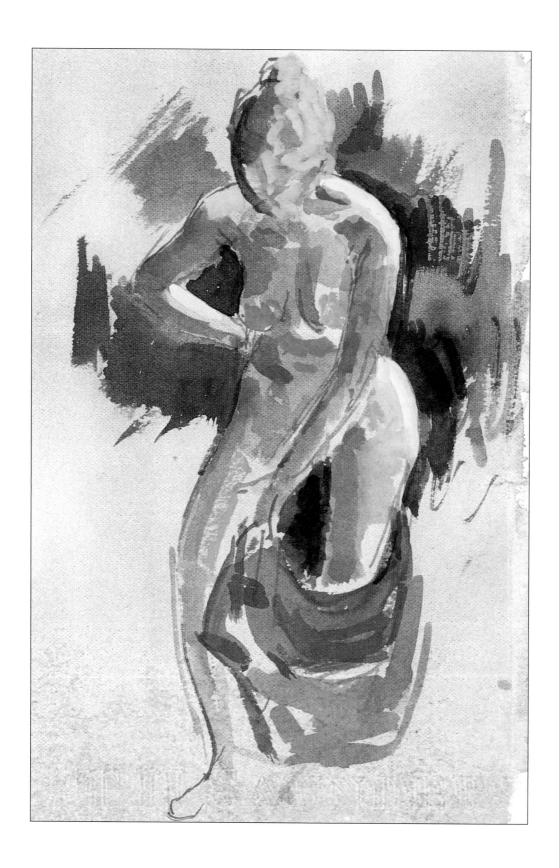

GALLERY

Each medium brings with it not only its own range of techniques but also its own problems of representation. Artists solve these in many ways and this small gallery of drawings and paintings done by different artists with a range of different materials aims to show just a few chosen solutions. The pictures have been selected to demonstrate how choice of material, technique, composition, framing, scale and colour, together with the figure's chosen pose, all contribute to creating a mood and style.

Woman Undressing
James Horton
25 x 18cm (10 x 7in)

Expressive brush work lends a sense of immediacy to this figure caught in the act of removing an article of clothing. Artists often do several pictures at one sitting with the model changing her pose every few minutes. The exercise is excellent practice for honing the artist's powers of observation.

Study of Debbie
David Curtis
25 x 30cm (10 x 12in)

A splash of bright sunlight streaming through a window has been seen as a perfect picture-making opportunity. The shadows cast by the window frame serve to show up the contours of the body in an otherwise flat patch of light.

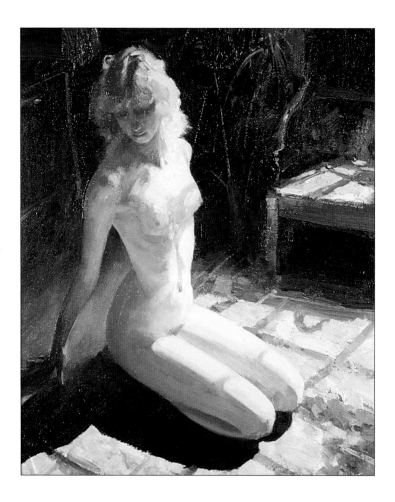

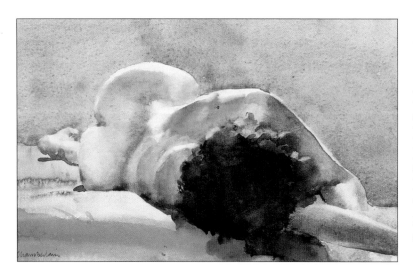

In the Spotlight
Trevor Chamberlain
18 x 25cm (7 x 10in)

Foreshortening occurs to some degree in most poses. Here the artist has solved the problem with clever use of colour and by painting what he sees, rather than what he thinks is correct. A splash of red in the foreground exaggerates the effect.

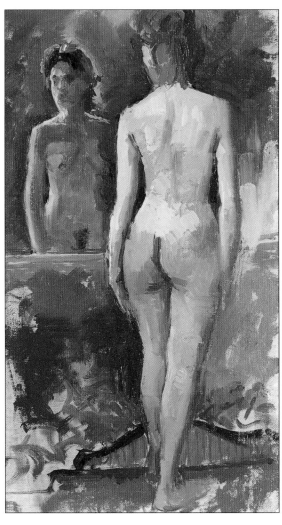

Nude By The Mirror

James Horton
25 x 15cm (10 x 6in)

This oil study is done on a canvas previously given a toned umber ground. The coloured ground acts as a mid-tone which shows through intermittently, giving the work a sense of harmony. It also speeds up the painting process and saves the artist from having to mix colours against a pure white background.

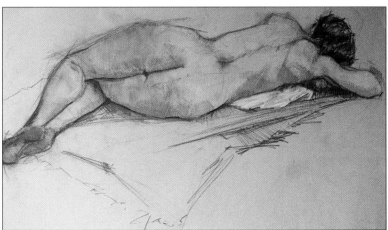

Life Study 2

Barry Freeman
76 x 56cm (30 x 22in)

There is a sculptural quality to this drawing. Done on toned buff-coloured paper which acts as a mid-tone, the figure is almost carved out of the paper using black and sanguine crayons. White chalk highlights give the finishing touches.

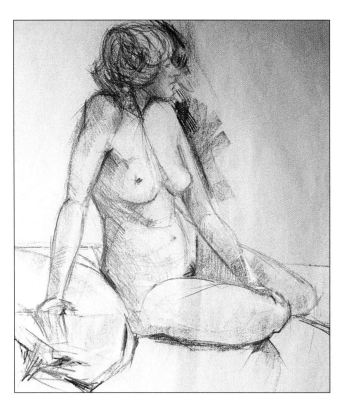

Life Study 1
Barry Freeman
76 x 56cm (30 x 22in)

Using three coloured chalks, the artist has drawn the model with a certain economy. He has made no attempt to cover underdrawing lines or construction marks, all of which add to the drawing's interest and give the viewer an insight into the creative process.

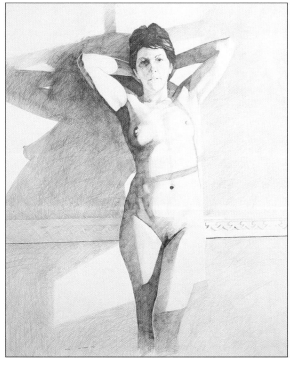

Standing Figure
Ian Sidaway
110 x 74cm (43 x 29in)

Careful hatching and cross-hatching with a range of graphite pencils create a full range of tones in this drawing. The graphite was fixed periodically, and an eraser was used to work back into the tone to modify and lighten areas.

South Carolina Girl

Trevor Chamberlain

25 x 36cm (10 x 14in)

This well-posed watercolour has been painted using predominantly wet-in-wet washes. Both warm and cool colour washes have been delicately introduced to give the figure a sense of contact with her surroundings.

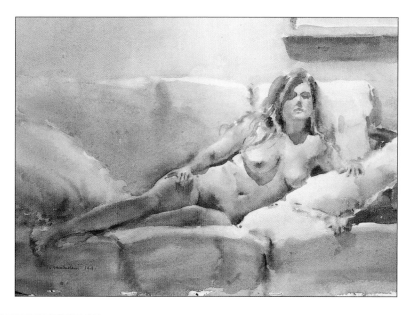

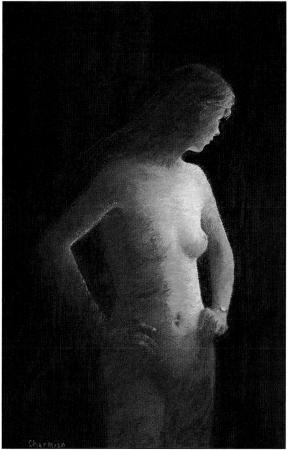

Evening Light

Charmian Edgerton

23 x 38cm (9 x 15in)

This pastel painting was made by the steady build up of pastel in broken strokes. Each layer allows a little of the previous layer to show through. Notice how the dark background is not a flat colour but built up with several different colours in much the same way as the figure.

Kim in a Green Scarf

Maureen Jordan
33 x 24cm (13 x 9½in)

A fluid line and sure sense of colour together with a clever choice of pastel paper all contribute to this delightful figure drawing. The artist has defined much of the outline, especially the right shoulder and breast, by working into the figure with the background colour.

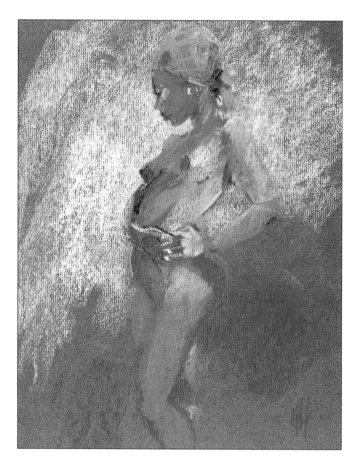

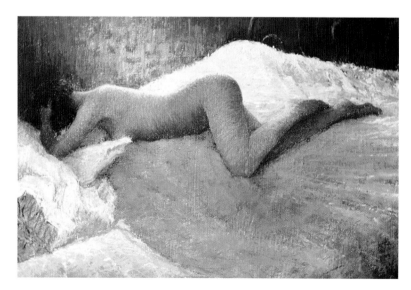

Blue Nude

Charmian Edgerton
20 x 38cm (8 x 15in)

This small pastel is delicately built up with strokes of pure cool colours placed next to each other, allowing the mixing to take place in the viewers' eye. There is little or no blending, which gives the work an intensity and brilliance that overworking could easily lose.

Pose

1

HELENA

This seated pose is a comfortable one and it should be possible for the model to hold it for a period of time quite easily. Mark those areas where the model touches the stool, so that after breaks it is easy for her to return to the same position. Dramatic lighting helps to accentuate the figure's form, adding interest and depth, and gives the student a little less, in terms of detail, to think about. The pose also allows the figure to be viewed from 360 degrees, making it possible to assess angles and shapes, and to select the best position to work from. The shapes seen around the figure, especially through the gaps made by the model's legs and the arms and legs of the stool, all help you to assess the precision of your work. This is achieved by looking at the negative space and shapes around the model and those created by her body, rather than just concentrating on the shape of the figure. A seated figure is more contained than a stretched-out figure, and makes far more interesting shapes, which should make it easier to relate one part of the body to another.

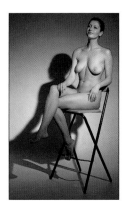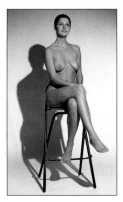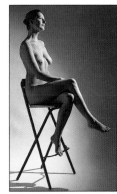

HELENA – SIDE VIEW

Materials and Equipment

• CARTRIDGE PAPER (ANY KIND OF PAPER CAN BE USED AS LONG AS IT DOES NOT HAVE A SMOOTH SURFACE) • VINE CHARCOAL STICKS IN A RANGE OF THICKNESSES • KNIFE FOR SHARPENING • OIL PAINTBRUSH, TO USE AS A STRAIGHT EDGE FOR MEASURING AND TO REMOVE LARGE AREAS OF CHARCOAL • PUTTY ERASER AND BALLS OF WHITE BREAD (FOR ERASING SMALL AREAS) • BOX OF TISSUES • FIXATIVE SPRAY

1. Use a narrow charcoal stick to make two dots at the top and bottom of the paper, joined by a guideline to denote the figure's general extent and position. Look at the angle of the head using the straight edge of a paintbrush, held at arm's length, with your thumb at the figure's chin and the top of the edge at the top of her head. Bring the angle down onto the paper and mark in a light guideline. This will form the basis for the rest of the figure.

2. Work down the figure, sketching guidelines for all of the body's key angles: shoulders, torso, hips and legs. Move the charcoal in the direction that the body moves.

3. Then start to flesh out the outline, working on either side of the central line. Pay attention to the spaces created by the figure, for example between the arm and the body, to assess the precision of your work.

Pose

1

H E L E N A

This seated pose is a comfortable one and it should be possible for the model to hold it for a period of time quite easily. Mark those areas where the model touches the stool, so that after breaks it is easy for her to return to the same position. Dramatic lighting helps to accentuate the figure's form, adding interest and depth, and gives the student a little less, in terms of detail, to think about. The pose also allows the figure to be viewed from 360 degrees, making it possible to assess angles and shapes, and to select the best position to work from. The shapes seen around the figure, especially through the gaps made by the model's legs and the arms and legs of the stool, all help you to assess the precision of your work. This is achieved by looking at the negative space and shapes around the model and those created by her body, rather than just concentrating on the shape of the figure. A seated figure is more contained than a stretched-out figure, and makes far more interesting shapes, which should make it easier to relate one part of the body to another.

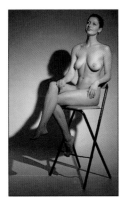 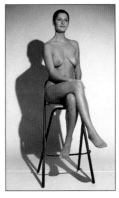 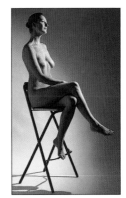

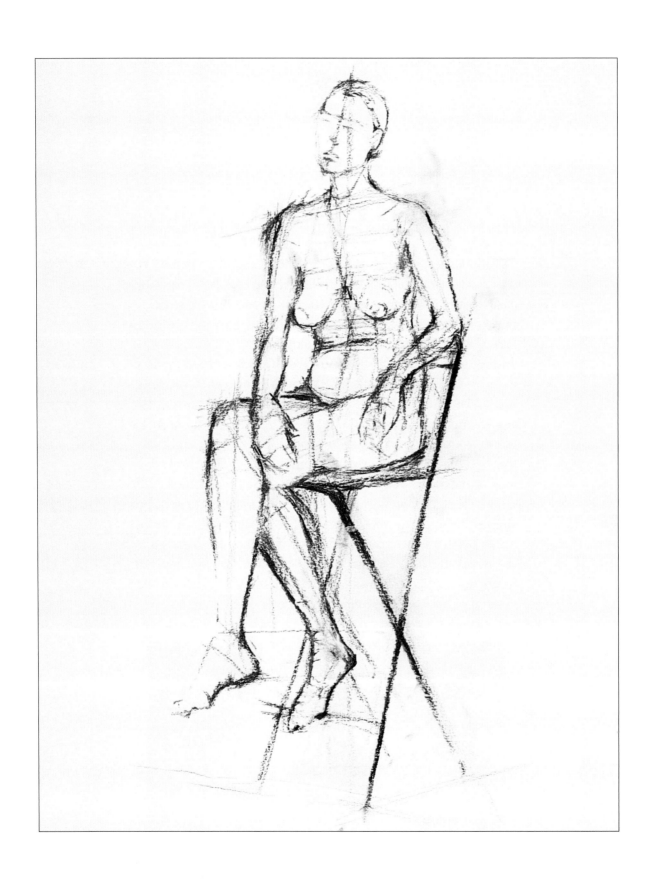

Project
1

CHARCOAL LINE DRAWING

Charcoal is a versatile and descriptive medium, which is perfect for showing the graceful flowing line that is a characteristic of the female nude. The medium allows a degree of detail but its very nature encourages a broader approach, forcing the artist to look at the figure as a whole. Charcoal has a beautiful line quality and by varying the pressure it is possible to make a wide variety of line thickness and degrees of tone. As charcoal can be messy, it would be wise to wear old clothes while you are working, and to protect the floor beneath the work area with newspaper.

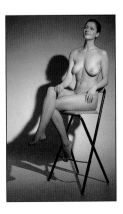

Charmian Edgerton
Helena – side view
36 x 25cm (14 x 10in)

HELENA – SIDE VIEW

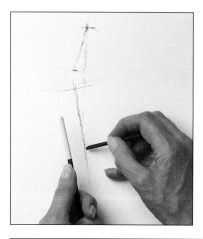

1.

Use a narrow charcoal stick to make two dots at the top and bottom of the paper, joined by a guideline to denote the figure's general extent and position. Look at the angle of the head using the straight edge of a paintbrush, held at arm's length, with your thumb at the figure's chin and the top of the edge at the top of her head. Bring the angle down onto the paper and mark in a light guideline. This will form the basis for the rest of the figure.

2.

Work down the figure, sketching guidelines for all of the body's key angles: shoulders, torso, hips and legs. Move the charcoal in the direction that the body moves.

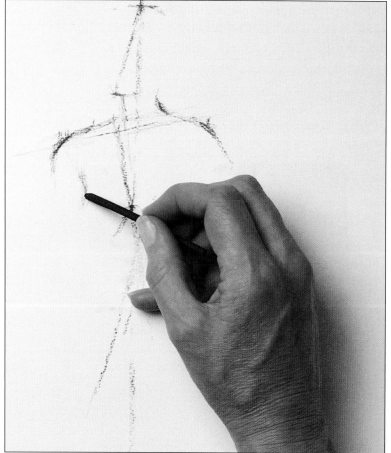

3.

Then start to flesh out the outline, working on either side of the central line. Pay attention to the spaces created by the figure, for example between the arm and the body, to assess the precision of your work.

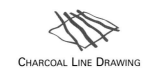

4.

As you work down the figure, use the straight edge of a paintbrush again to assess the angles created by the body. Compare the proportions of the different parts of the figure; for example, the distance from the top of the breasts to the chin is roughly equal to that from the top of the head to the chin. Do not get too bogged down in measurement, or the drawing will start to look static.

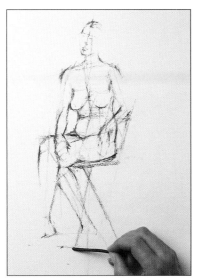

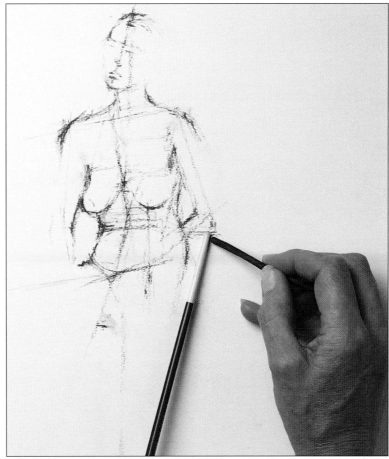

5.

Once the figure is almost complete, draw in the stool or chair, but beware of placing too much emphasis on this. Concentrate on the shapes and lines that the chair makes with the seated figure. Remember that the focus of the picture should be the nude, and the support should only really be hinted at in such a simple line drawing.

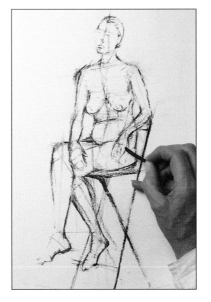

6.

In more difficult areas, for example in this drawing the hands and the angle of the arm resting on the chair, you may need to restate lines or adjust your initial framework to compensate for errors or movement by the model. Don't worry too much about detail, or erasing mistakes; remove lines only if they are making it difficult to redraw or if they are distracting to your eye.

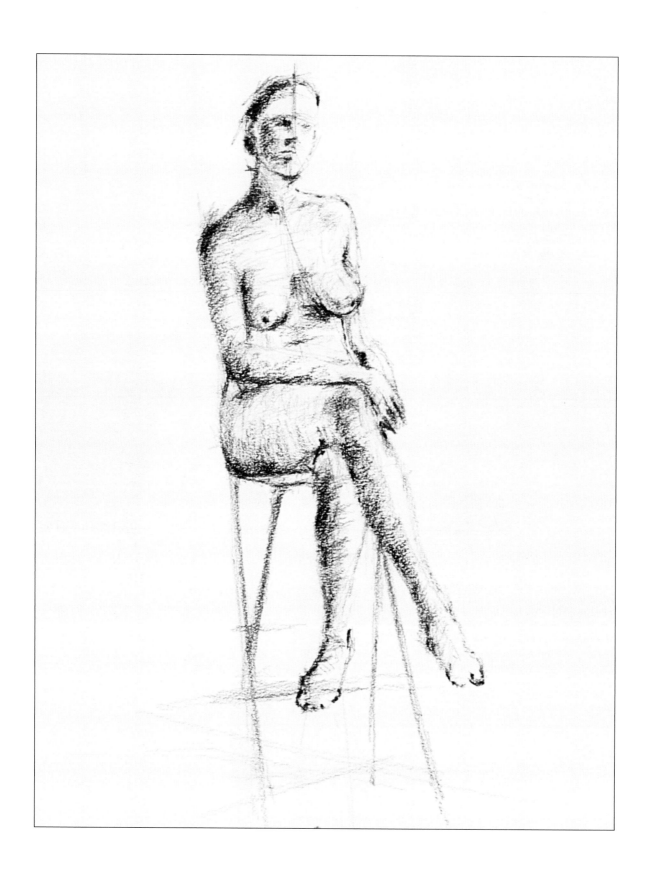

GRAPHITE

Graphite sticks are available in different grades, ranging from HB to 9B. They are available either in pencil shapes coated with a plastic film to keep the fingers clean, or as thicker, short, hexagonal-shaped sticks. They can be sharpened like ordinary pencils. Graphite is used to produce a full tonal range and, by altering the angle at which the stick meets the paper, you can produce various thicknesses of line. With practice you can make a smooth transition from a thick to thin line in one uninterrupted stroke. Take care when using graphite, as it is relatively fragile and will shatter if dropped. When pressing hard, do not hold the graphite pencil or stick too far up the shaft. Shading, blending and erasing are carried out as with a conventional pencil.

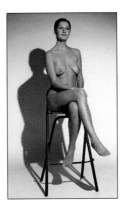

Charmian Edgerton
Helena – face on
25 x 18cm (10 x 7in)

HELENA – FACE ON

1.

Sketch out the body shape in line using the same principles to capture the basic angles and proportions as in Project 1. Work with a graphite pencil for this stage, as it is the easiest to control. As you sketch, look for the three main tones of the figure – dark, medium and light.

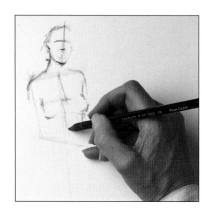

Materials and Equipment

- CARTRIDGE PAPER • SOFT (3B) GRAPHITE PENCIL • SOFT GRAPHITE STICKS • PUTTY ERASER • KNIFE FOR SHARPENING • FIXATIVE SPRAY

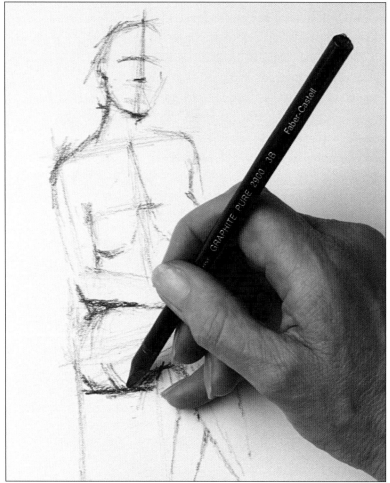

2.

Work down the figure, fleshing out the outline and adding contour lines and the areas of shadow which give the figure its weight – particularly where the body rests on the chair and the arm rests on the thigh.

3.

Choose one area of the darkest tone and shade this area, then go back over the figure adding the other areas of the same dark tone. Use the graphite stick for large areas. Draw with the graphite in the direction of the body's natural movement – across the thigh, then down the calf.

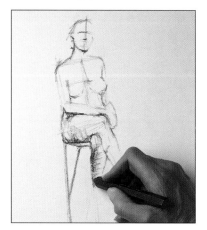

4

Look out for the tonal shapes created on the body by the light. Observe how the differences in tone bring out the contours to give the sense of depth and volume. Applying mid-tones, working around the contours of the body, will lift the figure off the page and recreate this weight. For example, the tones and direction of the shading on the thigh help to define its shape and volume. Go back over the figure applying the areas of darkest tone, for example where the foot meets the stool. In the lightest areas, work very gently with the stick or pencil with small strokes. On the lightest edges of the figure, gently dot and dash in the outline to give the illusion of the body curving away from your eye.

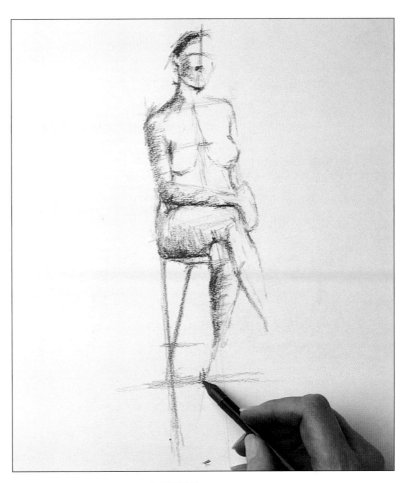

5

Do not concentrate on the detail of the face, but search out the three tones – light, medium and dark – to give an impression of the features. Here, the right side of the face and the forehead are in strong light and are the lightest tone. The left-hand side of the face is in strong shadow and is made up mainly of the darkest and medium tones.

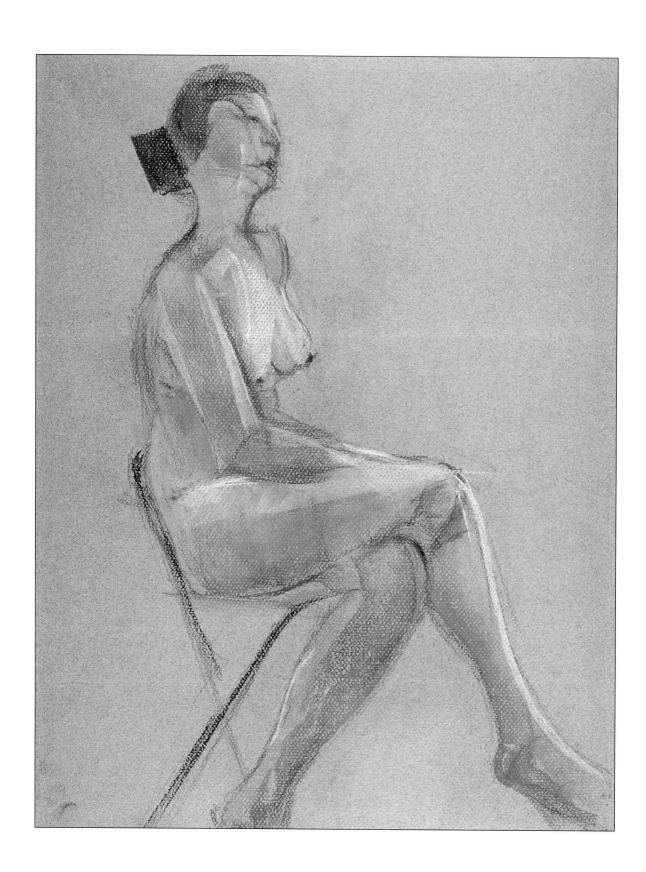

HARD PASTELS

Pastels are dry, coloured pigment mixed with a binder and formed into sticks. One of the best known manufacturers is Conté, who make a range of hard pastels, which for the beginner can be easier to work with. These come as pastel sticks or as pencils (crayons). Coloured pastel pencils have many of the characteristics of charcoal but are easier and cleaner to use. Both sticks and pencils can be sharpened with a knife, allowing for fine line work and the building up of subtle hatched and cross-hatched transitions of colour and tone. However, these pastels smudge as easily as charcoal and they can be more difficult to erase. Pastels benefit from using a broader approach: begin lightly and gradually strengthen the drawing once you are sure it is correct.

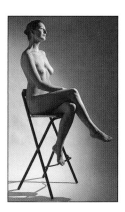

Frances Treanor
Helena – side view
56 x 41cm (22 x 16in)

HELENA – SIDE VIEW

1.

Using a spectrum blue pastel pencil, lightly sketch in guidelines to give the proportions of the figure as in Project 1. Work from the neck down, leaving the head until last. This is a working drawing, so don't be afraid to make mistakes.

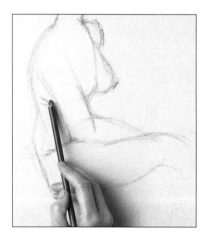

Materials and Equipment

• GREY INGRES PAPER WITH GRAINED SURFACE, A3 MINIMUM SIZE – USE ACID-FREE PAPER IF POSSIBLE • SPECTRUM BLUE PASTEL PENCIL FOR DRAWING OUTLINE • HARD PASTELS: SALMON PINK, YELLOW, OCHRE, BROWN, BURNT SIENNA, PURPLE AND WHITE • KNIFE FOR SHARPENING •TORCHON FOR BLENDING • FIXATIVE SPRAY

2.

Once you have completed the outline, look at the model to decide what the range of colours should be. In this case, the hair is the darkest, probably rating 8 on a scale of 1 to 10. Don't choose too many tones – keep it simple. Start with a salmon pink pastel stick, working from the top of the body down. Pinch the pastel between finger and thumb and use the side of the pastel to get a soft effect and cover broad areas.

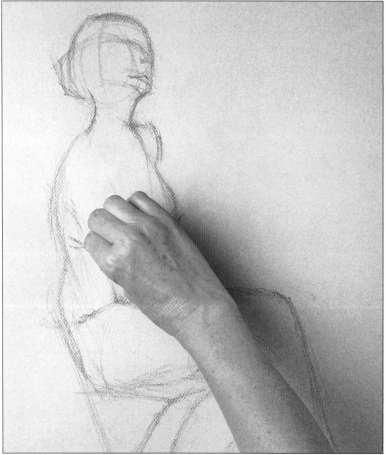

3.

Continue to add the pink in other areas with the same basic tone as the neck and shoulder – down the back and along the thighs. Sweep the pastel along the curves of the body. Try to think of the method as "drawing with pastel" rather than simply "colouring in" the outline.

4.

It's best to start with light tones and then add darker ones. Once you have applied the first, broad strokes, you can start to build up some tonal contrast – here burnt sienna is being applied over yellow. You're not trying to match the colours to life, but to render the tonal contrasts. Feel free to overlap colours or apply one on top of another and to blend them together.

5.

Continue to add colour – yellows and ochres are used here – but don't overwork the figure, keep it simple and work with the colour of the background paper to emphasise the highlights and shadows. Think about the direction of your strokes, following the direction that the body is taking in order to give a sense of the figure's shape and movement. Here, different strokes have been used to suggest the horizontal line of the thigh and the downward curve of the buttocks.

6.

Use the pale yellow pastel in the light-toned chest area. Sweep the flat side of the pastel around the curves of each breast to create a soft effect and to capture their form.

7.

As you work, you may find that you need to redraw. Don't be too concerned about erasing mistakes, unless they are distracting. If you do want to correct a mistake, use the torchon to blend the colour.

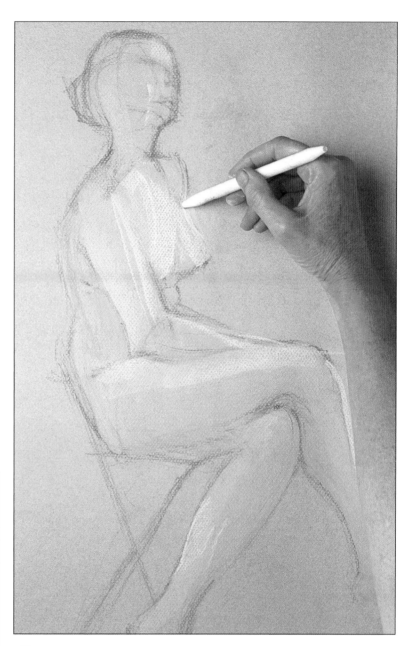

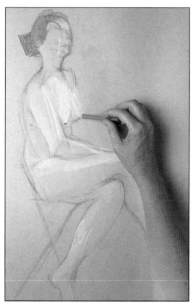

8.

Once you have added the main blocks of colour and got the tonal range right, including the highlights, you can add a minimum of detail using strong colours. Here a bold swathe of brown is used to delineate the hair, and burnt sienna for the nipples.

181

9.

Use your lightest tones sparingly, mainly for highlights. In this case, the figure is quite dramatically lit, giving very bright highlights, so some use of white is appropriate, but keep it to a minimum.

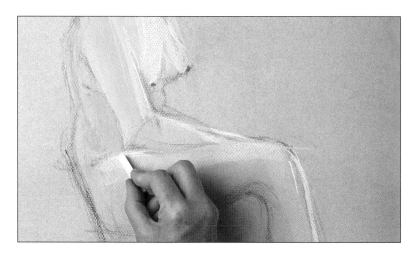

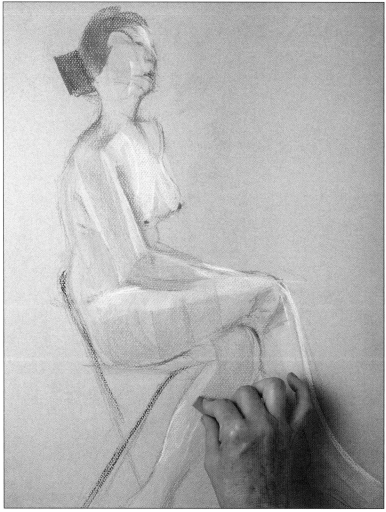

10.

Once you are satisfied with the overall figure, you can add a little detail to the face. You may also want to add some shading to give depth to the figure, but don't overwork it. Here, purple is used to strengthen the shading on the calves; a little has also been added to the hair.

Pose
2

L O U I S E

The second pose, again, is a comfortable one for the model and the addition of reading material has the effect of relaxing her even more. As with the first pose, the model can be approached from every angle and the strong lighting throws some interesting shadows. The main purpose of the pose is to present the artist with an outstretched figure. Parts of the body are seen to be much closer than others, and this presents the artist with problems of foreshortening where an outstretched foot, head or arm will look larger or smaller in relation to the rest of the body and out of proportion. For example, in a standing adult the head fits seven to eight times into the body, but when extreme foreshortening occurs this can be reduced to only three or four times. You will have to measure carefully and consider the body's perspective by breaking down the pose into simple blocks which follow perspective principles. Draw what you see rather than what you believe is correct, as this will help you to produce an accurate representation of the figure in front of you.

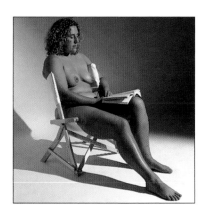
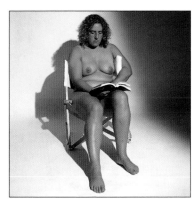
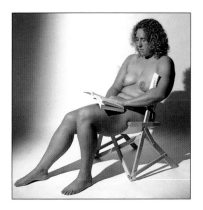

LOUISE – FRONT VIEW

Materials and Equipment

- PALE ORANGE INGRES PAPER
- RANGE OF PENCILS: B, 2B, HB
 - STICK OF COMPRESSED CHARCOAL ● ARTISTS' PAINTBRUSH TO USE AS A STRAIGHT EDGE FOR MEASURING ● PUTTY ERASER
- WHITE PASTEL PENCIL ● KNIFE FOR SHARPENING PENCILS
 - FIXATIVE SPRAY

1.

Use the HB pencil to sketch in the main lines of the figure, as in Project 1. Establish the basic proportions and position of the drawing on the page. With this position, the effects of perspective produce some quite extreme foreshortening. The feet and knees will appear quite large and the areas that move away from the eye, such as the thighs, will be shortened. This sketch needs to be fairly accurate, but don't worry about detail.

2.

Using the 2B pencil work down the figure restating the main outline. Screw up your eyes to help you to see the darkest tonal areas and use quite free hatching over these areas to start to give the figure form. Roughly indicate the facial features (the darker tonal areas and a few lines will do) and add the circles of the kneecaps (which are quite prominent in this pose).

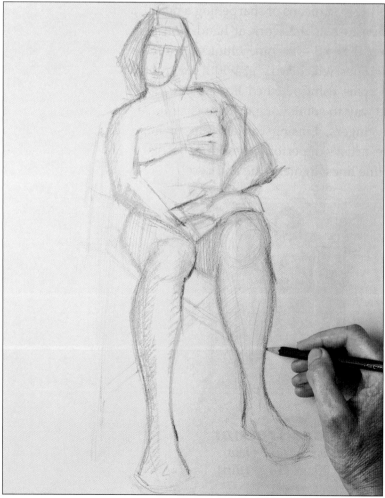

3.

Use the softest pencil (2B) to pick out the areas of medium tone and restate the main areas within the torso. Indicate the soft shadow beneath the breasts to give a more accurate rounded effect and emphasise the cylindrical shape of the thighs and arms.

Pose

2

LOUISE

The second pose, again, is a comfortable one for the model and the addition of reading material has the effect of relaxing her even more. As with the first pose, the model can be approached from every angle and the strong lighting throws some interesting shadows. The main purpose of the pose is to present the artist with an outstretched figure. Parts of the body are seen to be much closer than others, and this presents the artist with problems of foreshortening where an outstretched foot, head or arm will look larger or smaller in relation to the rest of the body and out of proportion. For example, in a standing adult the head fits seven to eight times into the body, but when extreme foreshortening occurs this can be reduced to only three or four times. You will have to measure carefully and consider the body's perspective by breaking down the pose into simple blocks which follow perspective principles. Draw what you see rather than what you believe is correct, as this will help you to produce an accurate representation of the figure in front of you.

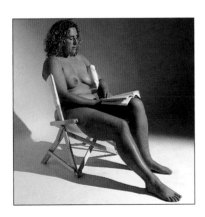
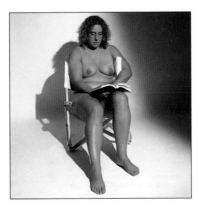
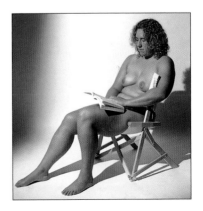

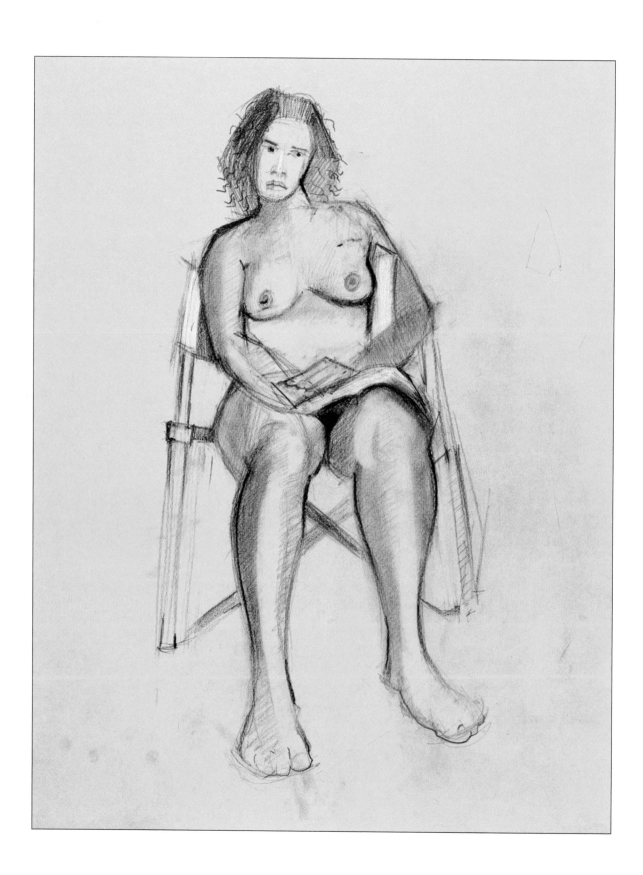

SOFT PENCILS

The traditional pencil is one of the most widely used and versatile artists' tools. However, it is not always used to its true potential. Pencils range in hardness from 9H hard to 9B soft, and are capable of producing drawings of great beauty. A knife is the best means of sharpening a pencil, as the point can be made to suit the work at hand. Soft pencils – which range from B to 9B – become blunt with use so it is possible to make lines which vary in width, or to build up intricate shaded areas using hatched lines. Heavy scribbled shading can give way to subtle tone when it is smudged and spread with the fingers. Erasing can also be an important technique in the artist's repertoire, working back into the drawing to redefine lines, lighten tone and add highlights.

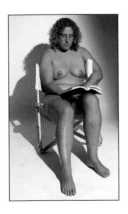

Frances Treanor
Louise – front view
36 x 25cm (14 x 10in)

LOUISE – FRONT VIEW

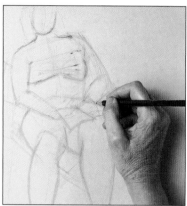

1.

Use the HB pencil to sketch in the main lines of the figure, as in Project 1. Establish the basic proportions and position of the drawing on the page. With this position, the effects of perspective produce some quite extreme foreshortening. The feet and knees will appear quite large and the areas that move away from the eye, such as the thighs, will be shortened. This sketch needs to be fairly accurate, but don't worry about detail.

Materials and Equipment

- PALE ORANGE INGRES PAPER
- RANGE OF PENCILS: B, 2B, HB
- STICK OF COMPRESSED CHARCOAL • ARTISTS' PAINTBRUSH TO USE AS A STRAIGHT EDGE FOR MEASURING • PUTTY ERASER
- WHITE PASTEL PENCIL • KNIFE FOR SHARPENING PENCILS
- FIXATIVE SPRAY

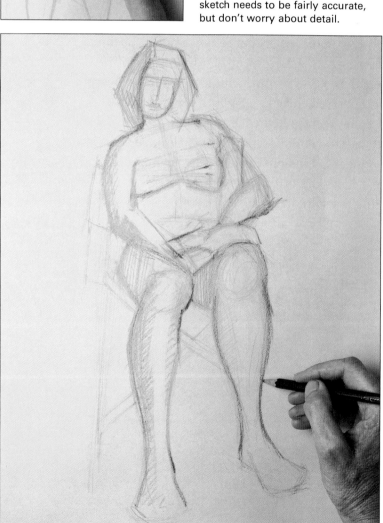

2.

Using the 2B pencil work down the figure restating the main outline. Screw up your eyes to help you to see the darkest tonal areas and use quite free hatching over these areas to start to give the figure form. Roughly indicate the facial features (the darker tonal areas and a few lines will do) and add the circles of the kneecaps (which are quite prominent in this pose).

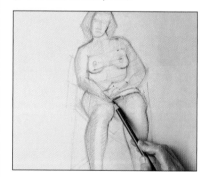

3.

Use the softest pencil (2B) to pick out the areas of medium tone and restate the main areas within the torso. Indicate the soft shadow beneath the breasts to give a more accurate rounded effect and emphasise the cylindrical shape of the thighs and arms.

4.

Because the pencil is soft you can use your fingers to blend the tones of the body to achieve a more flesh-like texture. As the form of the figure is cylindrical (which is especially pronounced on the legs and arms), the tone will be darkest furthest from the light source, gradually lightening to the highlights where the light hits the figure directly.

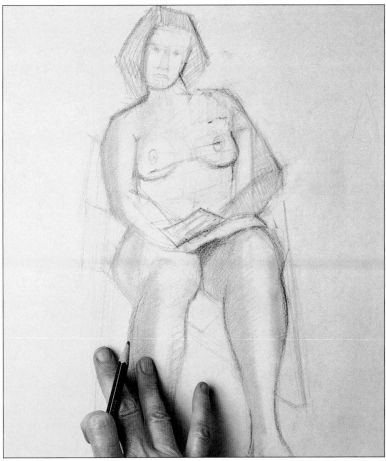

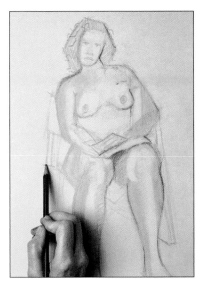

5.

Define the features of the face lightly using the 2B pencil – from straight on the nose is basically a triangular shape. Once the figure is almost complete, draw in the stool or chair more clearly with the 2B pencil. Pay particular attention to the position of the feet of the chair in relation to the model's feet so that she sits firmly on the ground. Also make sure that the effects of foreshortening in the figure are not contradicted by the relative position of the chair legs. Look at the shapes and lines that the chair makes with the seated figure. Remember that the focus of the picture should be the nude, and the chair should only really be hinted at.

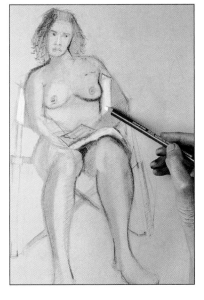

6.

Add final details to the hair, hands and feet if necessary. Use the putty eraser as a drawing tool to remove colour from the highlighted areas of the body. Finally, use a white pastel pencil to pick out the chair detail.

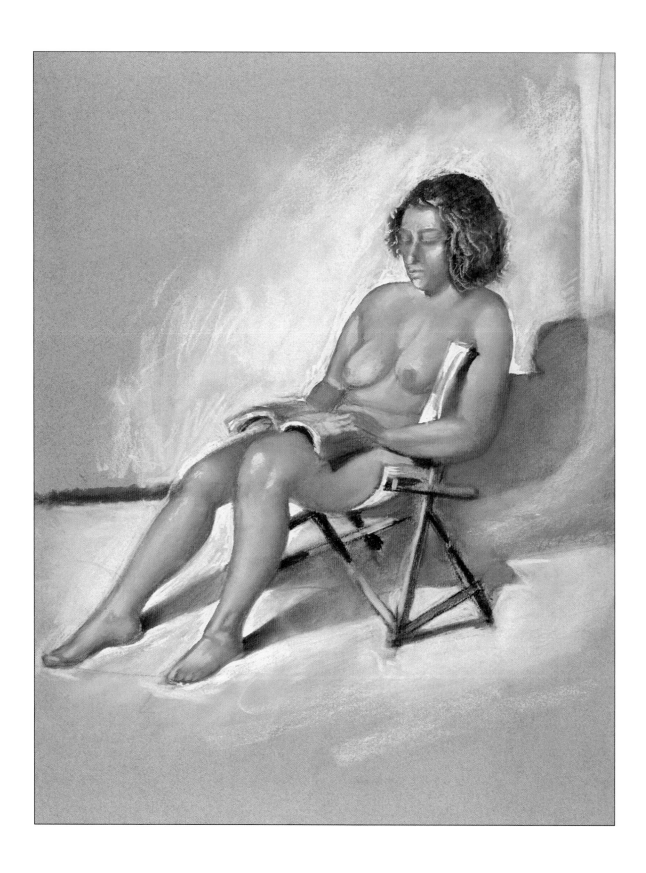

Project
5

SOFT PASTELS

Pastels have a brilliance and jewel-like quality, which is almost sensual, and they hold a unique allure for the artist. Using pastels is similar in many ways to working with oils; indeed pastel drawings are often described as paintings. Soft pastels are available in a wide range of colours, tints and hues in order to lessen the need for unnecessary mixing. Unlike paint, the sticks are mixed on the paper or board support, or by placing pure colour tints next to one another so that the mixing takes place in the eye of the viewer. Pastels are easy and straightforward to use, but good results are not so easy to achieve. Practice and a sure approach will help. Pastel paintings are delicate and will need to be sprayed with fixative in order to prevent smudging.

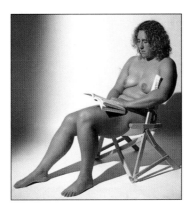

John Barber
Louise – three-quarter view
25 x 18cm (10 x 7in)

LOUISE – THREE-QUARTER VIEW

1.

Sketch out the body shape and the shape of the shadow around the figure, using a red pastel pencil, which will give you more control than the pastel sticks. As you sketch, look for the three main tones of the figure – dark, medium and light. In the areas of darkest tone use the torchon like a paintbrush and your finger to turn the lines of the sketch into areas of tone.

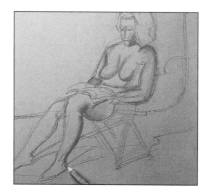

Materials and Equipment

GREY INGRES PAPER (SMOOTH SIDE USED) • PASTEL PENCILS: RED AND WHITE • TORCHON • PROFESSIONAL RANGE OF SOFT PASTELS: PURPLE-BLUES, LIGHT PINKS, WHITE, DARK BROWNS AND YELLOWS • PUTTY ERASER • KNIFE FOR SHARPENING • FIXATIVE SPRAY • WHITE GOUACHE • SOFT SABLE BRUSH

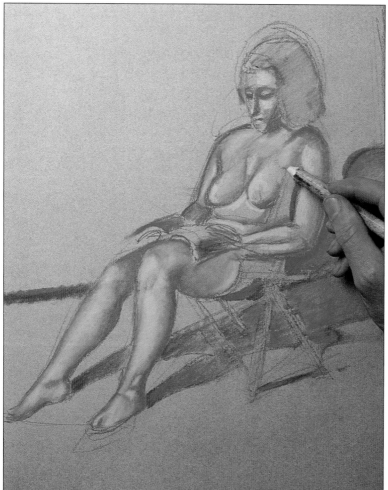

2.

Use the flat side of a purpley-blue pastel for the areas of cast shadow around the model and on the book. Blend to achieve a flat tone. It doesn't matter if the original red starts to blend in. Then use a light pink pastel to pick out the areas of the lightest flesh tone and blend with the torchon.

3.

Add white to the chair arm and to the book, then with a dark brown pastel, accentuate the darkest areas of shadow on the figure. These occur where the arm rests against the chair, where the cast shadow meets the feet, under the book and on the chair legs. In the same colour, block in the model's hair.

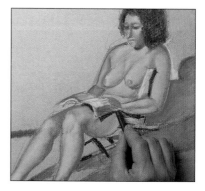

4.

 Use a white pastel pencil to bring out the background around the figure, making any alterations to the outline. Notice the differences in contrast with the background around the figure, where the edges of the body almost blend into the background in places, but stand out very harshly in others. Adjust the shadow to show any changes in the intensity of the cast shadow and blend with your fingers. Add yellow highlights to the chair legs.

5.

Use yellow, brown and white to add colour, texture and highlight to the hair; follow the hair lines to define the shape of the skull. Sharpen the white at the edges, using white gouache and a soft sable brush.

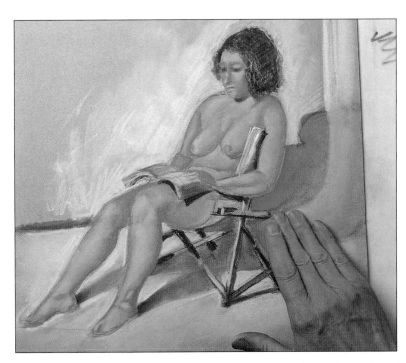

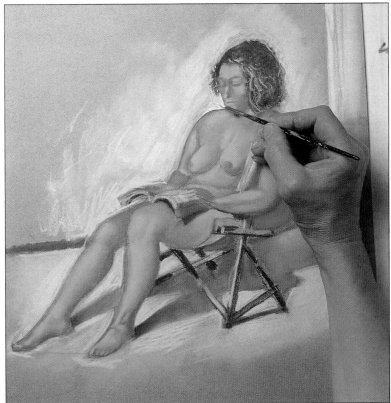

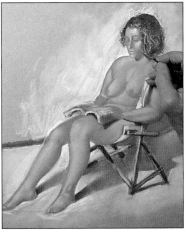

6.

Finally, use the brush and gouache to pick out the very lightest areas on the arm of the chair, and on the model's face where the light hits the cheek and forehead. Avoid making the brushwork too obvious. This final touch should be very subtle.
Do not attempt to make the face too detailed, otherwise the head will dominate the picture as a whole.

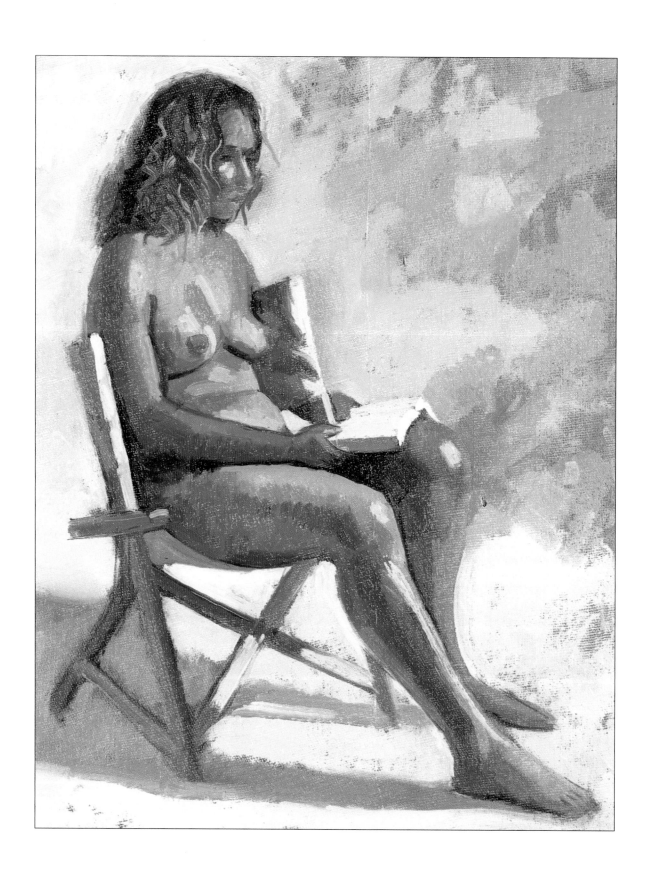

Project

6

OIL PAINTING

Oil paints are unmatched when it comes to versatility and depth of colour. The medium has a long tradition and it is possible that more artistic works are painted in oil than in any other medium. Contrary to popular belief, oil paints are surprisingly easy to use and the range of techniques and means of application are vast. Paint can be applied with a brush, a knife, the fingers, rags or even rollers. It can be trowelled on thick or applied in thin transparent glazes, and if the result is considered unsatisfactory, it can be scraped or wiped off. The main principle to apply is to work "fat over lean". This is done by using paint mixed with turpentine or white spirit thinners and little oil in the initial layers, and adding oil only to the mixes in the final or top layers of paint.

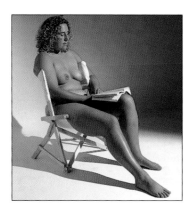

James Horton
Louise – side view
56 x 41cm (22 x 16in)

LOUISE – SIDE VIEW

1.

Use a weak ultramarine to sketch the outline of the figure in order to place the image correctly on the board and to establish the proportions and lines. Do not worry about accuracy because the work can easily be adjusted as you go and the lines will be obliterated by the overlaid paint. Once you are happy with the basic composition, paint in some of the background using white and ultramarine.

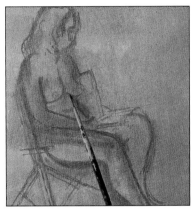

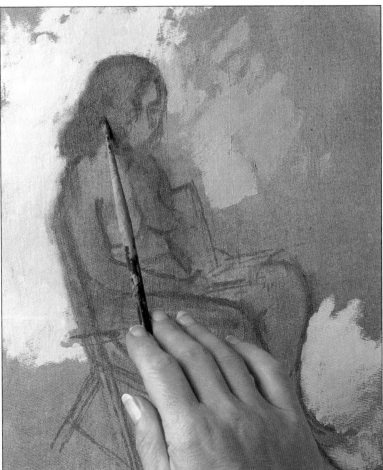

Materials and Equipment

● PRIMED CANVAS AND BOARD (SEE PAGE 23) ● PALETTE OF OIL PAINTS: BLACK, ULTRAMARINE, ALIZARIN CRIMSON, CARNELIAN RED, CADMIUM RED, BURNT UMBER, RAW SIENNA, YELLOW OCHRE, CADMIUM YELLOW, TITANIUM WHITE ● WOODEN PALETTE ● SEVERAL ARTISTS' PAINTBRUSHES IN NYLON, BRISTLE AND SABLE, RANGING IN SIZE FROM 2 TO 8 ● PALETTE KNIFE ● TWO CLIP-ON DIPPERS TO HOLD SOLVENT AND MEDIUM ● WHITE SPIRIT FOR WASHING BRUSHES ● RAG

2.

Starting with the model's hair, use a thick brush to put the basic colour building blocks in place, using a mix of yellow ochre, cadmium red and black. Try not to add too much detail at this stage – think of it as the first step in putting the colour in place.

3.▸

Mix a basic flesh colour with raw
sienna, cadmium red, white and
burnt umber, and start applying it in
broad blocks; picking out three
tones, light medium and dark. Try to
build up the figure as a whole,
rather than trying to finish any one
section in detail. Then, begin to work
on the figure's limbs. Use the side of
a palette knife to scratch at the paint
on the arms and legs to develop the
highlights. There is no need to add
too much detail at this stage of the
painting.

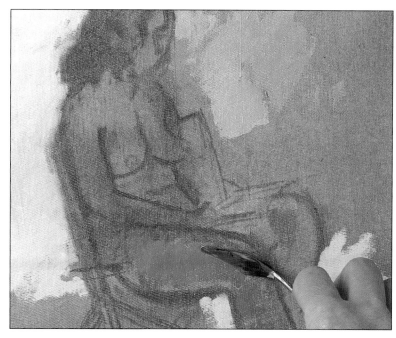

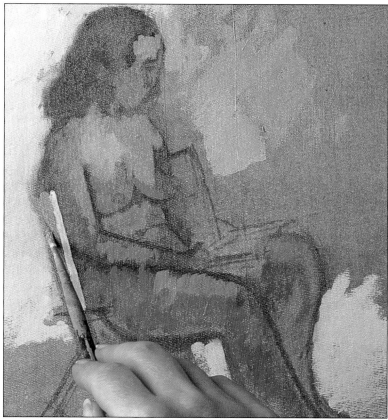

4.◂

Now develop the shape of the chair.
Begin to fill in the shape with a
combination of yellow ochre, burnt
umber and ultramarine, to give it
more definition. Pick out the
highlights with white. As before, do
not worry about detail.

5.

Use a rag to remove any areas that you are not happy with or any accidental blobs of colour.

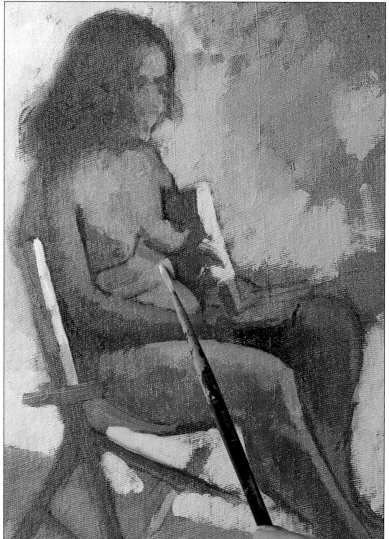

6.

Start to look in more detail at the subtle colour changes over the model's body, such as the stomach. With one of the medium brushes, revisit small areas within the main colour blocks, making small adjustments to colour and tone, using the three flesh tones. Skin is not simply one flat colour; it varies enormously over the body's surface and with the effect of light.

7.

Taking the finest brush, use white and cadmium yellow to build up layers of colours through the hair to give it texture. As the hair colour will change in the light, aim for the correct balance of colours and realistic tonal relationships, rather than an exact replication.

8.
Using a fine brush, continue with the development of the chair. Sharpen the colour of the background in relation to the chair in order to bring out its shape.

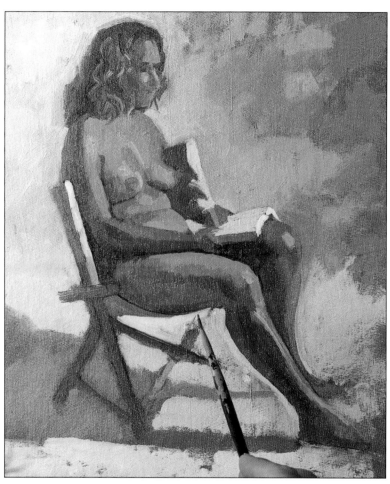

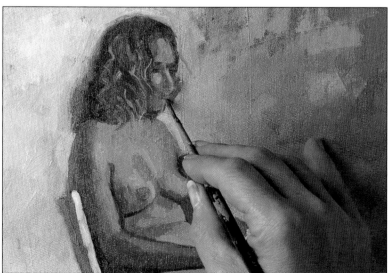

9.
Concentrate on the head, first by adding colour to the hair. Then, using the finest brush, start to pick out some of the details on the face, paying attention to the eyes and nose. For the mouth, use a mix of cadmium red and raw sienna.

OIL PAINTING

10.

When the colour on the head is complete, use the end of a brush to scratch away at the back of the hair to soften the line and give the hair texture. At the same time, use the back of the brush to remove any small splashes of paint.

11.

As the painting nears completion, add the finer details to give a final polish. Bring out the tonal values of the figure and background by making small adjustments to the colour in critical areas such as the knees.

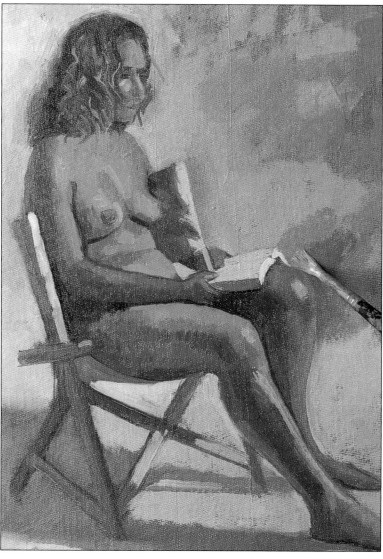

Pose

3

SARAH

The straightforward standing figure may at first seem to be the simplest to draw or paint, but this is not necessarily the case. Here, the model is lit from the side to accentuate the tonal contrast from light to dark, which means that much of the tone which defines the form could be inferred rather than accurately represented. The main problem with drawing or painting the standing nude figure is achieving the correct balance and distribution of weight. Working from a vertical line, either imagined or actually drawn, will help you to position the figure correctly. This line should be positioned to run vertically from the centre of the neck to the floor as this represents the body's centre of gravity. Correct measuring of proportion is critical in order to prevent the figure appearing too short or long, and correct use of this vertical line will prevent the figure seeming to fall over. Make frequent reference to the shapes around the figure to check and reassess the accuracy of your work, and readjust as you go.

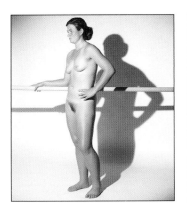 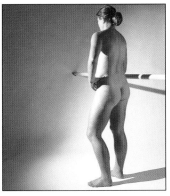 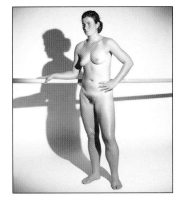

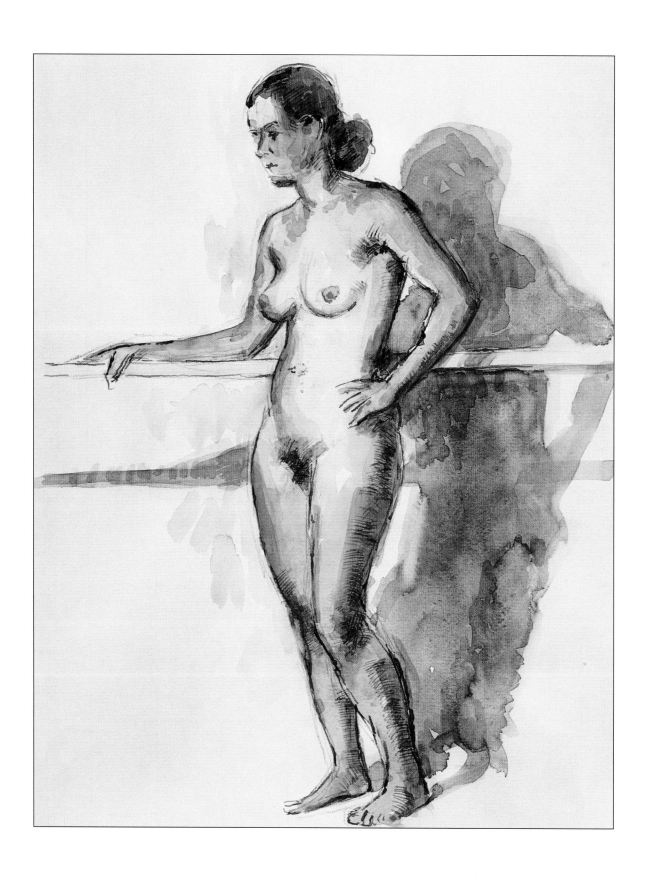

Project

7

PEN AND WASH

Using pen and wash can be deeply satisfying. The pen can produce beautiful line work of varying thickness and solidity, or hatched, cross-hatched, broken, dotted, ticked and smudged lines. Diluting the ink with water extends the possibilities even further. Water-soluble ink washes extend the medium's potential, enabling you to add solid blocks of line and tone. Corrections are difficult to make in pen and wash and are best incorporated into the work. Any mark should be considered carefully and, to this end, a light pencil drawing can be of assistance as a guide. This will enable you to concentrate on the pen work, which can be suprisingly varied. The pen and wash should work together, rather than the wash being used simply as a means of "filling in".

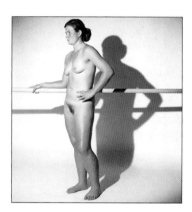

James Horton
Sarah – three-quarter view
36 x 25cm (14 x 10in)

SARAH – THREE-QUARTER VIEW

Materials and Equipment

- CREAM WATERCOLOUR PAPER
- HB PENCIL • WATERCOLOUR
PALETTE: CADMIUM RED, YELLOW
OCHRE, COBALT BLUE, PAYNE'S
GREY • RANGE OF SMALL, SABLE
ARTISTS' BRUSHES • WATER
- BROWN INK • TWO OR THREE
GOOSE QUILLS CUT INTO A
POINT • FINE METAL-NIBBED
DIP PEN

1.

Sketch the basic lines of the figure using an HB pencil. Do not include any shading or form, as the pen and wash will be used for this. Using cadmium red and yellow ochre, with a touch of cobalt blue for the darker tones, mix one or two basic skin colours and start a watercolour wash across the figure with a small brush. Aim to indicate only the broad areas of the main variations in tone and colour across the flesh. Use very transparent layers of paint.

2.

Build up thin layers of colour, to indicate changes in the depth of tone. Pick out the shapes of the shadows on the body by using the darker skin colour. Then using a grey-blue wash and a larger brush, add the background shadow.

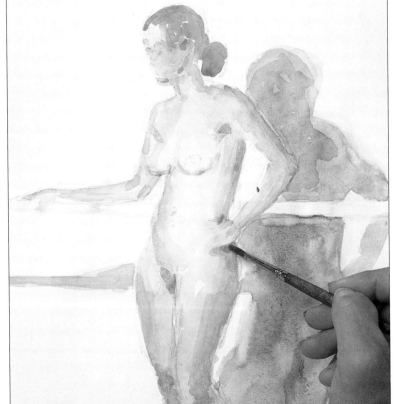

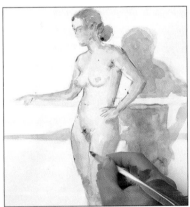

3.

Wait for the paint to dry, then use a quill and brown ink to restate the main lines and add some detail to the face and hands. The quill is not a totally controllable tool and the blotches and variations in line add to the spontaneity of the picture.

4.

Use fairly light hatching in the areas of darkest tone to accentuate the form of the figure and changes of plane, for example around the knee cap where the leg angle changes. Keep the hatching fairly loose so that the ink does not dominate the picture and give the impression of a "coloured-in" line drawing.

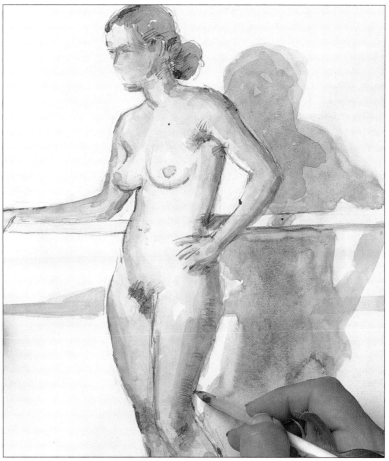

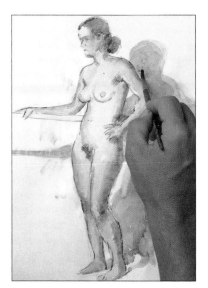

5.

Using a small brush, mix Payne's grey with a little cobalt blue and build up the changes in depth of the background shadow. The shadow should be slightly darker around the figure to "lift" the nude off the page and to indicate the space between the figure and the background.

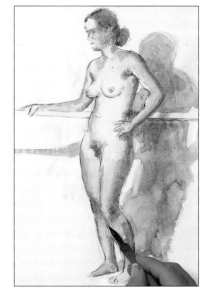

6.

Finally, use a fine metal-nibbed dip pen to restate any fine lines and the finer detail around the face and head. The position of the ear is particularly important as it indicates the angle of the head, but do not try to achieve too much detail.

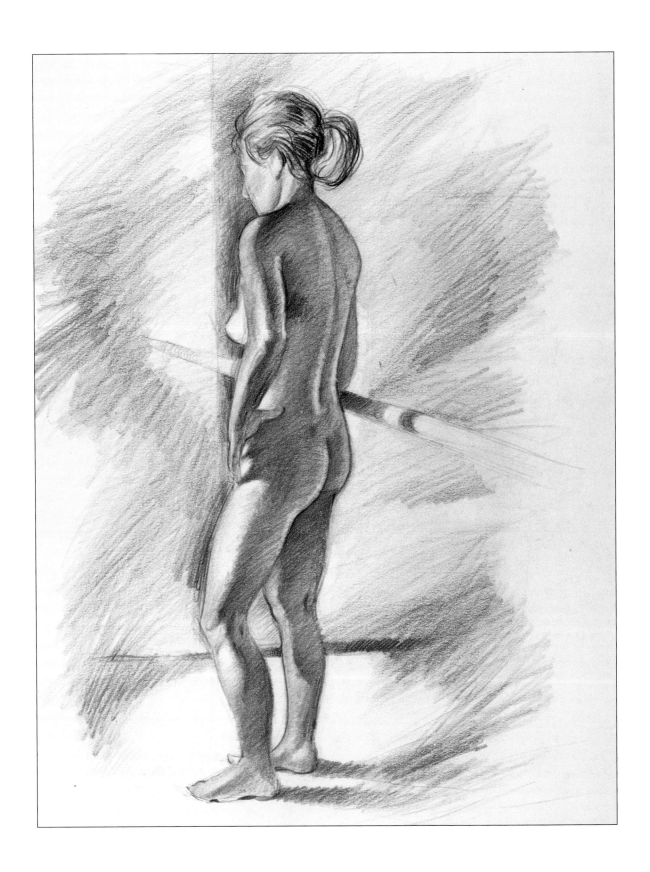

Project
8

COLOURED PENCILS

Coloured pencils give the tight control found with ordinary lead pencils. The techniques that can be achieved using coloured pencils far outstrip the traditional image of them as children's playthings. Although they are capable of producing loosely scribbled expressive work, they can also produce very subtle images of almost photographic quality. The range of marks that can be made is similar to graphite pencils, but because they are made from pigmented wax they can be more difficult to erase. Coloured pencils are mixed either by layering one colour over another, or by laying colours close to one another so that when viewed from a distance they are mixed in the eye of the viewer.

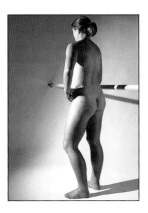

John Barber
Sarah – rear view
25 x 18cm (10 x 7in)

SARAH – BACK VIEW

1.

Make a preliminary sketch, using a reddish brown pencil, to get the proportions and position of the figure correct. Make sure that the feet are firmly established in relation to each other. The shin of the leg that is taking the weight should be vertical. Block in the head and mark the position of the left ear. Then refine the sketched outline.

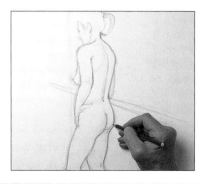

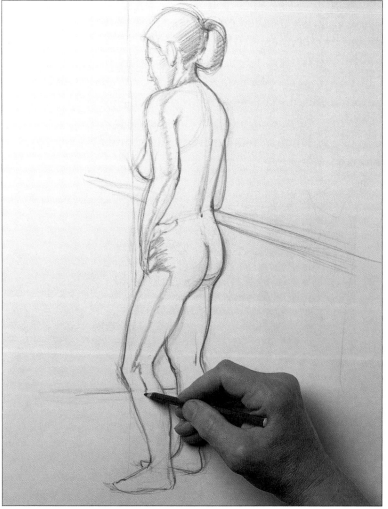

Materials and Equipment

• LANA WATERCOLOUR PAPER (A3) • SELECTION OF COLOURED DRAWING PENCILS: RED-BROWN, PALE ORANGE, PALE BLUE, PURPLE, LILAC, GREY, BROWN, DARK GREY • KNIFE FOR SHARPENING • RUBBER ERASER • ADHESIVE PUTTY

2.

Notice which parts of the body turn away from the light and draw a line from the top of the head to the feet, splitting the figure into a basic dark side and light side. The shape of the cast shadow tells a lot about the form. For example, the shape of the shadow where the hand meets the hip shows that there is a space between the arm and the body.

3.

Using a loose hatching technique, block in the area of darkest tone all across the body. Do not try to show the changes in form of the body. Concentrate only on the patterns of light, shade and tone in order to keep the emphasis on the fluid lines of the nude.

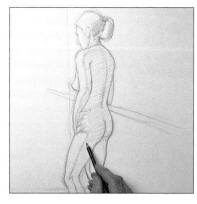

4.

As you work, continually readjust and restate the lines of the figure. Each stage of work is likely to draw your attention to areas of inaccuracy in the drawing. Use an ordinary pencil eraser to remove any inaccurate lines.

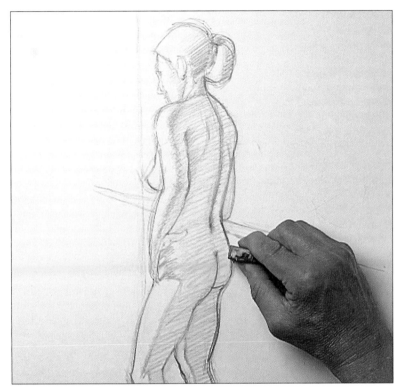

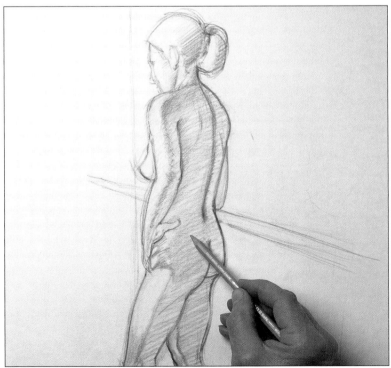

5.

Change to a pale orange and hatch in the mid-tone areas, but continue into the shaded areas, to keep the continuity of colour across the skin.

6.

Once the basic three tones have been established, look at the figure again and using the pale orange start to elaborate on the changes of tone across the body, darkening and deepening the colour where appropriate. For example, the edges of the areas of shadow often give the impression of having a deeper, richer tone and colour. This will start to bring out the form of the body.

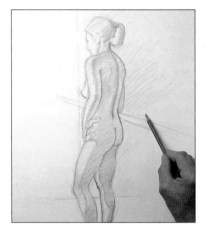

7.

Use pale blue and purple pencils to hatch in the background. To achieve a continuous tone, use the side of the pencil. The background will give the picture more depth and will bring out the leading edge of the figure because the cool colours contrast with warm flesh tones. In some areas around the edge of the figure the contrast will be more marked than others. For example, along the model's back the tone of the wall and the figure are much closer than down her front.

8.

Use a purple pencil to add the cast shadow. Because the model is well lit, this will be quite an intense colour with definite edges. The angle of the shadow tells you where the light source is (as does pattern of light and tone over the figure). The shadow can be drawn to denote the texture and angle of the background. It can also be used to judge whether the model has taken up the correct pose after breaks.

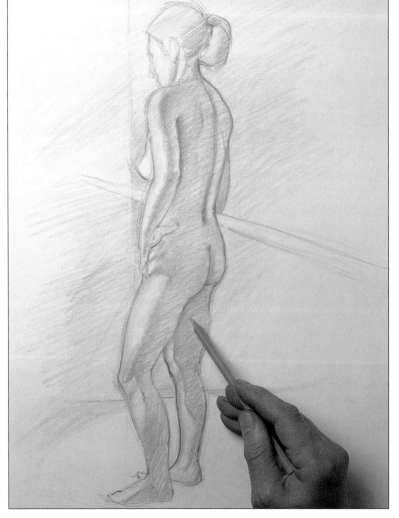

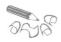

9.

Start to add the final touches. Bring out strength of colour in relation to the background by adding the reddish tones of legs, emphasising the strong shadow edges. If areas begin to look too "hot", tone them down with a cool lilac hatched over the top. Add the shadows on the barre using grey and brown. These shadows indicate the gap between the furthest arm and the body, even though this cannot actually be seen in this view. Then using a piece of adhesive putty, moulded into a point, gently dab off some of the colour on the highlighted areas of the body, for example, on the breast, where the hand meets the hip, and down each side of the spine.

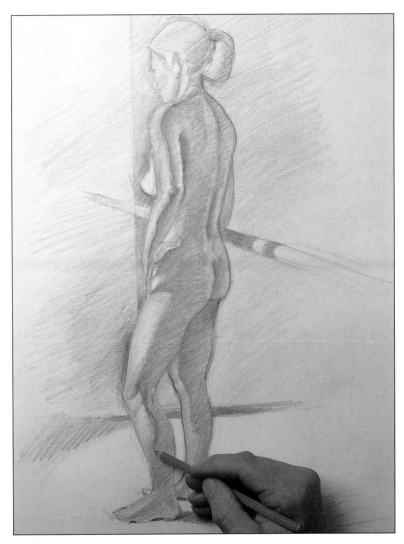

10.

Finally, use the brown pencil to pull together the figure with more line work, and using the same colour, add the final detail to the hair. Look carefully at how much of the face is actually showing: about sixty per cent of the head is covered by hair. Use a darker grey to bring out the face, and the front of the shoulders. Do not overdo the hair and face or the head will dominate the picture, and this is not intended to be a portrait, but a celebration of the female form in its entirety.

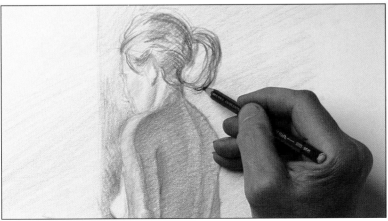

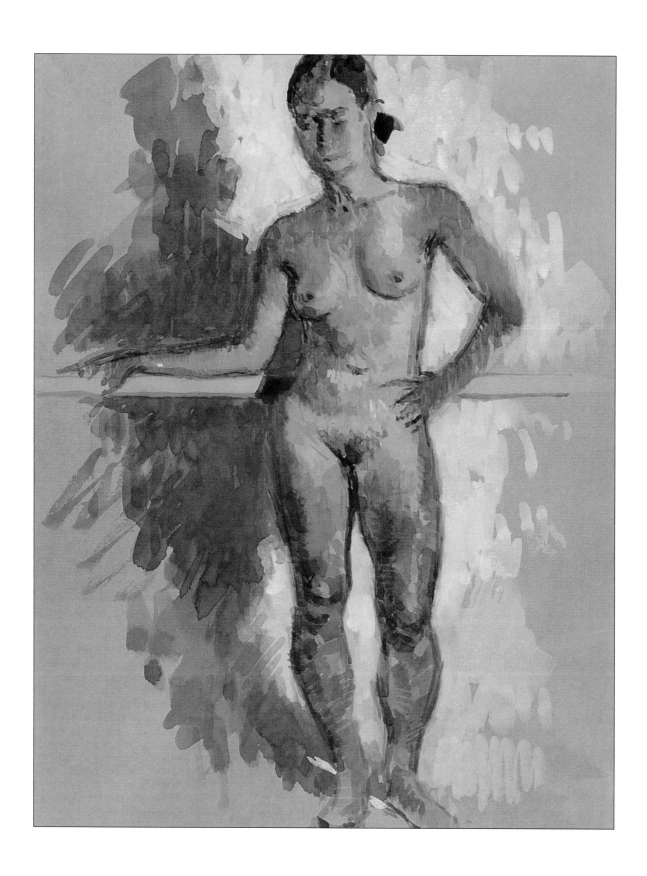

WATERCOLOUR

Water-based mediums have been in use longer than any other. The nature of watercolour – its unpredictability – is part of its attraction. The best work combines simplicity, spontaneity and the elusive Inner Light, which is the main characteristic so evident in pure watercolour technique. This is achieved by allowing the paper to reflect light back through the thin washes of paint. It is for this reason that watercolour paintings are usually painted on very light papers. The medium perfectly suits the subtle gradations of colour and tone seen on the nude form. Its application can be fast and loose, with colours and washes being allowed to mix on the support, or worked in a more considered way, "wet on dry", each layer altering and qualifying the next.

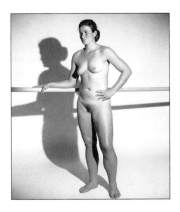

James Horton
Sarah – front view
56 x 41cm (22 x 16in)

SARAH – FRONT VIEW

1.

Using a small brush and a thin wash of yellow ochre and cadmium red, sketch the figure outline. Do not worry about details. Work on getting the axis down the torso correct and the feet in the right place in relation to each other. Paint in some of the background using Payne's grey and yellow ochre. Use a very pale grey, mixed with a little white gouache to make it more opaque, and darker grey for the shadow. This will eventually fill the whole paper.

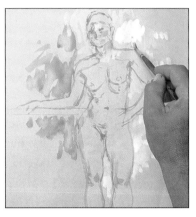

Materials and Equipment

• GREY INGRES PAPER WITH GRAINED SURFACE, MINIMUM A3 SIZE • BOARD TO ENSURE AN EVEN SURFACE TO WORK ON •WATERCOLOUR PALETTE: ALIZARIN CRIMSON, CADMIUM RED, CADMIUM YELLOW, YELLOW OCHRE, ULTRAMARINE BLUE, BURNT UMBER, PAYNE'S GREY • THREE SMALL SABLE ARTISTS' BRUSHES •WATER •WHITE GOUACHE • RAG OR TISSUE

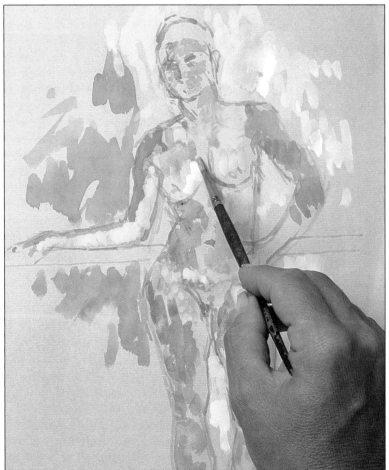

2.

Mix a basic flesh colour with cadmium red and cadmium yellow; this can be mixed with ultamarine to create the darker skin tones. Go across the body with a thin covering of colour first and then start to pick out the tonal changes, sounding out main colour and tonal differences in a broad way.

3.

Once the basic tonal differences have been established over the figure, use burnt umber to paint the hair. Bear in mind that the head is a dome shape so there will be differences in tone even within the hair. Because the model is lit from the front, the sides and back of the head are darker, with a lighter area across the front and top. Using a darker mix of the background grey, bring the shadow behind the model into a sharper focus, working the colour right up to the figure. This will start to bring the figure out from the page, indicating the space between the model and the wall behind. The angle of shadow also gives information about the direction of the light source and its intensity.

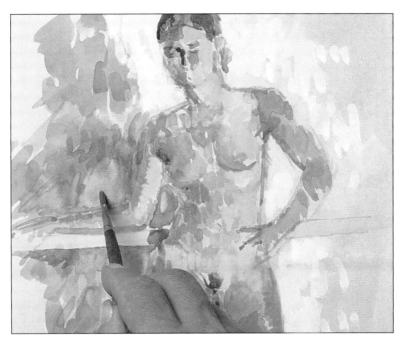

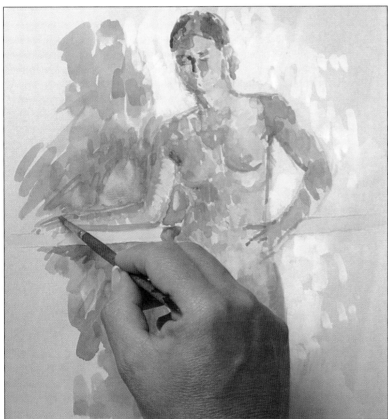

4.

The addition of the background colour will probably bring your attention to areas of the figure's edge that you want to alter and correct. Here, the forearm along the barre was thinned slightly by painting the background up to a new edge.

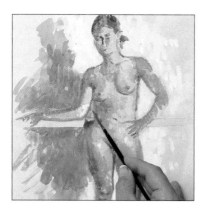

5.

Define the modelling on the body with the skin colour. Bring out more subtle tonal differences by mixing with Payne's grey and burnt umber. Use the darker, more brownish skin tone down the left hand side of the figure to "carve" it out of the paper. Add light pinks to the areas where the light hits the paler skin of the abdomen and breasts. Contrasting thin and thicker layers of colour will help to bring out texture and tone.

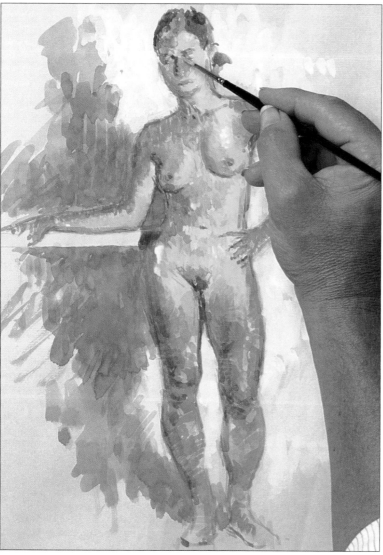

6.

Finish by adding the finer details of the facial features, using the smallest brush. However, do not try to create an exact portrait. A suggestion of the main features and the pattern of colour and tone will suffice.

INDEX